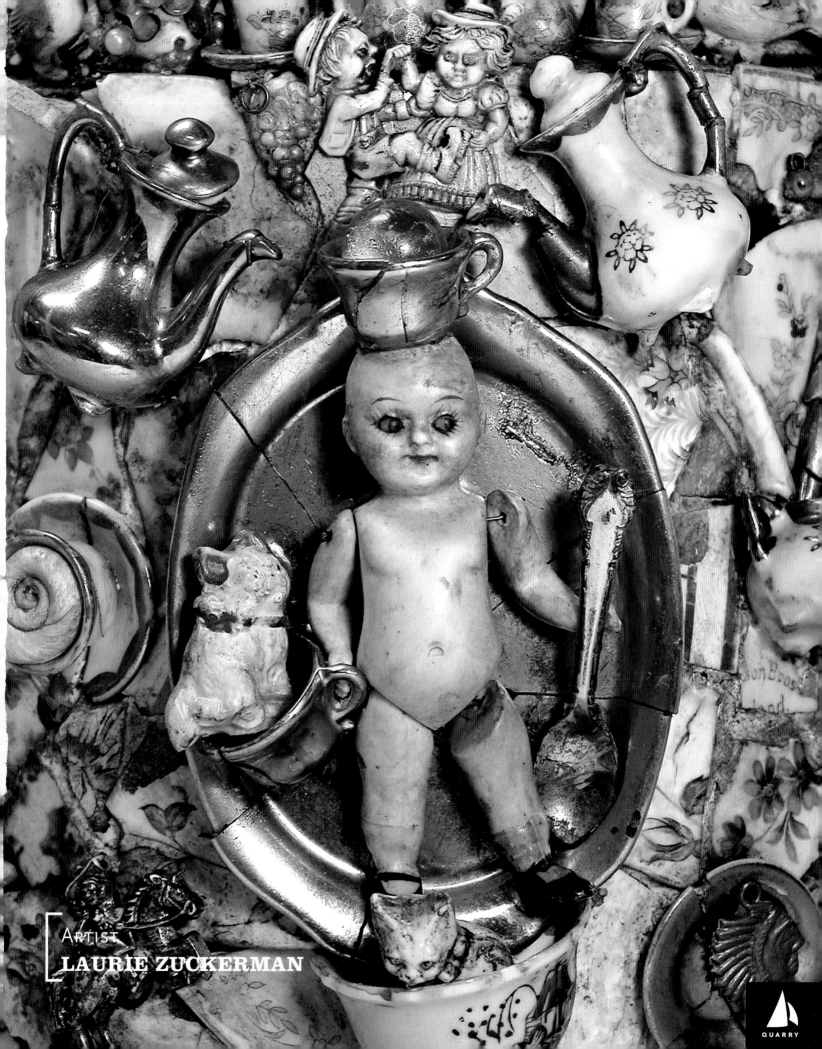

First published in the United States of America by
Quarry Books, a member of
Quayside Publishing Group
100 Cummings Center
Suite 406-L
Beverly, Massachusetts 01915-6101
Telephone: (978) 282-9590
Fax: (978) 283-2742
www.quarrybooks.com

Library of Congress Cataloging-in-Publication Data
Perrella, Lynne.
 Art-making, collections, and obsessions : an intimate
exploration of the work and collections of 35 artists /
Lynne Perrella.
 p. cm.
 ISBN 1-59253-363-9
 1. Handicraft. 2. Assemblage (Art) I. Title.
 TT880.P47 2008
 745.5–dc22 2007026722

ISBN-13: 978-1-59253-363-3
ISBN-10: 1-59253-363-9

10 9 8 7 6 5 4 3 2 1

Cover Image: Sarah Blodgett

All photography by Sarah Blodgett and art direction by
Lynne Perrella, except for page 90, by John Wong, page 147,
by Denise Andersen Photography, and the following pages by Glenn
Scott: 10, 22, 36, 58, 59, 67, 70, 74, 89, 124, 126 .

Printed in China

ART MAKING,

COLLECTIONS & OBSESSIONS

LYNNE
PERRELLA

BEVERLY MASSACHUSETTS

QUARRY
BOOKS

AN INTIMATE EXPLORATION OF **35 ARTISTS**
THE MIXED-MEDIA WORK AND COLLECTIONS OF

CONTENTS

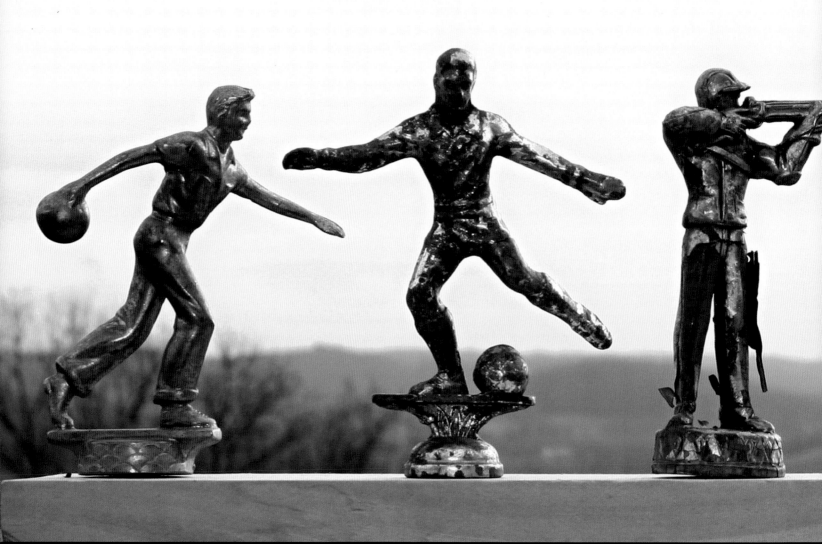

Introduction
6

CHAPTER ONE

FINDERS,
KEEPERS
10

*Discoveries and finds,
serendipitous survivors,
arcane collectibles,
recycled goods*

CHAPTER TWO

PRECIOUS
AND FEW
36

*One of a kind, ultra
personal, made by
hand, singular and
cherished*

CHAPTER THREE

RARE
EARTH
70

*From the natural
world, the great
outdoors, inspired by
nature, rustic revival*

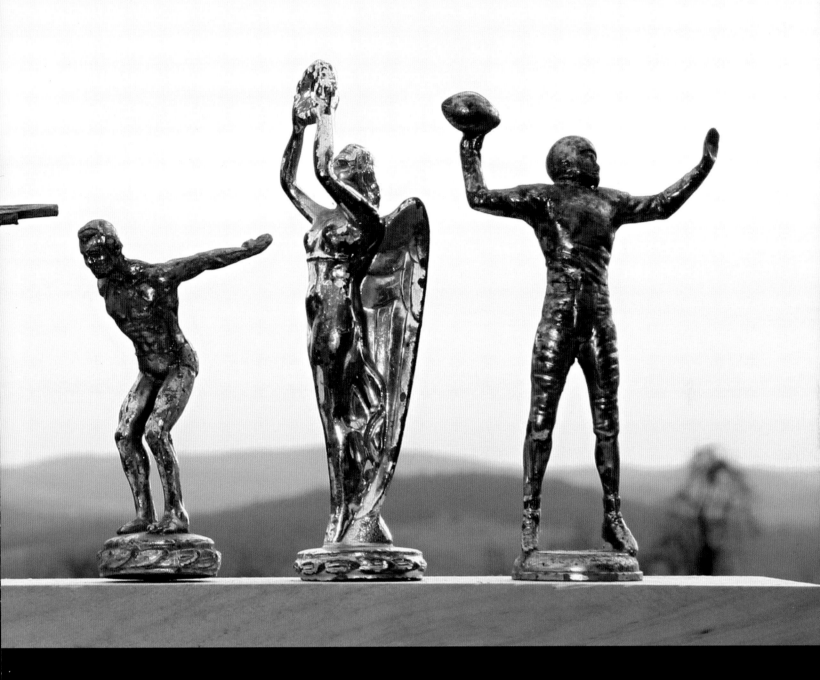

CHAPTER FOUR

HUMBLE
PIE

108

*Dimestore cheapo,
glorious funk and junk,
ephemeral treasures,
tattered and true*

CHAPTER FIVE

GLITTERING
PRIZES

126

*Regalia, elegant frills
and frippery, jewel-like
finds, gem-encrusted
finery*

ARTIST
CREDITS

156

*Contributing Artists,
Avid Collectors,
Helpful Resources*

About the Author
158

Acknowledgments
160

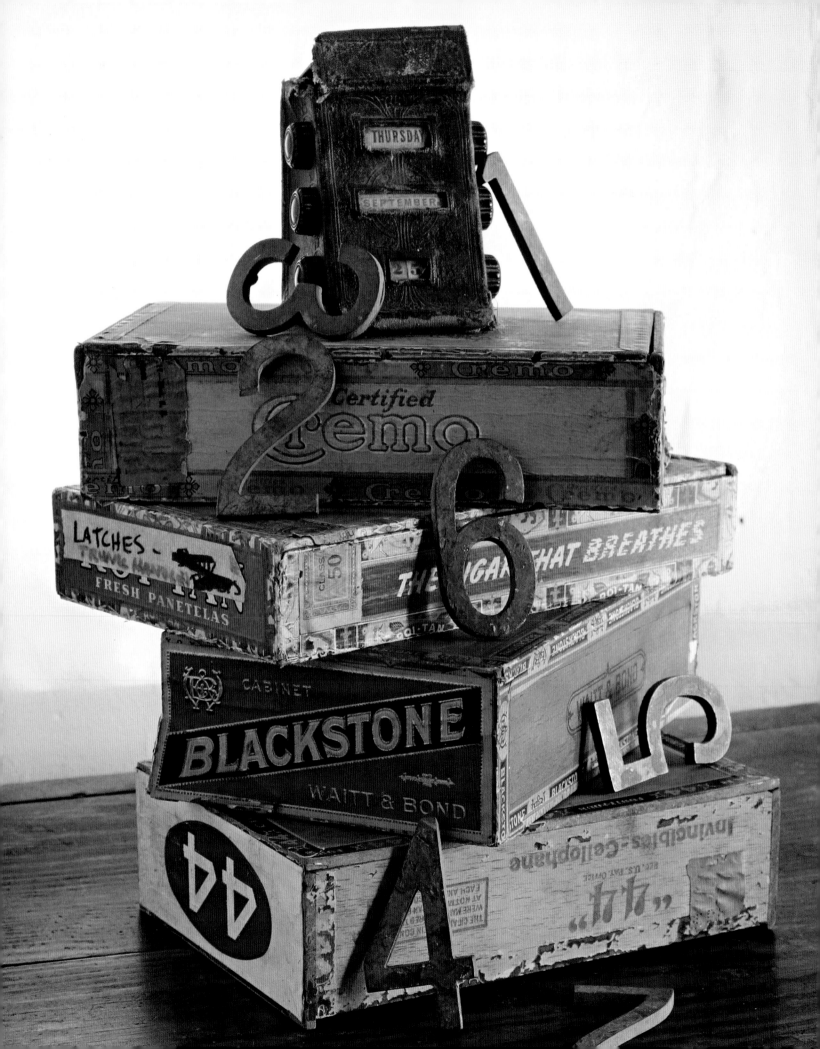

Accumulation, Abundance, and Aberration

Whether we call it collecting, scavenging, accumulating, scrounging, gathering, or junking, it's all about the urge to surround ourselves with our stuff, our loot, our stash, our hoard, our mother lode of treasures, and to reap the inspiration that these sometimes inexplicably irresistible objects provide. Every artist in this book has professed a different "favorite thing" to collect, and yet the kindred threads that run through all of their stories are a common zeal for collecting and a rampant urge to create. Whether the collected objects are actually used in works of art or merely provide inspiration, the synchronicity between Artist and Object is undeniable.

A persistent theme throughout this book is a yen for visual abundance—the yearning for *every* color of yarn, and *every* old book in the stack, and the *whole* clump of rusted keys hanging on the nail. This desire for Plenty translates to mixed-media artwork that is rich in textural detail, layered in materials and colors, inventive in technique, complicated in design, and deeply personal.

Self-professed "Dumpster divers" take delight in transforming the most humble finds into reinvented objects of rare beauty, and, conversely, many of these artists have shown their knack for working against common ideas of traditional finery to create an edgy, alternative look. Collecting and creating becomes the ultimate game of push-pull. Ultimately, it's all about letting the objects speak and provide the spark.

In the hands of these inventive artists, even the most offbeat (shall we say grungy?) object finds a new life and has a new chance to shine. These alchemist-artists are the first to admit that their collecting habits are often confounding, or even hilarious, but they have been at the collecting game long enough to know that it is a surefire way to stir up new ideas in the studio and provide a fascinating sidebar to their lives. Mixed-media artist Gail Rieke defines the joys of scouring an outdoor flea market in Kyoto, Japan. Rustic maker Nick Nickerson tells of a late-summer shoreline cruise in an inflatable dinghy, looking for sun-bleached driftwood. Like me, many of these artists began their fascination with collections and found objects as children, and the special joy of unearthing some special something never seems to get old. Once a collector, always a collector.

To a true hunter-gatherer, practicality has little to do with the process. Most of the artists in this book will affirm that they normally do not have any specific end use in mind, as they drag home their finds. Nor do we (in any literal sense) *need* the quantities of things we amass. And yet, like the art process itself, there is something rewarding about trusting our instincts and letting each discovery unfold. Keeping our inner radar tuned to the innate possibilities of each object is an important part of the game, a way to keep energized and engaged throughout a whole lifetime of creativity.

Like a cabinet of curiosities opening wide, *Art-Making, Collections, and Obsessions* will provide an intimate glimpse into the unique treasures amassed by this renowned group of mixed-media artists and reveal how the compulsion to collect drives the urge to create. But, beware—collecting is contagious!

—LYNNE PERRELLA

"Generally speaking, as I work, I derive pleasure from the beauty or appropriateness of a particular object, and it doesn't really matter how I came to have it."

—JAMES MICHAEL STARR

"You find a bad piece here, you lose a good one there, you pay too much here, you get a steal there. That's the organic quality of a collection, and you live in it. You inhabit its activity."

—JOSHUA BAER

Spoken Like a
Seasoned collectors speak their mind and describe

"I no longer feel bad about my stuff. In fact, I now classify it all as 'collections.' They are my tools. They are both the materials and the art itself."

—LESLEY RILEY

"I find things all the time, wherever I am. I often have the feeling that they have been waiting for me to come along and pick them up. It thrills and excites me, because I know that I am going to begin a new piece based on my latest find."

—BERYL TAYLOR

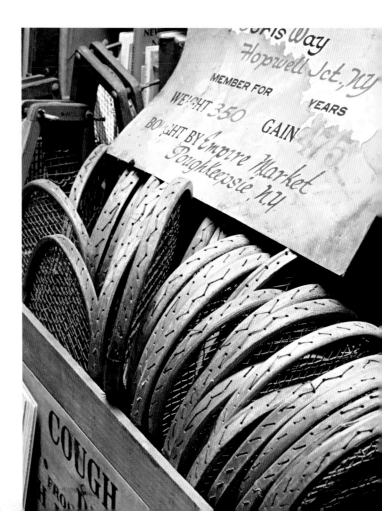

"It always surprises me to discover how little I enjoy shopping, and yet how much I love hunting and collecting. Go figure!"

—LYNNE PERRELLA

"There's an exhilaration in the quest and a great satisfaction in organizing and communing with your loot."

—MARILYNN GELFMAN KARP

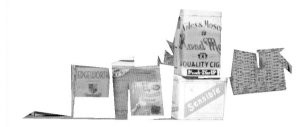

"I always have my collections in mind. It saves time when I power shop at flea markets. When I've bagged an amazing bargain, I drive home in total euphoria, giving a high five to the car ceiling."

—MELISSA SORMAN

True Collector

the joy of searching for the next great discovery.

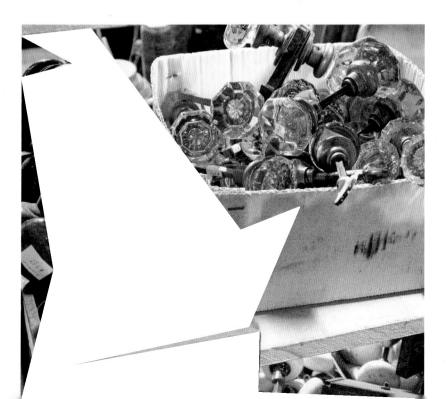

"A discovery is said to be an accident meeting a prepared mind."

—ALBERT SZENT-GYORG

"Happenstance, or synchronicity, is everything to me. I believe that synchronicity controls what I will find. When I want something, I put my mind to it. I look specifically for that item. My process is to show up, and if it is there, then it was meant for me. It is my destiny."

—LAURIE ZUCKERMAN

FINDERS, KEEPERS

*Discoveries and finds, serendipitous
survivors, arcane collectibles, recycled goods*

Are you a softhearted, sentimental collector? When you see
a whole collection of chinaware elephants at an estate sale,
do you insist on giving them all a good, new home? Old love
letters, grammar school report cards, blueprints, and photo
albums—all of these flea market finds connect us to the
human condition and might just provide the "perfect thing"
for mixed-media artwork. Like an enviable collection of vin-
tage passports, it's all about the drama of unknown past lives
and fresh creative possibilities. Musty drawers slide open,
and goods emerge, ready to pass into new, appreciative
hands. From a child's lone Mary Jane shoe to an entire wall
constructed of nearly forgotten suitcases and trunks, the
power of each object is strong. The artist's role is to recog-
nize the potential of every relic. The collecting, saving,
rescuing, and most of all, keeping of these items becomes
a vital mission.

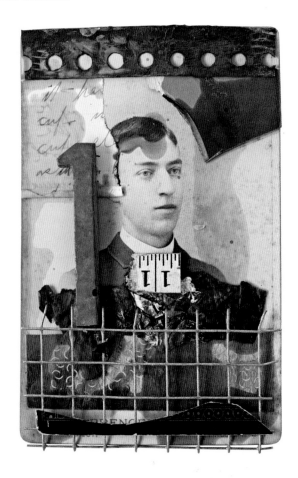

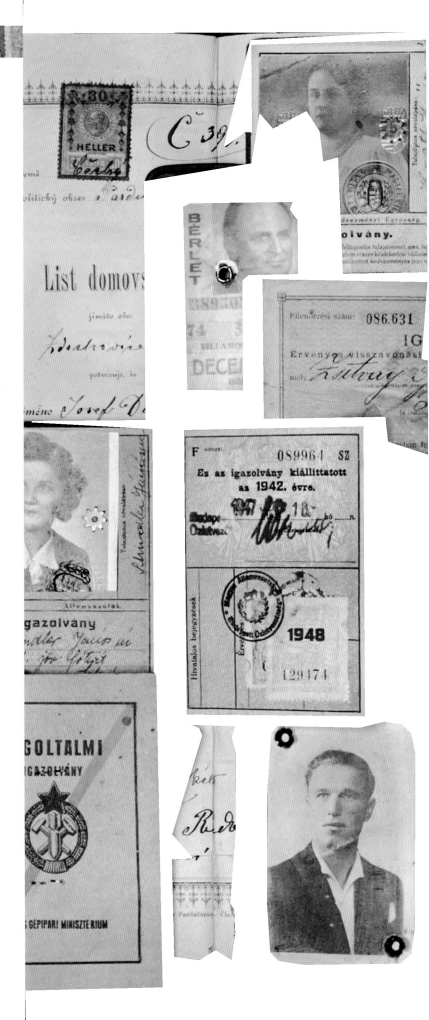

Hivatalos bejegyzések

19 43
Miskolc

122258
Elenőrzési szám: 258

Kocsiosztály:

Horváth György úr foglalt ügye

1941. JAN.

Gerbelicz
Károly
308

VASAS
SPORT CLUB

Sorszám: 1107

...VÁNY.
...bb azonban 10 év tartamára.

Zilveni Imre

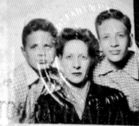

Photograph of bearer

Catherine F. Perrell

048768 szám.

Név: SCHINDLER JÁNOS
Leánykori név:
Anyja neve: MANNER MÁRIA
Születési éve és helye: 1909
BUDAPEST
Foglalkozása: SZOBAFESTŐ SEGÉD
A munkásmozgalomban részt vesz 1946 óta
Párttagságának kelte: 1946

Alapszervezete: LÁGYMÁNYOSI DOHÁNY-GY.

kerületi, járási, városi titkár
1957. XII. 16.
kiállítás kelte

IS SUBJECT TO
IMUM PERIO
YEARS IMMED
ORIGINAL TER
RENEWED, A
BE PLACED IN

SZTAHANOVISTA
IGAZOLVÁNY

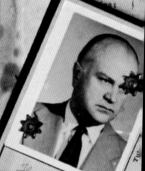

Personalbeschrei
1. Datum der Geb
dzień urodzin:
2. Ort:
miejsce:
Gemeinde:

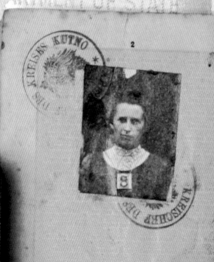

KREISES KUTNO

Personalbeschreibung nebenstehend.
Opis osoby drągostronnie.

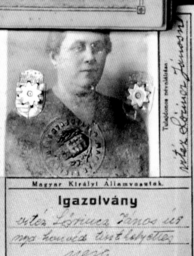

Tulajdonos névaláírása
vitéz Lőrincz János

Magyar Királyi Államvasutak.

Igazolvány

vitéz Lőrincz János úr
mga honvéd tiszthelyettes
úrja
részére.

9/a sz. igazolv. minta. — Máv. Jegynyomda. 277/1940.

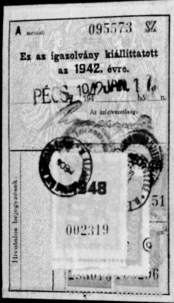

A korrulati 095573 SZ

Ez az igazolvány kiállíttatott
az 1942. évre.

PÉCS, 194 JAN.

948
51

002319

Hivatalos bejegyzések

Kovács Antal
a hadköteles aláírása.

BUDAPEST
SZÉKESFŐVÁROS

30
HARMINC
FILLÉR

40 fillér 40

...könyvnyomdája 1938 — 1777

2. Szül. év és hely:
M. Ortopán

3. kiállító pság:

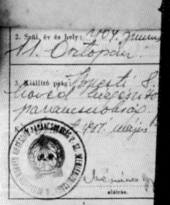

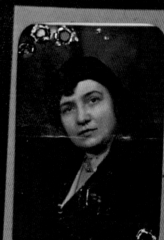

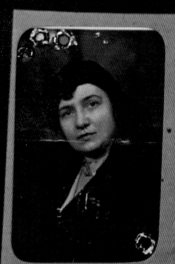

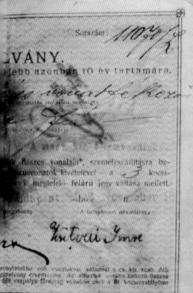

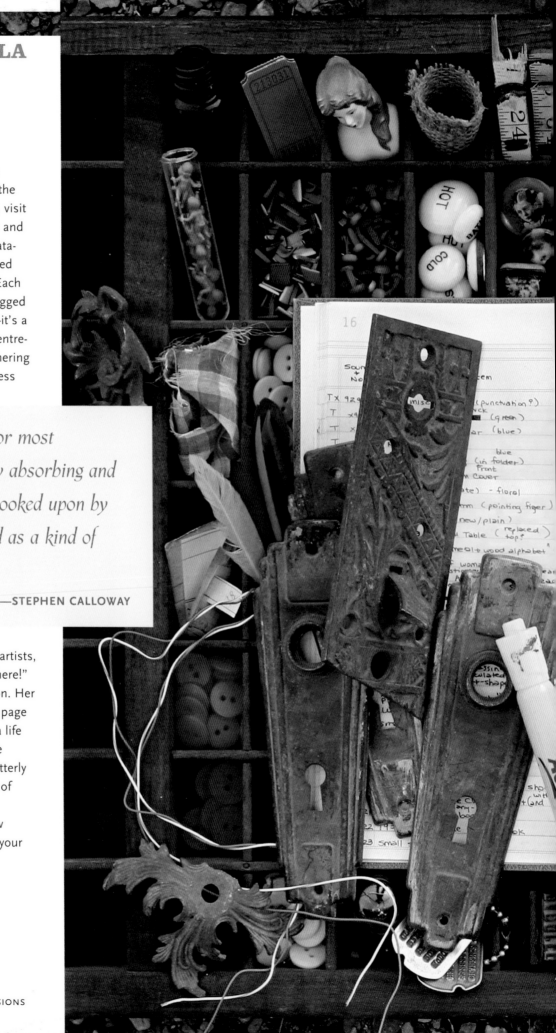

Tracking the Goods

Laura Stanziola's answering machine announces that she is "the lady with the stuff." If you have any further doubts, visit her endless archives of found objects and special treasures-for-sale, all neatly catalogued in composition books, inscribed with her small, precise handwriting. Each find, no matter how momentary, is logged into a ledger with helpful notations—it's a miracle of orderliness. An artist and entrepreneur who specializes in savvy gathering and collecting, Laura makes her endless

"Collecting is, of course, for most collectors just a reasonably absorbing and largely harmless pastime, looked upon by an uncomprehending world as a kind of gentle madness."

—STEPHEN CALLOWAY

collections available to mixed-media artists, who attest to the abundant, "it's-all-here!" nature of her always growing selection. Her inventory notebooks, with page after page of lists and descriptions, document a life spent hunting and gathering, and the books themselves have become an utterly personal collection, not unlike a row of diaries on a shelf.

Speaking of gentle madness, how many notebooks would it take to log your collections?

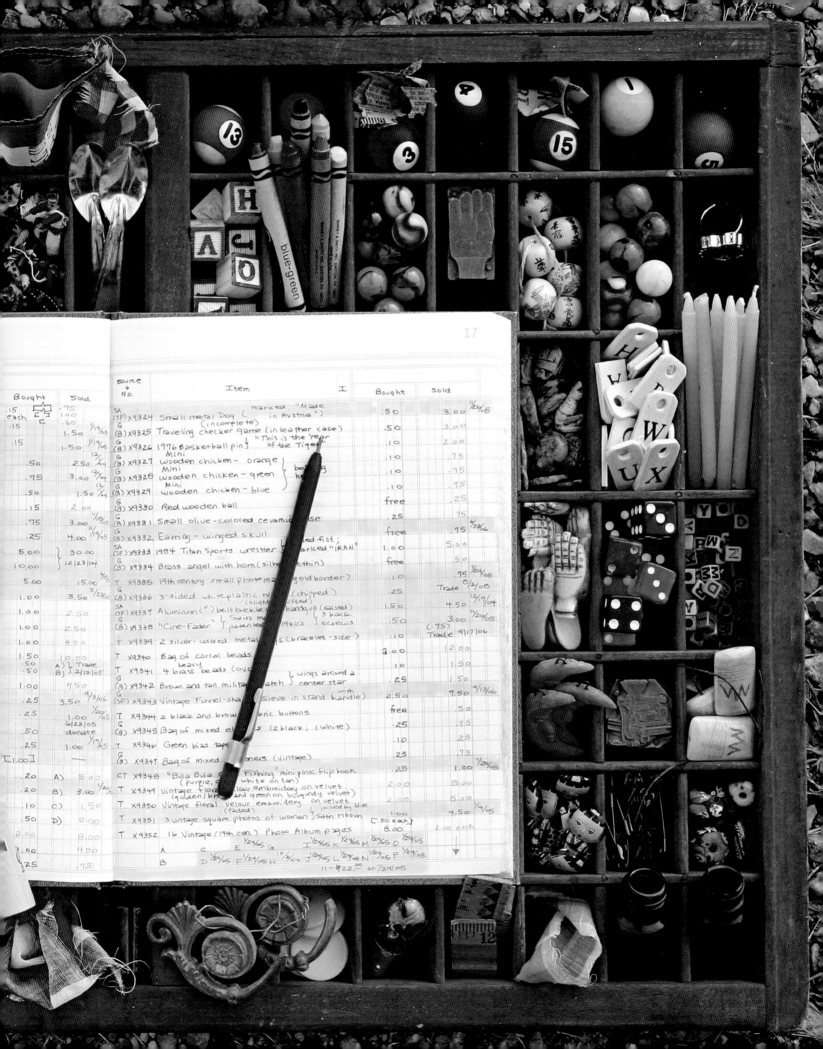

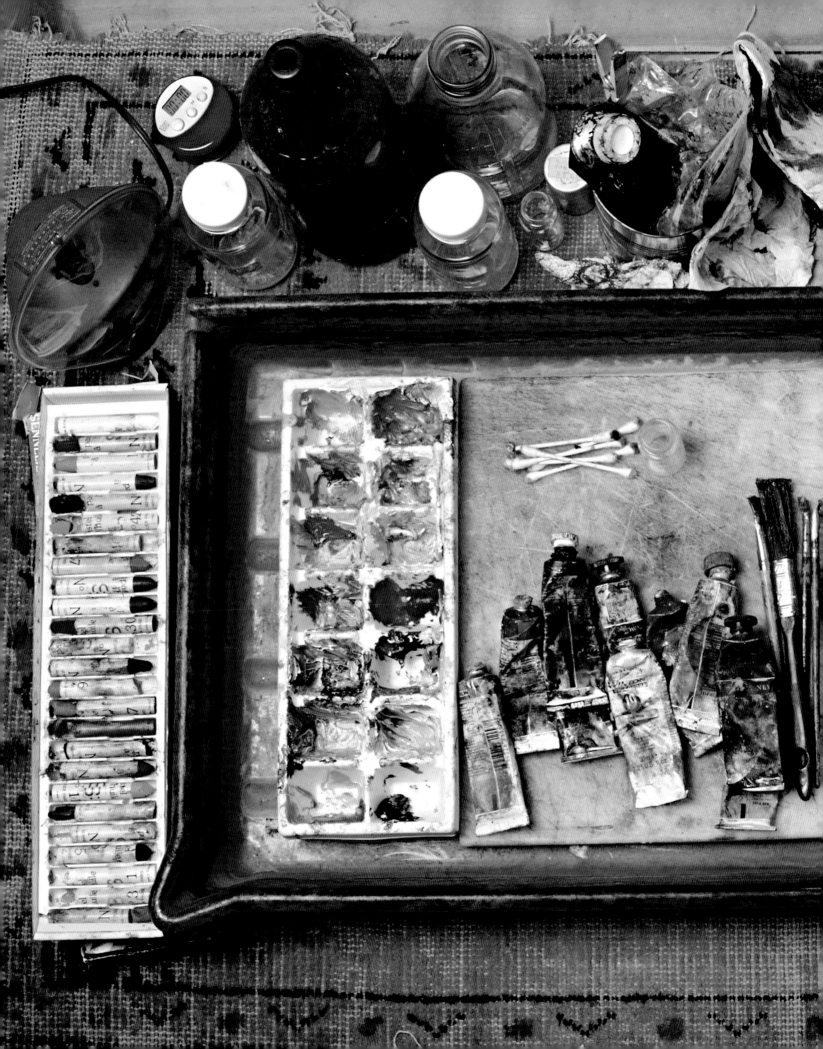

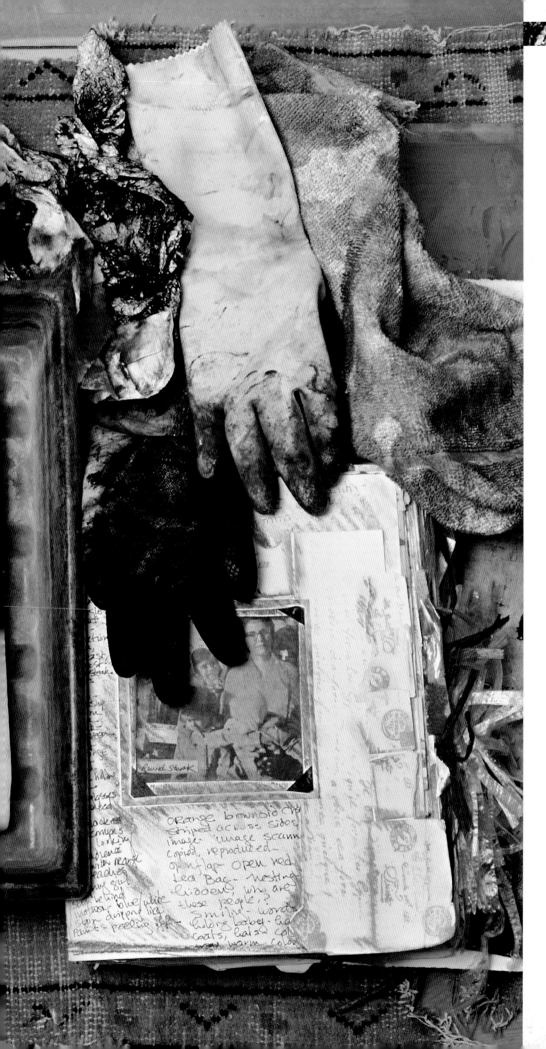

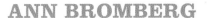

Hands On

Art becomes inevitable when Ann Bromberg sets up her work space, and her gathered supplies form their own special kind of well-worn, ultrapersonal collection. From paint-encrusted rags and a well-used palette to jars of thinners and solvents, Ann's objects speak of the ongoing creative process in the studio. Although her mixed-media work uses collections of dimensional found objects, she always begins her process by working in her sketchbooks. "My sketchbook is essential before I start any project," she says. "I have to dialogue, collage, paint, draw, write, and photograph everything, to see what works in a final piece or series."

ANN BROMBERG AND STEVE TEETERS

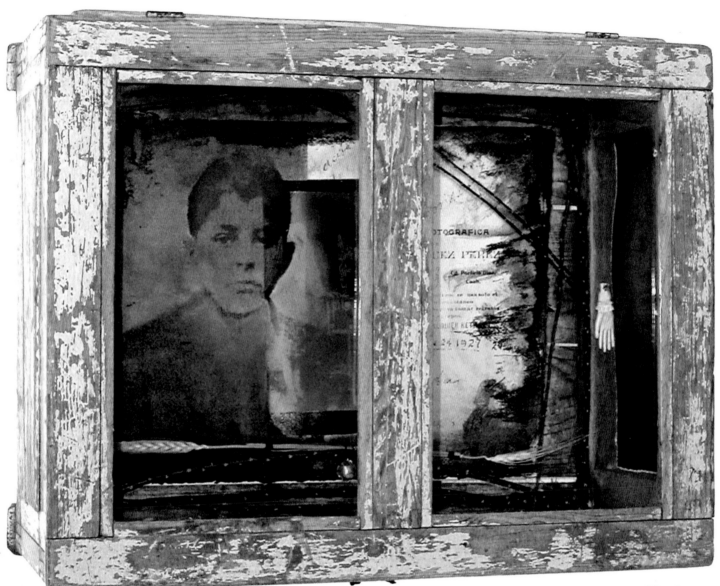

▲ *Ruben*

Tender Turquoise

Ann Bromberg and Steve Teeters collaborated on a series of mixed-media assemblages entitled *Migrating Feasts*, which sent the artists on many collecting excursions and, more importantly, brought them into contact with the stories, legends, recipes, and deeply personal memorabilia of many immigrant families. Steve's find of a worn, scratched turquoise-painted pie safe became the ideal shelter for a series of portraits incorporating sterling silver milagros and inscriptions. Ann works with found photographs, using a gum oil technique to transfer the images onto watercolor paper, achieving a look similar to hand coloring, although it is a photographic pigmentation process. "Art making and collecting are my breath and life force. Image making is my voice," says Ann, an artist who collects with passion and specializes in compassionate, revealing narratives.

The worn antique shipping trunk stands open, a repository of endless tales of immigrant families of all cultures, a reminder to every viewer of his or her own connection to a multiethnic melting pot. The trunk, sturdy and eternal, opens to reveal a tender passport photo of Lin Wong Ong, a transparency superimposed on a stylized manufacturer's label affixed to the lid of the weathered trunk. Folds of vintage embroidered fabric in soft shades of rose and pale yellow are placed in the bottom of the trunk, symbolizing the endless packing and unpacking of family belongings and mementoes. Other items are wrapped and bundled in the tradition of Chinese herbalists and placed inside the trunk. Steve Teeters, an artist who favors visiting roadside junk places, spotted the primitive table used as the base for this compelling and narrative assemblage.

▾ *Cultural Layers*

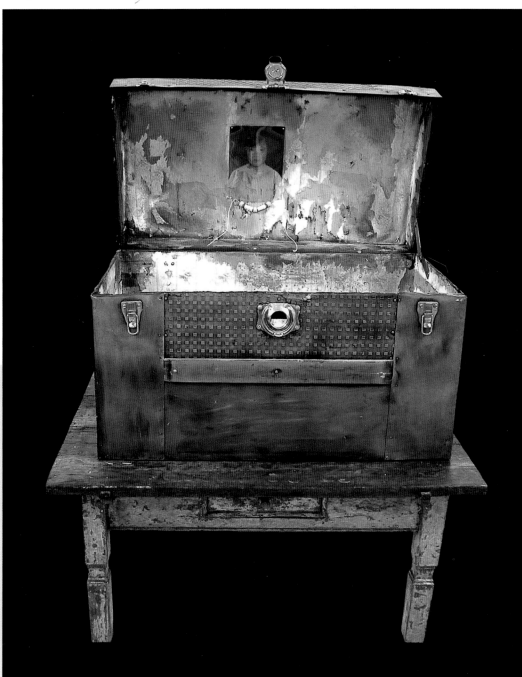

"My grandparents' names were Wing Ong and Lin Wong Ong. They immigrated to this country in about 1928. Their two families arranged their marriage, and their wedding day was the first day they met."

—PAUL JEW

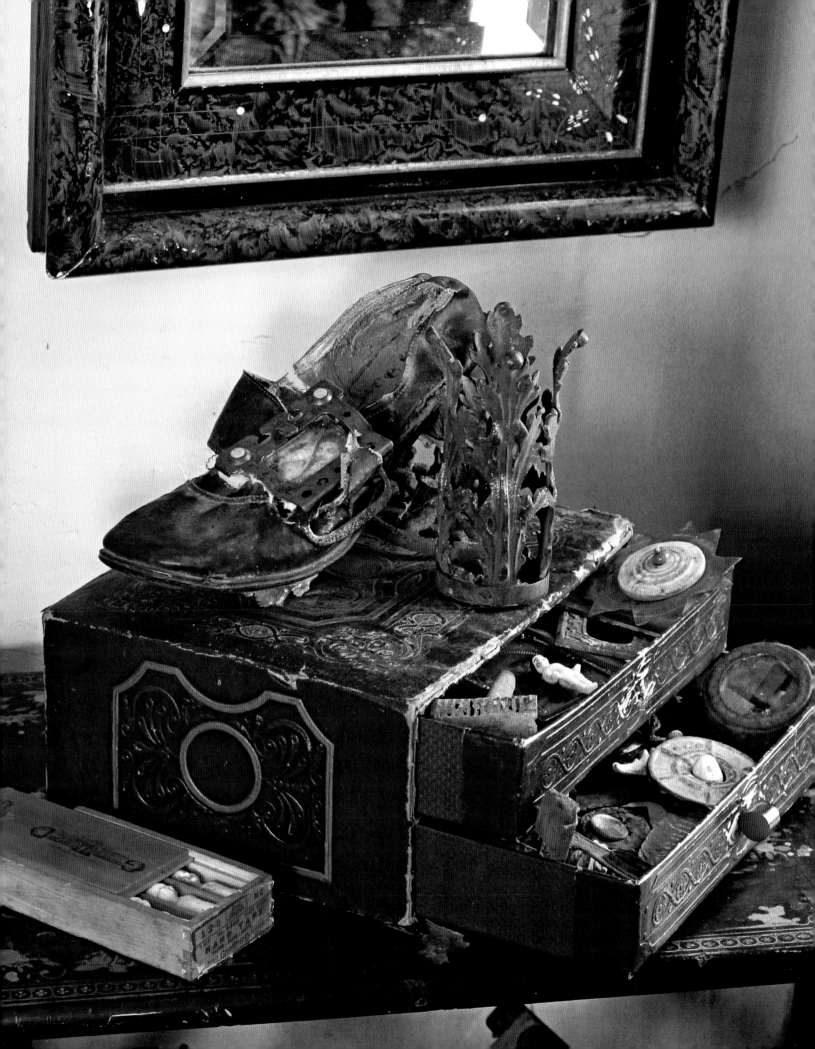

Perfect Destiny

A length of aged tin, studded with a found medallion and an image of a Madonna, arches above panels of various vintage fabrics and canvas, as photo transfers suggest a narrative. The decorative, rusted-iron scrollwork at the top of the piece contrasts with the austere mood of the minimally patterned panels. Normally insignificant bits of wood and stone provide a fascinating tactile "fringe" to the bottom edge of the hanging, an example of how a handful of small bits can provide a strong design element. This nostalgic piece includes many "throwaways" that would normally be overlooked, although here they are gathered together with a vivid sense of storytelling, as Nancy conveys a sense of strength in men and women, sun and religion, all so enduring in New Mexico.

"I have a barn full of rust. I treasure the stuff. I search for meaning in nostalgic items, such as an old shoe. My artwork and my collecting are directly intertwined. One cannot exist without the other. The art of collecting is about the power and history that each found piece already holds."

—NANCY ANDERSON

▾ *Under a New Mexico Sky*

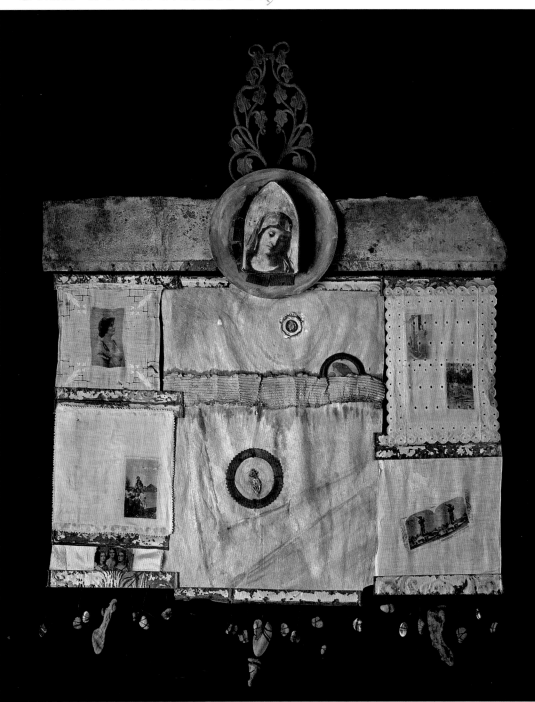

Read the Signs

Small-town flea markets throughout the United States and abroad are Graceann's favorite places for finding "the unexpected thing," regardless of whether the end use is obvious or latent. Experience has taught her that objects will eventually find their place in her work, and she reveals that there is a strong visual thread between her home décor, her artwork, and even her clothing—as she defines it, "total connection." She balances a love and appreciation of objects with a commitment to make work that is always authentic and does not rely on static collections and symbols. *Circle Study* incorporates encaustics and found objects, reflecting her choice to strenuously edit her work and clarify the message.

Collections of plumb bobs and unevenly shaped spheres from Warn's studio drawers are reminders of imperfect beauty and classic forms. All have the patina of often-handled, timeworn worry beads and are equally elegant.

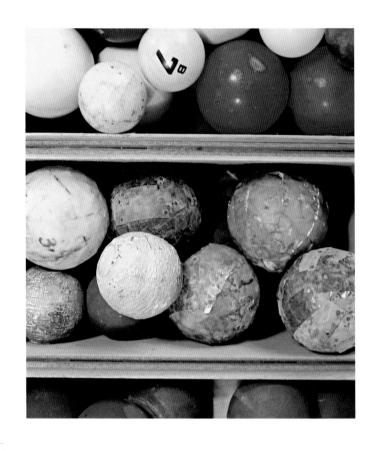

design/provenance

"I tend to collect vintage things with numbers, lists of words and numerals, foreign text, weights and measures, text and drawings related to archeology, architecture and mathematics. I love old hand tools and gauges."

—GRACEANN WARN

Circle Study ▶

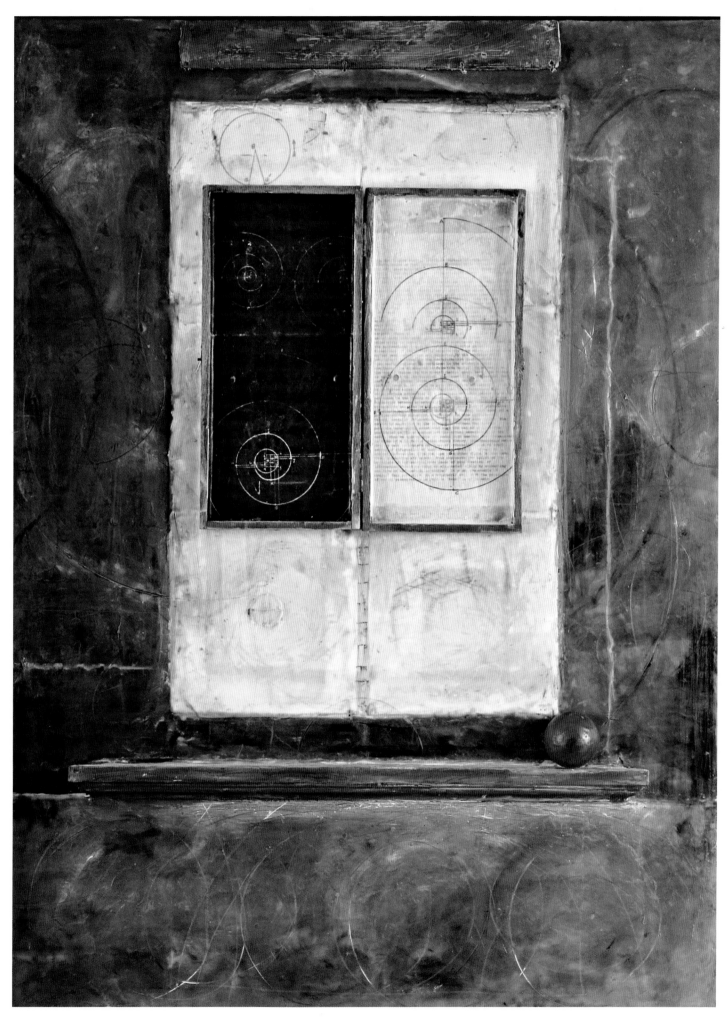

Cargo Cachet

"The studio is a collection of collections," says Gail Rieke, describing her studio, which functions as both a workspace and an installation environment. The "suitcase wall" is a large floor-to-ceiling structure designed to hold the antique suitcases and trunks that provide endless storage for her ongoing collections, including vintage Japanese textiles and papers of all kinds. "I love everything about paper, especially old paper or handmade papers," she says. "The way they feel, look, sound"

Additional collections of containers, boxes, baskets, and carrying cases provide more storage and display space, as Gail slowly accumulates objects and eventually finds their perfect use. On her collecting expeditions, from Santa Fe garage sales to outdoor flea markets in Asia, she is always looking for serendipitous, exotic discoveries, regardless of their perceived purpose.

Gail prefers to work on many collages simultaneously over long periods of time, allowing the art elements and creative approach to evolve and develop instinctively. Sometimes, an object that has languished in her collection for more than twenty years will end up being the perfect finishing touch for a collage. Other objects become part of the visual abundance of the studio environment and might never be incorporated into works of art.

Some of the exotic contents in Gail's studio drawers include vintage travel stickers and luggage tags; Asian lidded baskets and lacquered trays; vintage glassine postage envelopes; tea ceremony papers; books of silk *gampi* paper; candy wrappers; tickets; vintage mother-of-pearl hearts strung on black waxed linen; *Kumihimo* braided *haori* ties wrapped around graphite rubbings; Japanese paper, hand-dyed with persimmon; calligraphy scrolls featuring small paintings of temples; and examples of origami.

"My collection of Asian novelties, tags, labels, and ephemera is stored in a twenties-era, wicker suitcase, and I am always amazed that such colorful, delightful paper goods can be purchased so inexpensively. As someone who loves lots of vivid, strong color, Asian paper goods are the perfect paper treat."

—LYNNE PERRELLA

Artist
Lynne Perrella
◄ ◄ ◄

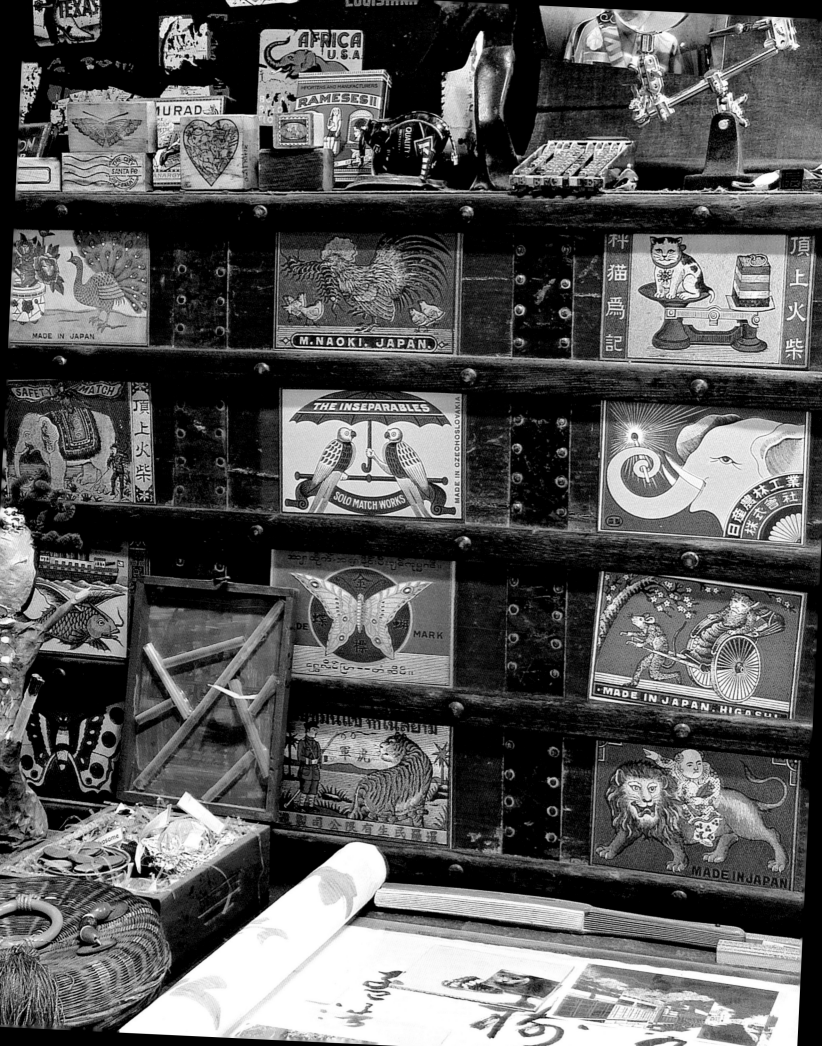

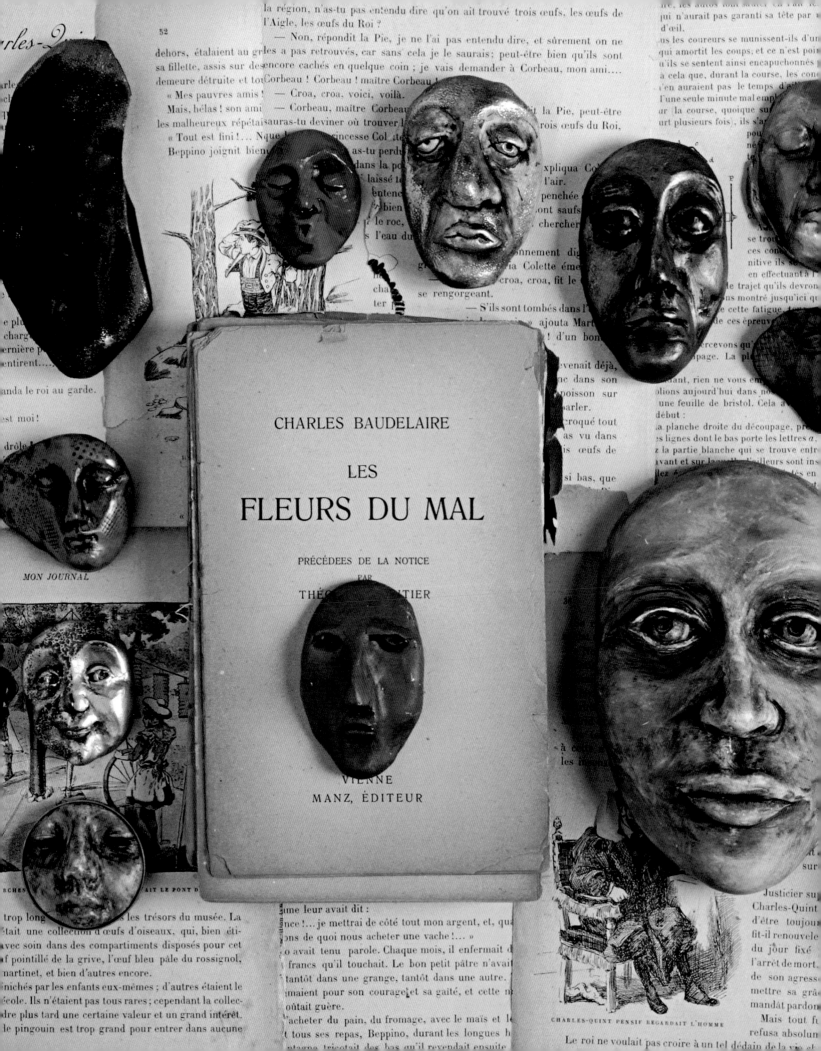

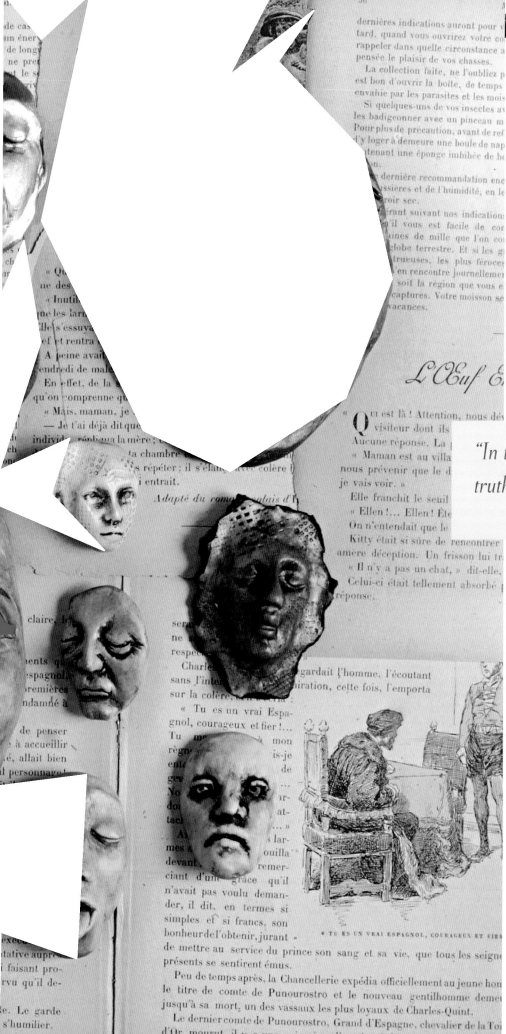

Face the Narrative

The affinity between collecting and creating is given a fresh twist by Lisa Renner. Her artwork is an extension of her various collections, most notably, her ever-growing grouping of face molds, mostly made from found objects. Old porcelain dolls provide an interesting starting point for making a face mold, but Lisa takes her greatest enjoyment in interpreting the initial imprint through distortions, alterations, texturing, and her personal specialty, faux finishing. A noted polymer clay instructor, Lisa uses endless techniques for creating

> *"In thy face I see the map of honor, truth and loyalty."*
>
> —WILLIAM SHAKESPEARE

both realistic and fantasy-driven effects, and her completed faces provide the finishing touch for book covers, art dolls, jewelry, and assemblages. She also fabricates original sculpted faces to add to her large arsenal and is always pleased when a colleague contributes to her collection. "Every time I receive a new face mold, the excitement of using it is almost overwhelming," she says. "A particular face, for example, may completely dictate the structure and spirit of a new creation."

For this savvy collector and artist, the molds and clay impressions of her collections allow her to use and reuse her finds endlessly, fostering a continual circular process.

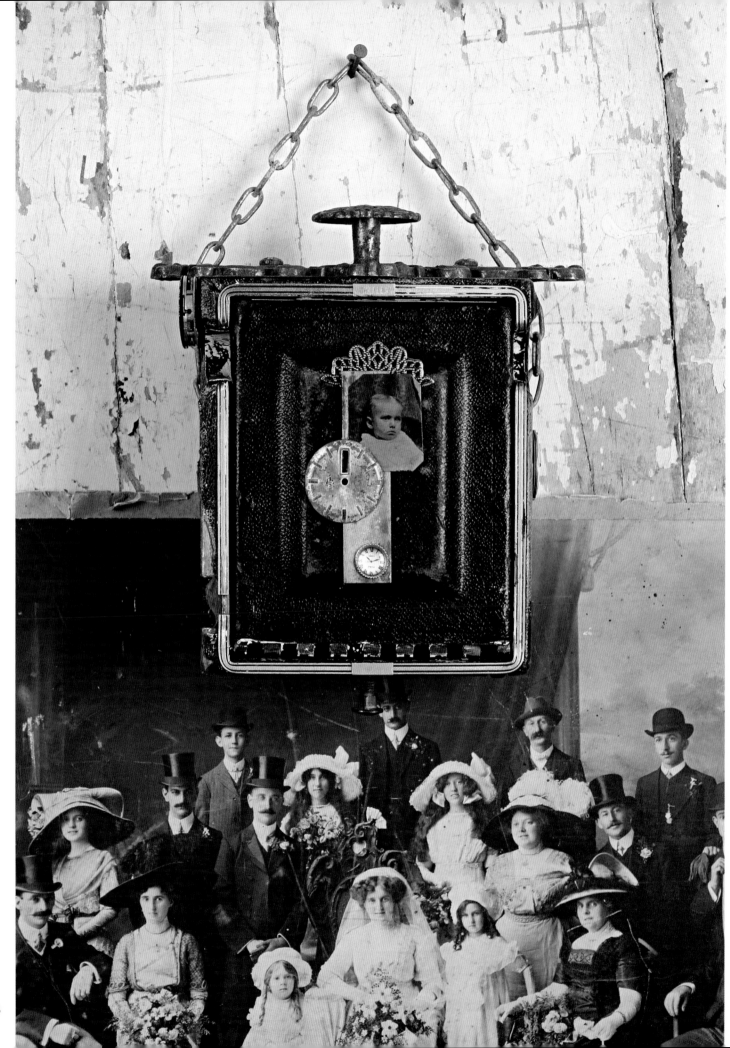

JOANNA PIEROTTI

Snap

A vintage box camera, with a handsome, well-worn leather housing, became the enclosure for this wall-hung assemblage. With the touch of a hidden button, the camera opens, revealing a found-object composition inside. The artist, who favors reviving arcane and defunct objects, enjoyed the challenge of making the camera "work" once more and used some favorite collections, including sturdy, brass drawer hardware, metallic touches of workmanlike chain, and a filigree jewelry remnant. Joanna searches for old timepieces, enjoying the meditative process of disassembling all the parts and saving small gears, watch hands, and tiny numerals for her mixed-media artwork. "This little baby just fit for me, a young one just beginning her time," she says, describing a tender tintype image.

Old photographic equipment gets maximum exposure when grouped in a vintage cabinet. The visual impact is heightened by adding secondary collections of old correspondence, antique photography books, and Victorian albums. Staging an entire collection as a visual display is one of the joys of being an artist and collector.

Whether your collections become part of your home décor, or an interesting studio still life, keep your favorite finds out in the open, where they can prompt new ideas.

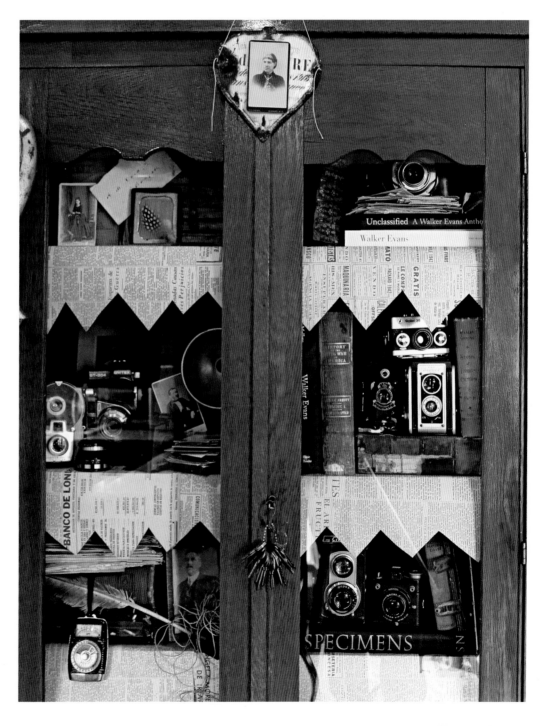

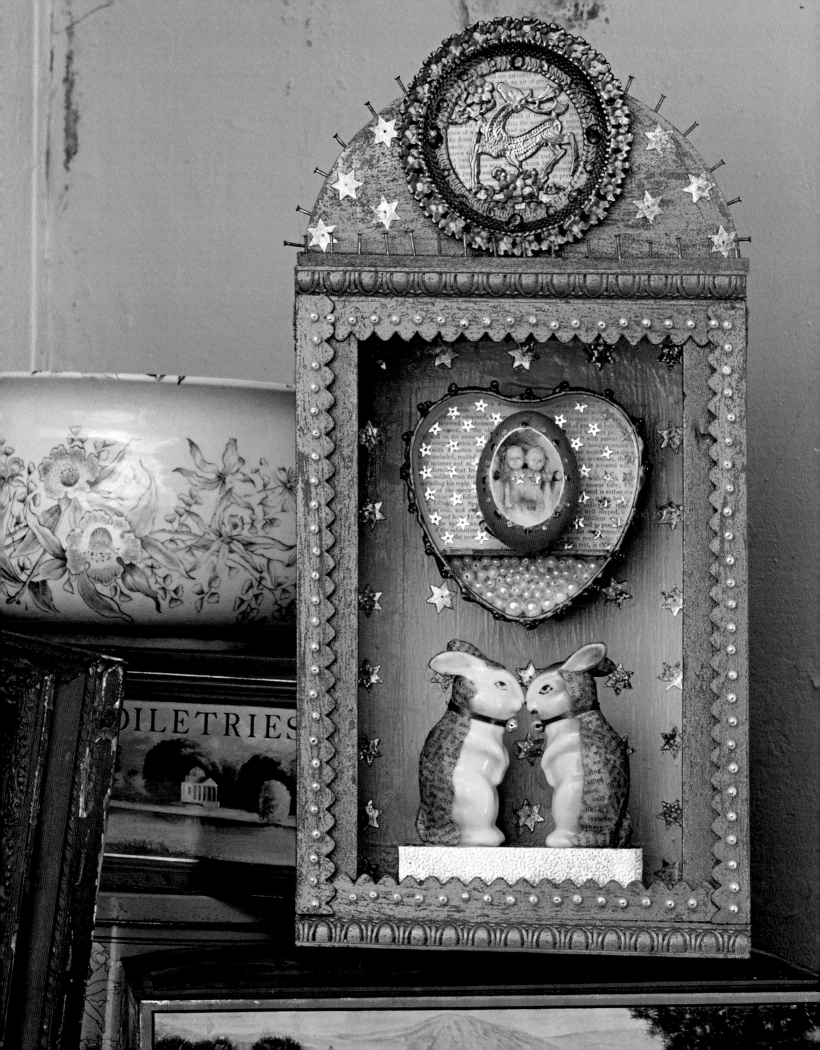

JANE WYNN

Rabbit Redux

"I covet what I see. I make work from what I covet. I am my art," says Jane Wynn, describing her creed on creativity and collecting. Her fondness for rabbits and their gentle nature led her to begin a collection of vintage toys and ceramic figures, and the grouping quite customarily seemed to spontaneously multiply. Mindful of the concept of rampant abundance, Jane focused on the purity and intended emotion of her mixed-media construction and was inspired by the colors and austerity of ancient Italian religious shrines. A small light, installed in the ceiling of the box, shines down on a pair of vintage, rabbit-themed salt and pepper shakers, which were collaged with text. Another of her collections came into play, as she fashioned a brown egg into a small shelter within a shelter. Jane completed the tender mood by lining the egg with rabbit fur from a vintage garment, to surround the twins.

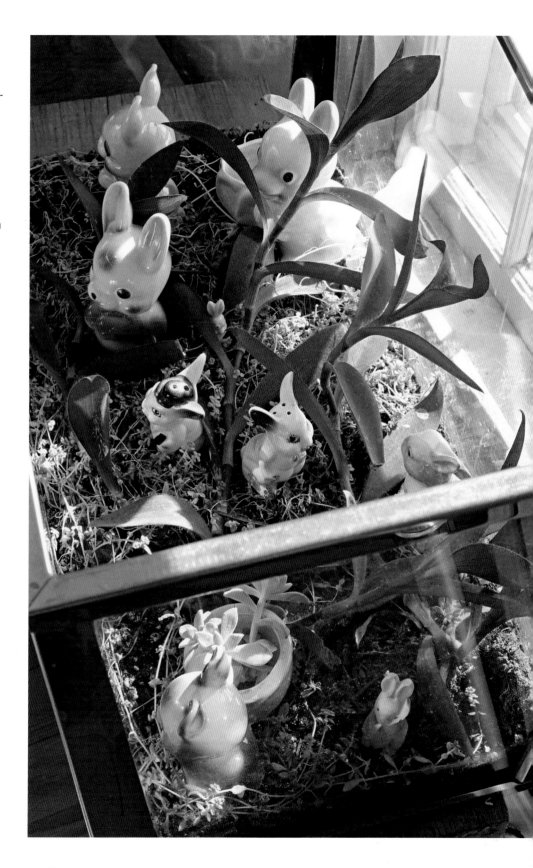

◂ *Shrine for Saint Melangell*

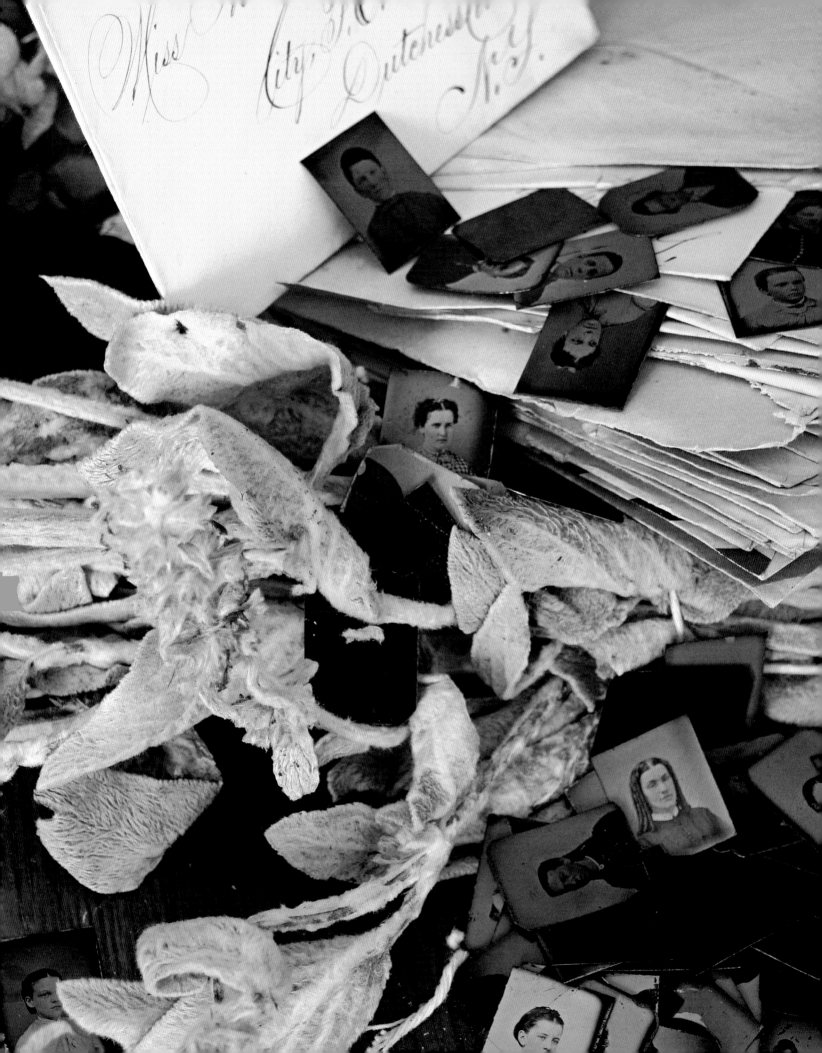

Come Close

Well known for her fabric collages and *Fragments* series and an expert on cloth journals and transfer techniques, Lesley Riley distills her multiple loves of collecting, gathering, stitching, and quilting into one succinct pronouncement: "It's visual storytelling." To illustrate her point, she has created a soft, tactile quilt top, featuring a grid design of ribbons that form an artful garden lattice. Felt was used to create the dimensional flower-like shapes, and gem tintypes from her well-loved collection form the centers of each blossom.

A choice collection of dozens of the small, exquisite, metallic portraits was scored in an online auction, but Lesley saves in-person shopping for her ever-growing collection of fabrics. "Nothing takes the place of surrounding yourself with the color, texture, and feel of fabric," she says.

Her impulse to use the tintypes in her fabric collage was instigated by a desire to draw the viewer closer, to appreciate the dimensional details of the quilt, and to take an intimate look at each tiny face. The quilt literally became an album, in which each small photo has been given a new home. "The thrill comes," Lesley says, "when you combine parts of your collection and create a story through your art."

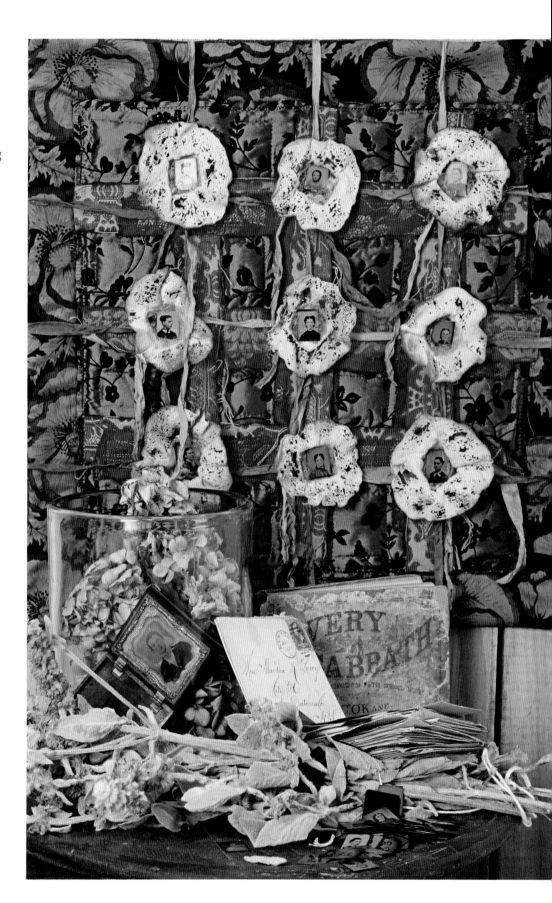

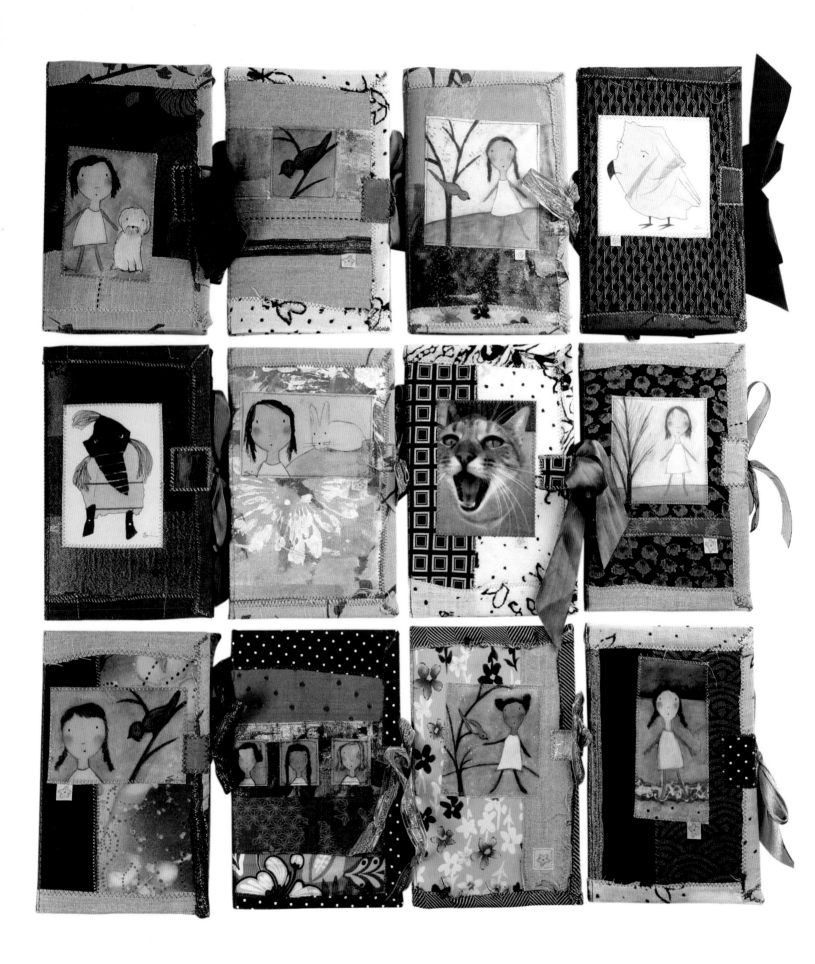

CARLA SONHEIM

Handmade and More

Journals, by definition, are about personal expression, but Carla Sonheim's handmade blank books provide an additional component—her appreciation of recycled cloth scoured from thrift shops, yard sales, flea markets, and her family's outgrown clothing. Standing at her work table, surrounded by large piles of scraps, she begins the design phase, eventually sewing the pieces directly onto a piece of card stock. Every element of the journal, including the signature pages, is machine sewn together, and the emphasis is on making it feel personal. "When I find something I really love, and it's cheap or free, I probably feel as positive about life as I ever do," Carla says.

An illustrator and designer with a strong contemporary style, Carla's personal aesthetic also embraces the sentimental mood of the softened, worn cloth that she collects, and working in book form was a logical response. Most of her handmade blank books feature her own distinctive illustrations on the cover. The journals, stacked to reveal their fabric bindings, create their own kind of collection, and the urge to have one of each is irresistible.

Many artists have a visual radar that is always tuned; they know that their finds will eventually and inevitably lead to new discoveries in the studio. Collecting and gathering seems to depend on an almost subterranean sixth sense about what will stir future ideas at the work table.

design/provenance

"It all works together. A color combination from a piece of found fabric or paper will show up in a painting. A painting composition might inform a journal design. I don't use found objects in my paintings, but I still collect things. It is a part of being a visual/tactile artist."

—CARLA SONHEIM

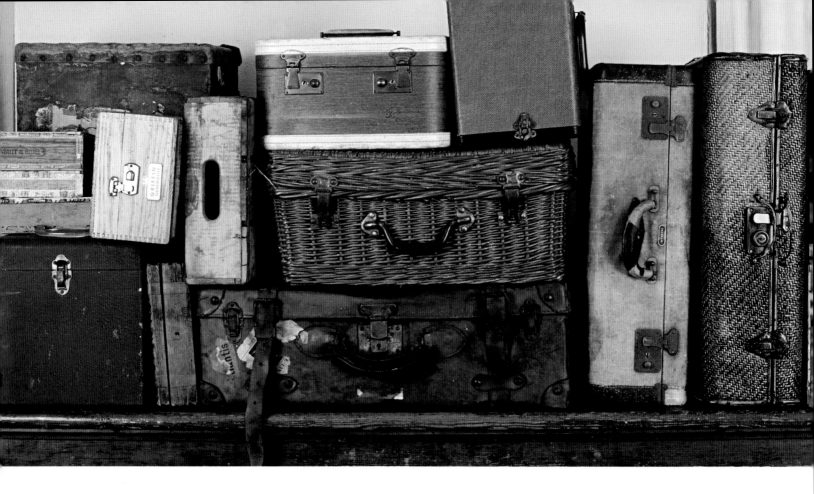

"Whenever I find rusted barbed wire in nice straight strands, I have been known to gasp. And vintage pillow ticking? Wrap it up and give it to me for Christmas. I couldn't want a better present."

—KC WILLIS

Score!

"I feel satisfaction and exhilaration at the same time, often followed by the need to get into the studio and make stuff. Sometimes it can be a very intimate moment, and I have been reduced to tears after finding photos, letters, diaries, and memorabilia. Almost like secrets have been revealed, and I need to respect that moment of reverie."

—JUDI RIESCH

"After all, how do you describe the joy when your heart skips a beat, and your soul is ignited? Maybe it is for this moment that I collect."

—NANCY ANDERSON

"It's thrilling! Yes! It feels as if I am in my element and doing what I am good at, spotting something odd and knowing the perfect thing to do with it. "

—LYNN WHIPPLE

"My eyes are responsive to anything, but my mind is trained to flash on objects with certain qualities of patina. The object will stop me cold, and I will sweat with excitement. I always hunt at my own, thorough pace. I like to ponder what I need and review where I am going with each of my art projects. I find it stimulating and quieting."

—LAURIE ZUCKERMAN

"I can't get back to my studio fast enough. I have speeding tickets as proof."

—GRACEANN WARN

Artists describe the magical moment of discovery, when their travels lead them to perfect treasures.

"Suitcases hold the enigmas of past adventures."

—GAIL RIEKE

"While scavenging in an old dump outside of Santa Fe, we were like kids on Christmas Day, oohing and ahhing over rusted aspirin tins discovered amid piles of oil cans and tires."

—MONICA RIFFE

"I get a severe case of the vapors! How very Victorian of me! Honestly, my heart flutters, and I start to feel faint. I get excited, my optimism grows, and I feel enormous."

—JANE WYNN

"I feel like a mad scientist, discovering a hot smoldering meteorite! I can't wait to get it back to my 'lab' and play."

—TRACY V. MOORE

PRECIOUS AND FEW

*One of a kind, ultrapersonal,
made by hand, singular and cherished*

These are items to have and to hold. They are singularly significant and essentially eccentric: often-read telegrams; a once-worn, now termite-infested wedding gown; tangled shreds of a lifelong correspondence; stampings and imprints confirming unique journeys; bisque dolls lovingly saved and carefully protected; bits of old textiles and beaded finery; a baby spoon with a feathery engraved monogram. Whether from our own family archives or rescued from oblivion, these are goods too good to hide in drawers. They are personal and imperfect, chosen and cherished, obsolete and obsessive—in short, the good stuff.

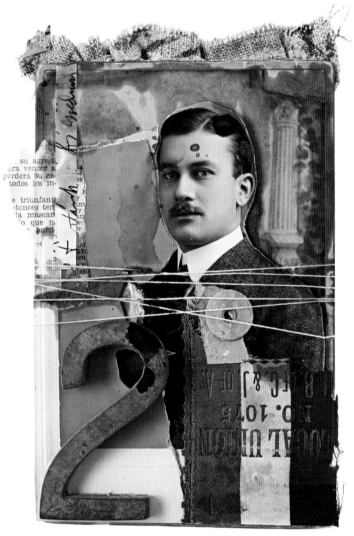

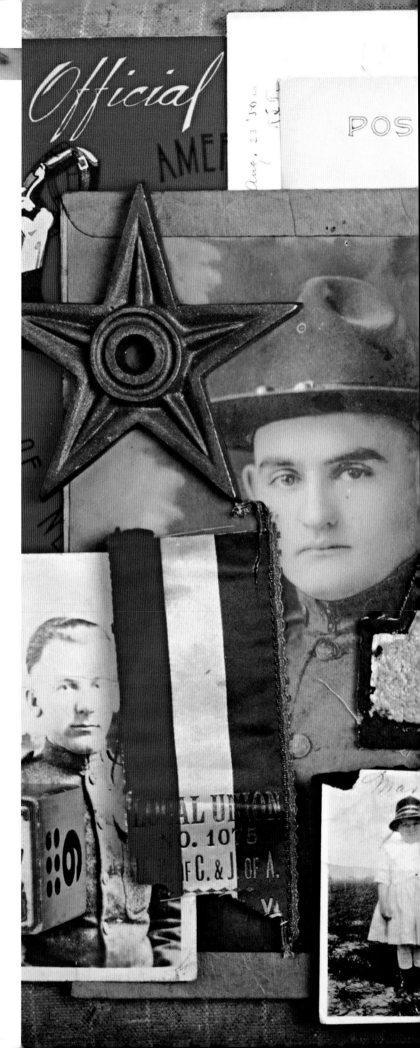

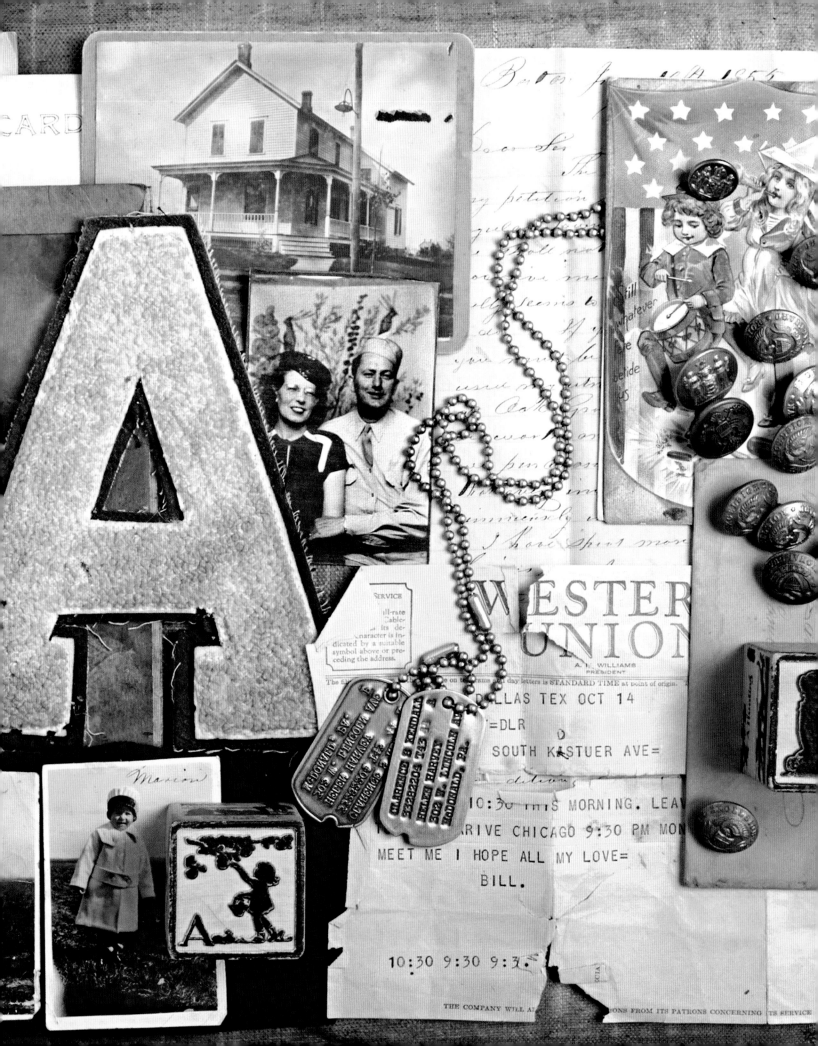

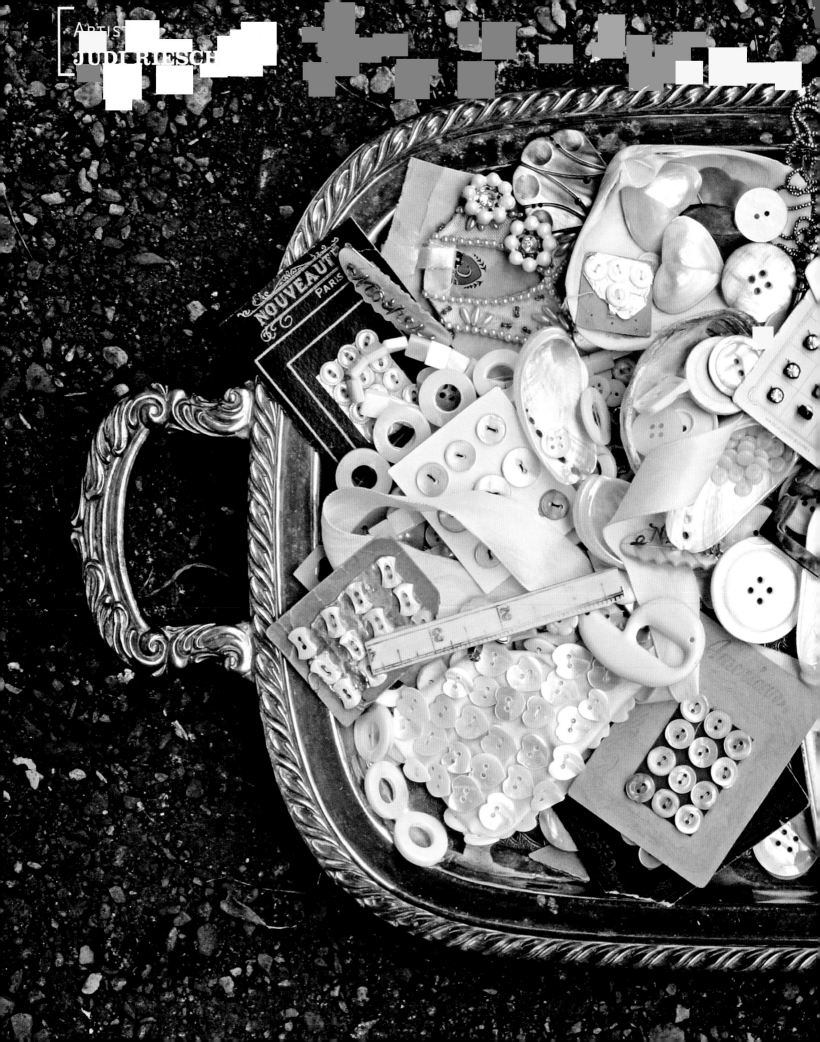

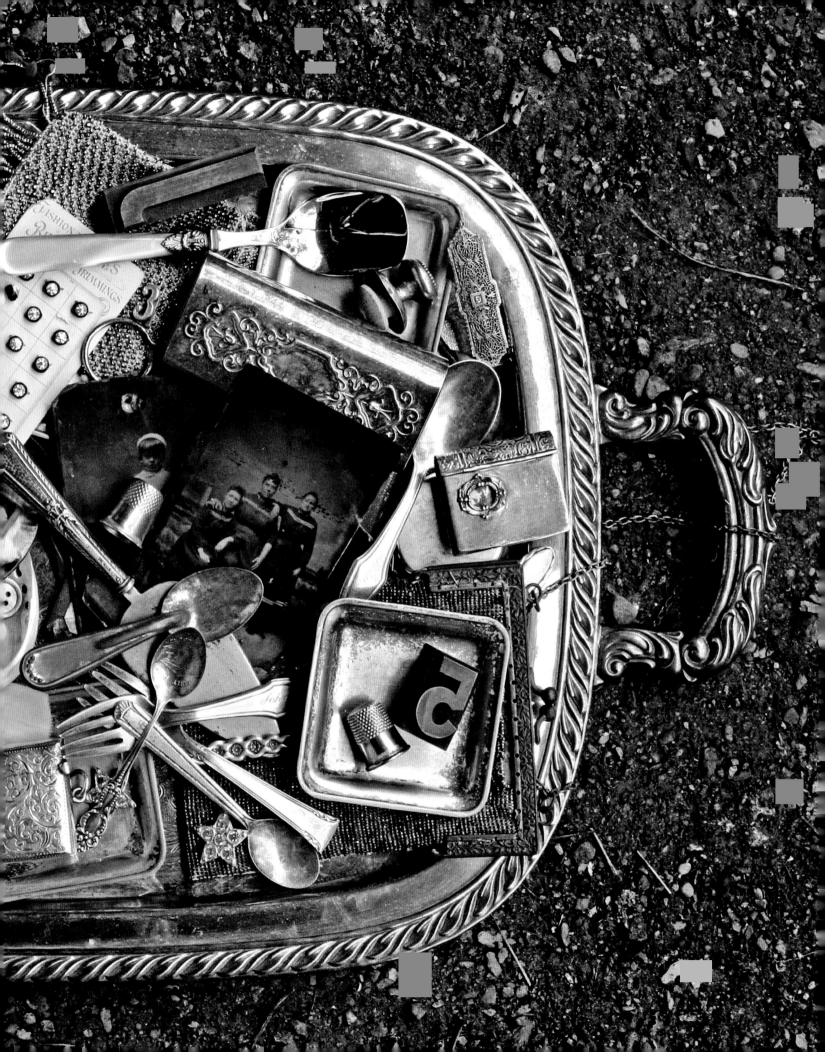

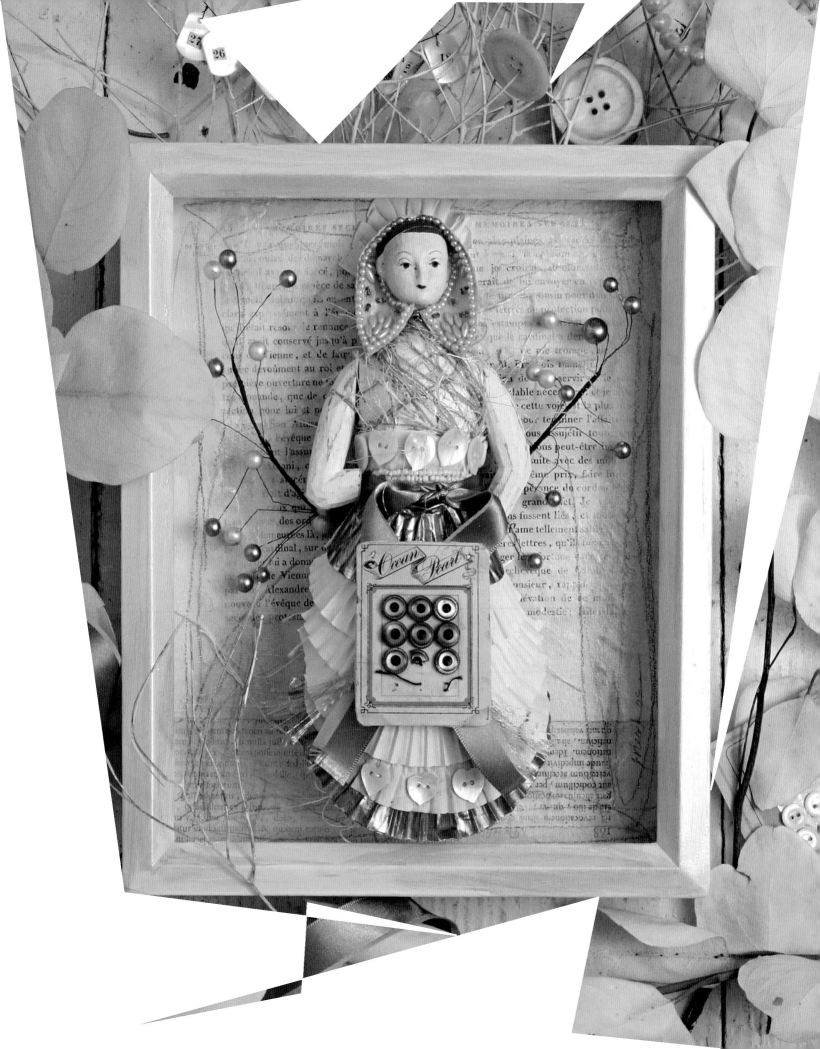

Pearl Gem

While sorting and gathering a grouping of mother-of-pearl items for a project, Judi placed them all on an old silver tray (see the photograph on pages 38 and 39). Seeing the burnished glint of silver next to the soft glow of the pearl items gave her the idea to create a pair of companion boxes. Two wooden mannequins, from her growing collection of articulated figures both large and small, provided an ideal opportunity to compose costumes using various findings, including a lace and pearl doll's collar, satin ribbon, and vintage paper cupcake liners. Taking her cue from the "Ocean Pearl" advertising text on an old button card, she introduced shells and painted touches that emphasize a seaside mood, with colors as soft as ocean spray.

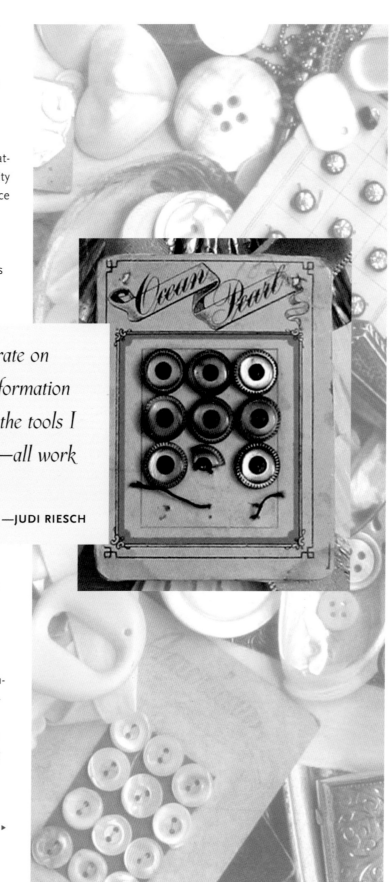

> "When I connect with an object, I concentrate on color, texture, and presence and use this information when integrating it into my project. I think the tools I use—paint, paper, pastels, crayons, pencils—all work to bring the parts together."
>
> —JUDI RIESCH

Well known for her ability to spot great finds at markets and sales, Judi believes that surrounding herself with her favorite items, in both her studio and home, is an ideal way to remain consistently inspired. By constantly changing and fine tuning the visual tableaux in her home and sifting through collected items in her studio, she is continually stimulated by images she loves. With a strong preference for vintage finds, she loves breathing new life into old items and giving a new life to a lost memory. For this artist, who needs to touch and connect, the joy of a new find is both satisfying and exhilarating. In her studio, overflowing with cabinet cards, vintage brass stencils, old books, girls' autograph books, and diaries, the mood of abundance prevails.

▶ ▶ ▶

◀ *Mother of Pearl*

JUDI RIESCH

Sterling Legacy

The special gift, more than forty years ago, of a lovely crystal and silver toothbrush holder led Judi Riesch to begin a growing collection of perfume and dresser jars with sterling silver lids. They in turn inspired her to gather less precious silver pieces to use in her assemblages. Baby spoons, bits of jewelry, chains, buckles, thimbles, and vintage tinsel, mixed with daguerreotypes and old metal type slugs, inspire new works of art.

> *"As long as I can remember, I have been a collector. As an artist, I feel compelled to integrate these objects into a final piece that works as a whole."*
>
> —JUDI RIESCH

In *Silver Belle*, Judi created a costume for the wooden mannequin, using a vintage, 1920s-era beaded bag that belonged to her grandmother. The bag, in tender condition, is reborn in this shadowbox that also incorporates silver paper cupcake liners, German scrap, and tiny rhinestone buttons, which dot the feathery trees drawn on the backdrop. The figure holds a small open "book," illustrated with a tintype. The artist revels in the full circle aspect of her approach to art, in which long-ago and nearly forgotten things have a fresh chance to engage and delight the viewer, while Judi serves as archivist and storyteller.

> *"Of course, I live more than one life all the time, anyway. Don't we all, who read books?"*
>
> —MARY OLIVER

Daguerreotypes, ambrotypes, and tintypes find new life in Judi Riesch's assemblages, and even the hinged wood and leather cases that once held these engaging portraits are saved. Deep red, cut-velvet pillow-like inserts and embossed and gilded photo mats, regardless of condition, are set aside, awaiting new assignments.

In the mid-1800s, Louis Jacques Daguerre, a former French scene painter, discovered he could produce a photographic image on a silver-coated plate by treating it with iodine vapor. Later refinements to Daguerre's original formula made portraits even easier and more affordable to produce, and soon throngs of eager entrepreneurs set up shoppe to serve the whims of an enthusiastic public. Who could blame them, when, for $1.50, a miniature portrait could be "taken, colored, finished, and neatly put up in cases?"

design/provenance

> *"Collecting is something people do for reasons buried deep inside themselves. To be a good collector requires a big heart, an open mind, and lots of faith because the collector will inevitably find himself taken to unexpected places."*
>
> —WESTON NAEF, *HIDDEN WITNESS*

Silver Belle ▸

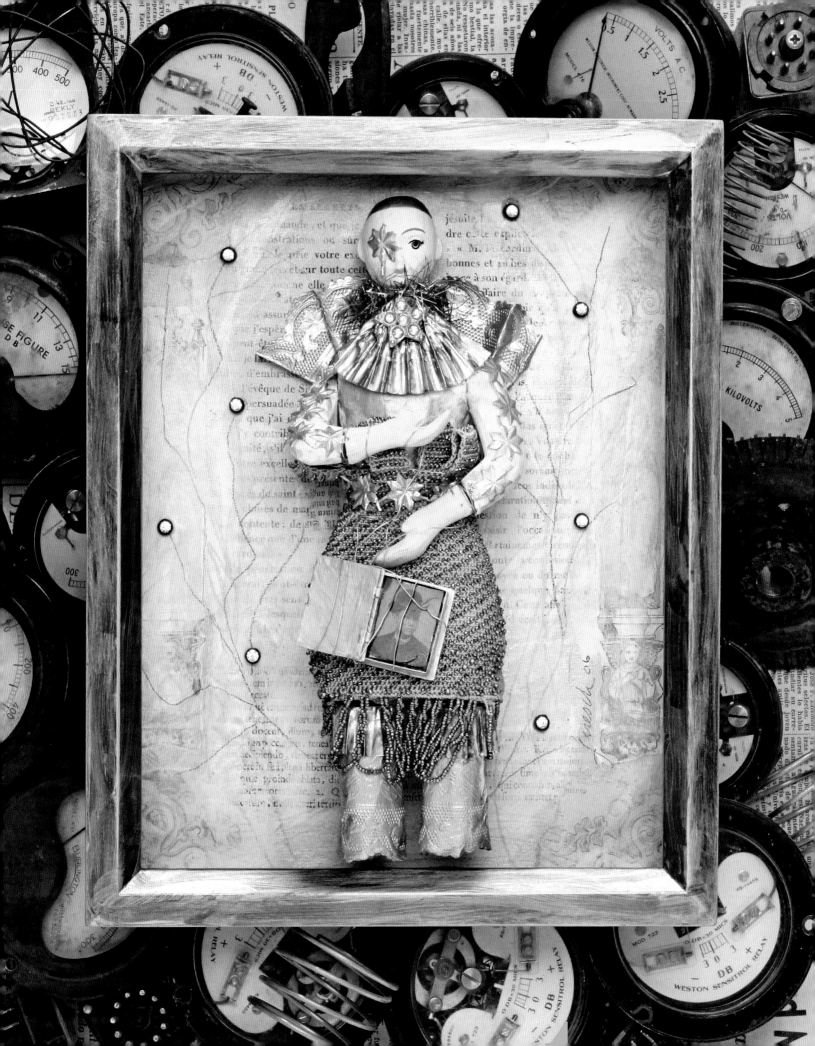

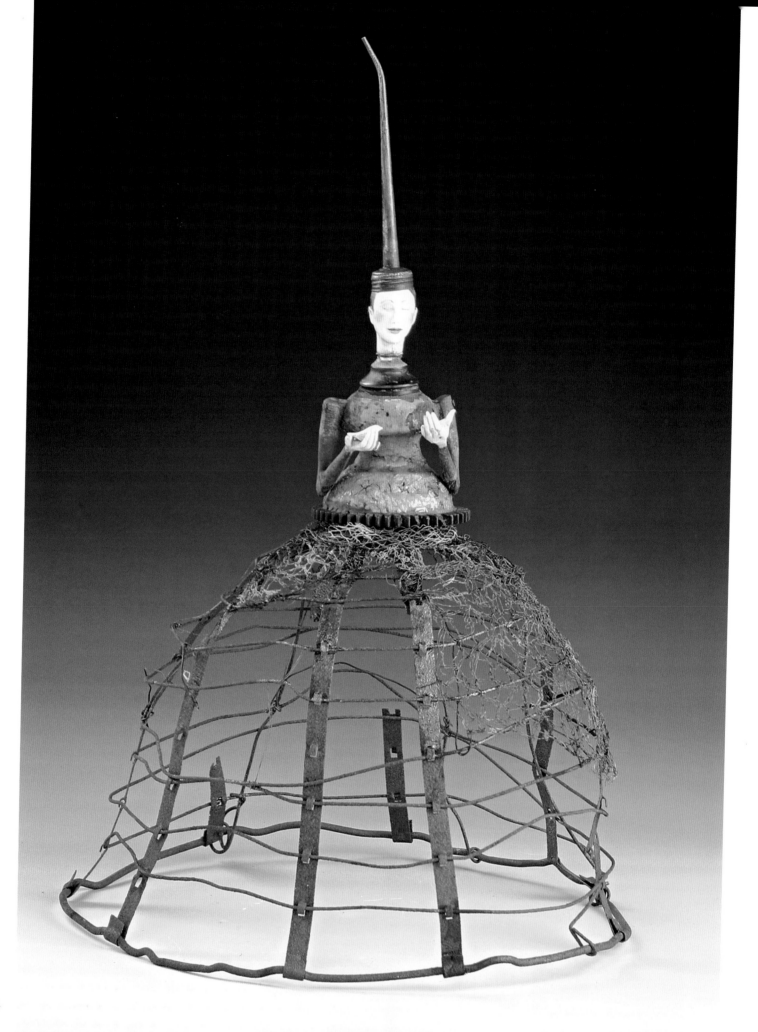

Skirting It

Although mixed-media artist Cathy Rose makes use of countless fascinating objects and is always eager for more collecting opportunities, her focus remains on the distinctive porcelain figurative work that commands each of her pieces. She begins each day in the studio by making sets of faces, hands, and feet from clay, forming all the pieces by hand. She allows the expression on the face of the figure, or the gestures of the hands, to determine what is next, just "going along with the whole thing," as she describes it. Some figures will emerge as marionettes, some as dolls; others are freestanding or wall sculptures.

On Cathy's list of favorite things to collect are doll parts and dresses, wooden shoe forms, and wooden boxes. Pieces are discovered, carried home to the studio, sometimes hoarded, and eventually used in assemblages. Cathy welcomes donations from other artists and friends, especially if they share her eye for "moldy, nasty, old junk." Almost anything she uses in her assemblages is initiated by sanding, grinding, or cutting, to create the wonderfully worn mood of her artwork. In this pair of compelling figures, found objects provide the wardrobe details, from an oilcan spout hat to a wonderfully tattered skirt made from a fringed carnival umbrella.

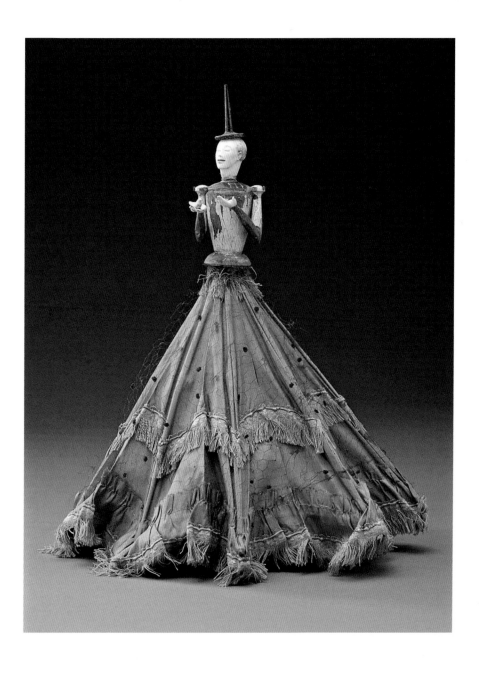

LYNN WHIPPLE

Happy Endings

With more than ten thousand photos to choose from, the creative opportunities to turn an old cabinet card into another of Lynn Whipple's signature *Ninnies* are limitless. And, yet, Lynn's collection continues to grow, as she finds shopping opportunities across the country. She considers herself lucky when great stuff arrives through the mail or just shows up at her booth at an art show. Lynn insists on hand picking her finds (no Internet shopping for this avid traveler) and affirms that handling the goods is a great way to get a vibe for the eventual use of a new object or image.

She admits that practical considerations are not part of her collecting process, preferring to just load up the van with things that fascinate and engage her. Lynn thinks of her finds as worthy opponents, providing the muse, the jazz, the juice, and the impulse for her assemblage artwork. She considers it

> *"Let's see . . . number one on my list of collections is old photographs."*
>
> —LYNN WHIPPLE

part of her mission to honor the objects she finds, and use them in inventive ways that will pique the viewer and tug at their sleeve. Her *Ninnies* series, for example, was born when she tried adding humble house paint to old photos as a way of distorting and reinventing them.

Her process involves peering at the photos sideways, then applying paints and pencil markings in a limited color palette, always with a huge dollop of Whipple humor. Despite the many years that she has been doing this continuing series of altered portraits, "they still make me laugh," says Lynn. Not surprising, for an artist who describes her approach to art and life in the most joyful terms. "Surround yourself with things that interest you, and play," she says. "Know that your instincts are flawless; fill the cup, and just make good stuff. Send your messages."

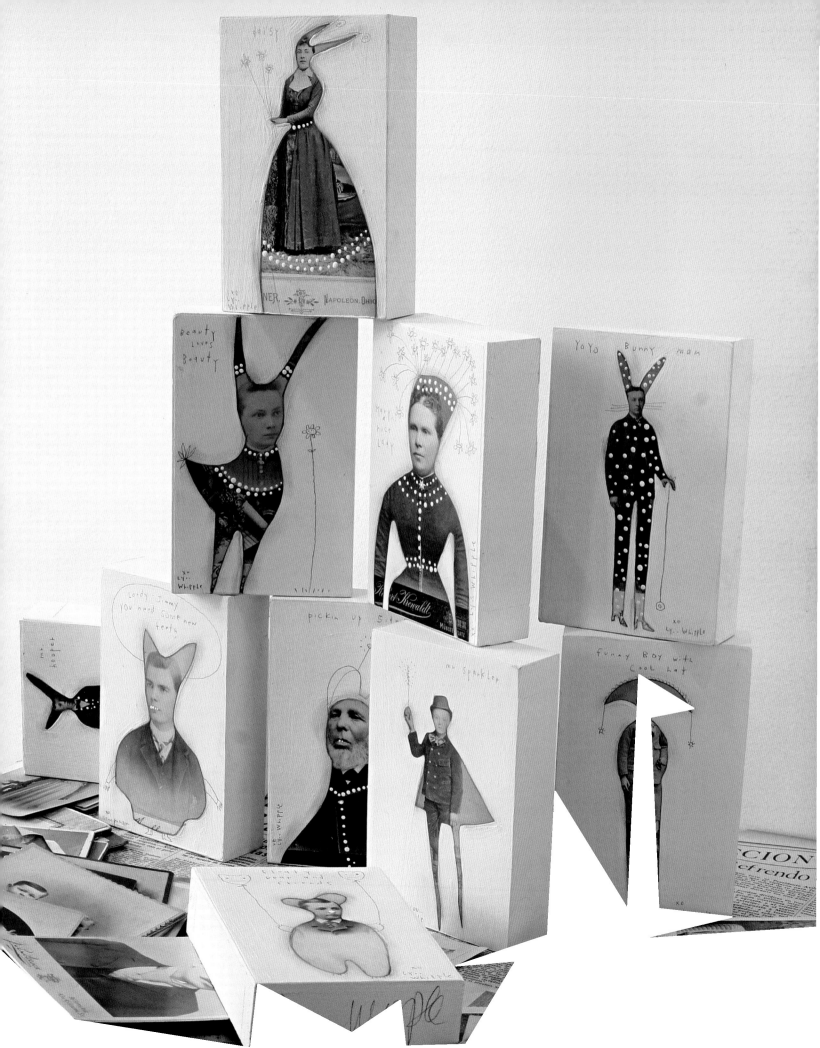

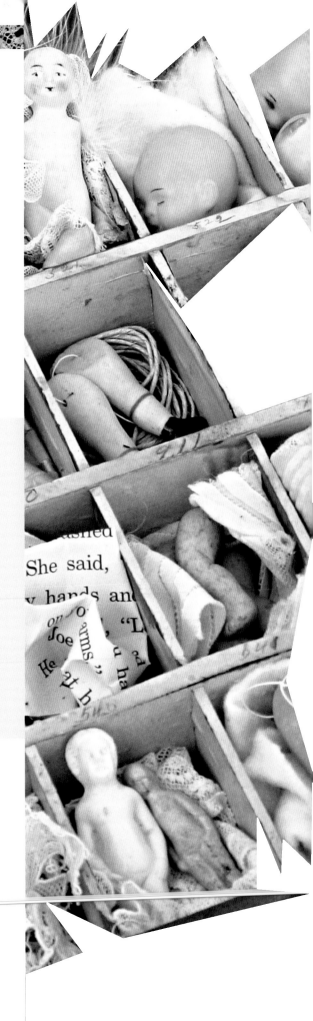

LISA KAUS AND LYNNE PERRELLA

Dolls and Folderol

An antique embroidery thread display cabinet provides ideal storage for the commingled collection of doll bits and pieces of two artists, as well as related special finds. As each narrow divided drawer slides open, the eye feasts on groupings of china, cloth, and bisque doll bits, nestled among lace and trimmings. Other kindred groupings of doll dress patterns, tiny children's books, small kid gloves, and miniature porcelain tea cups and saucers fill the other drawer segments, and the open drawers create their own kind of engaging still life. The old cabinet echoes the mostly vintage mood of the doll findings, a reminder of trips to long-ago dry goods stores to select fabric and notions for making doll clothes.

"To the child, the doll is a presence. It is forever on the threshold of becoming, of being whatever the child or adult breathes into it. One begins with innocence, and the experience of time breeds knowledge and the power for good and evil. Time transforms the levels of play, which may be as secret as the confessional or as brash as theatricals to an audience coaxed with ice cream and cookies. Nothing and everything is revealed, the heart laid bare."

—CARL FOX

Manufactured by the millions in the late nineteenth century and never intended to survive the ages, tiny, breakable Frozen Charlotte dolls have outlasted all predictions of longevity and have become a favorite collectible, ideal for use in assemblages and other mixed-media artwork. Tiny enough to fit into the closed hand of a small child, the nonarticulated white dolls were made of bisque, china, or porcelain, and the urge to collect them, in any condition, is obviously irresistible. Whether coming home with a whole shoe box of twenties-era baby dolls or a single, broken Charlotte wrapped in a tissue, the urge to just keep searching is undeniable.

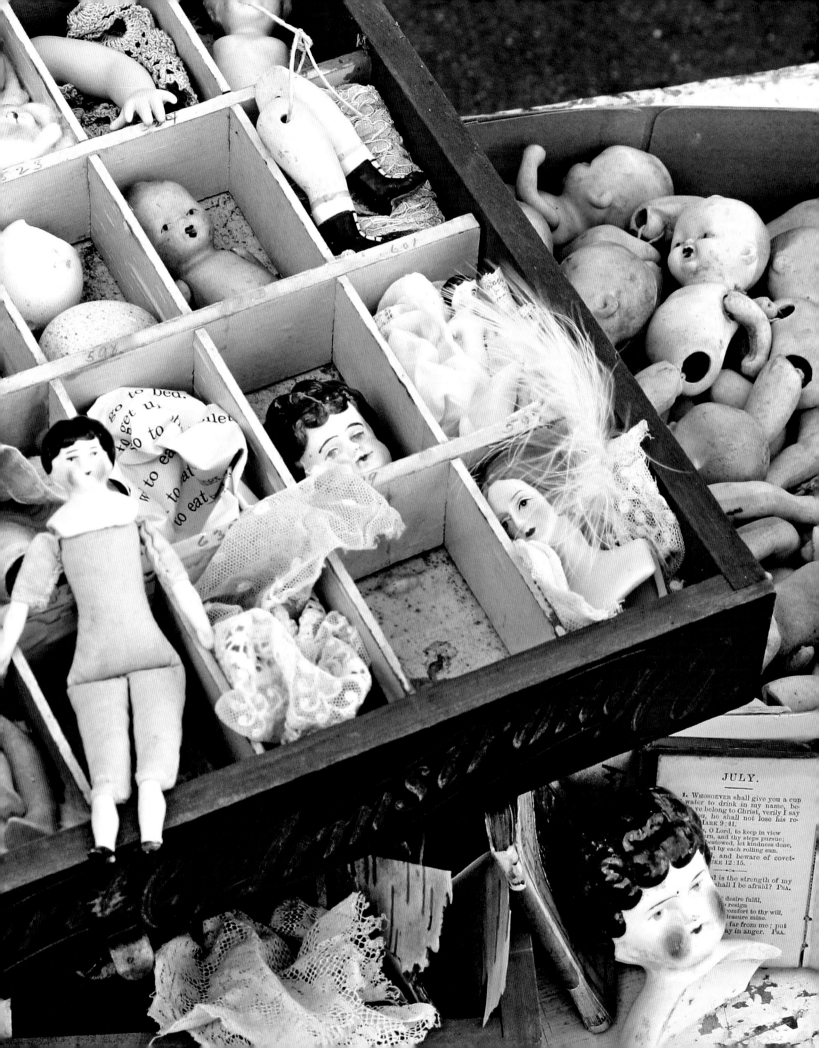

JULY.

1. WHOSOEVER shall give you a cup
of water to drink in my name, be-
ye belong to Christ, verily I say
u, he shall not lose his re-
MARK 9:41.

, O Lord, to keep in view
rn, and thy steps pursue;
estowed, let kindness done,
d by each rolling sun.

l, and beware of covet-
LUKE 12:15.

l is the strength of my
shall I be afraid? PSA.

desire fulfil.
resign
omfort to thy will,
leasure mine.

far from me; put
ay in anger. PSA.

Baubles and Beads

Lisa Kaus describes collecting as "a wonderful passion that has enhanced my work and life" and admits that her recent series of wall-hung, found object figures is way of returning to childhood memories of playing with her mother's vintage dolls. The key component, then and now, is make believe, a state in which a couple of inches of rare, glittered millinery trim or a row of humble rhinestones can provide the crowning touch to one of her petite "glamour dolls." She begins with possible ideas for colors and design but depends on an endless stash of collections to provide surprising ideas and impulses. Fond of collecting German doll parts and complete figures, she depends on her various collections to provide unlimited possibilities and motivation to expand into additional collections. "It certainly isn't for the faint of heart," she warns.

"I can see them standing politely on the wide pages that I was still learning to turn, Jane in a blue jumper, Dick with his crayon-brown hair, playing with a ball or exploring the cosmos of the backyard, unaware they are the first characters. The boy and girl who begin fiction."

—BILLY COLLINS

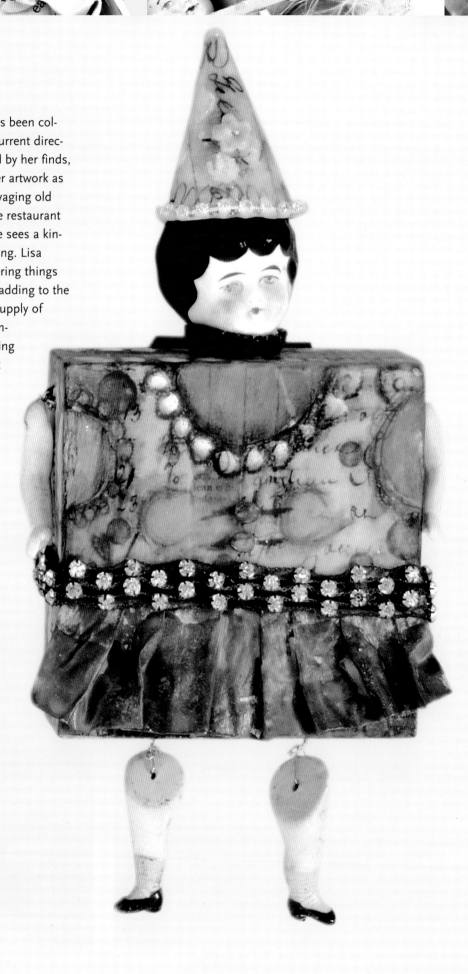

Like many of the artists in this book, Lisa has been collecting and gathering since childhood, and her current direction in mixed-media artwork is heavily influenced by her finds, particularly anything that sparkles. Describing her artwork as a natural progression of a lifelong interest in salvaging old finery, antique papers, artisan jewelry, and Jadeite restaurant ware (especially favored for its unique color), she sees a kindred connection between collecting and art-making. Lisa rarely has a specific end use in mind when gathering things in secondhand shops or estate sales, but favors adding to the overall stash, as a way to guarantee an endless supply of materials to prompt new ideas. An artist who confesses to feeling "delirious and giddy" upon finding a new treasure, her delight is reflected in artwork that has childlike verve with a sophisticated edge of fine couture.

"I think true mixed-media artists are born collectors."

—LISA KAUS

Prime Meridian

This fine gathering of globes in Gail Rieke's studio hints at former lives in classrooms, libraries, dens, and one-room schoolhouses—although they now appear as a simpatico reflective grouping of mystical orbs and spheres, bearing equatorial rings, vertical meridians, cartouches, shields, oceans of blue-green or deepest black, and celestial constellations. Gail quite literally welcomes the world into her studio, by displaying her growing collection of globes and presenting and preserving her archives of fine Asian textiles, brought back from her extensive travels.

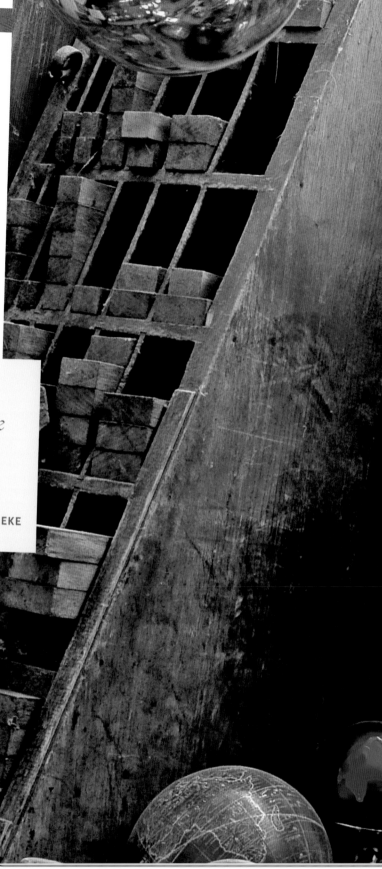

"My artwork is a response to awe—a way of being entirely alive to the moment. It comes free from constraints of time considerations and the 'marketplace.'"

—GAIL RIEKE

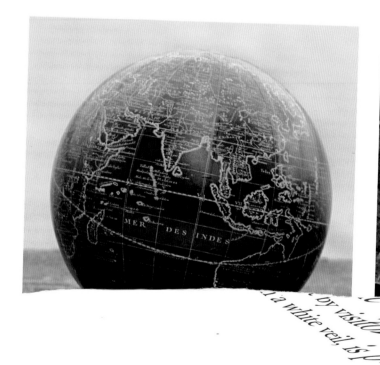

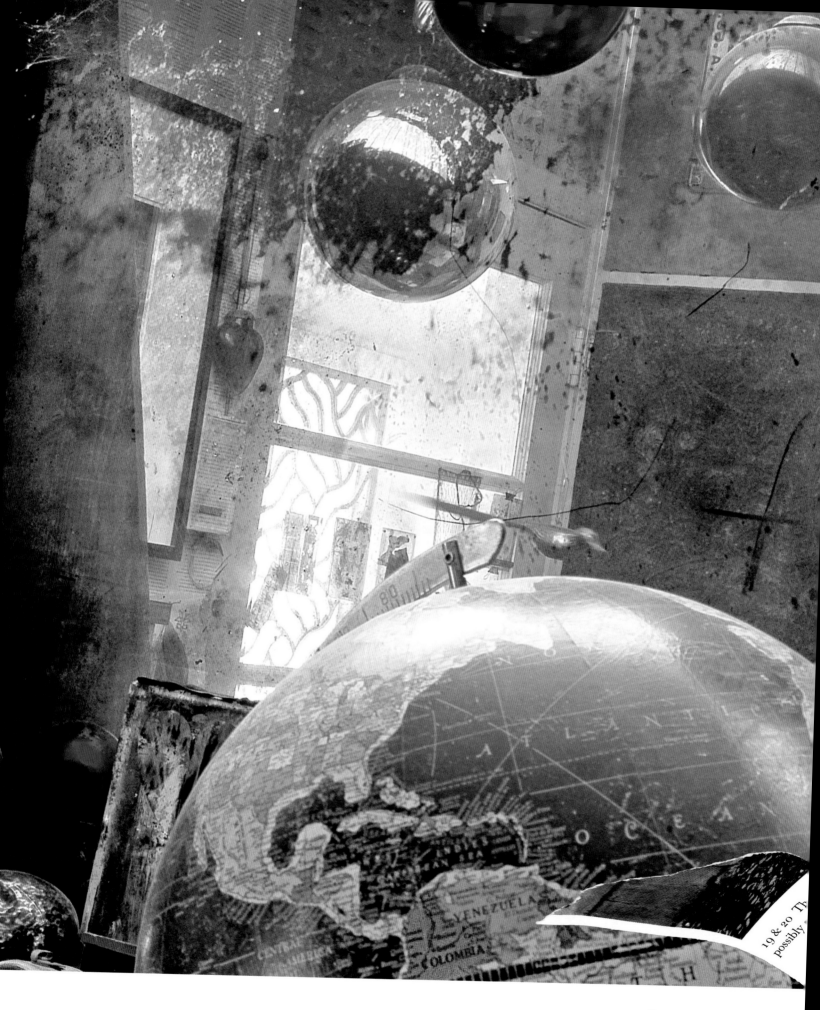

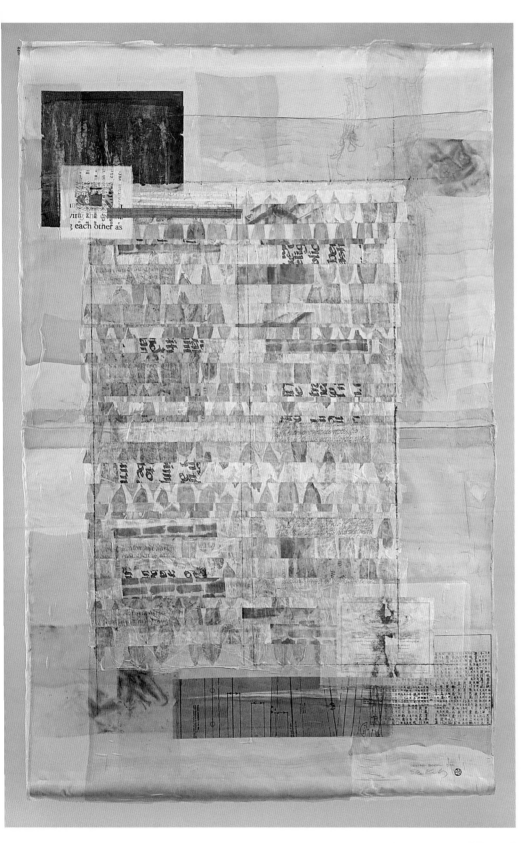

▲ *Sewing Book*

Marginalia

A textile artist who unfailingly prizes the value of the things we throw away, Ellen Kochansky affirms her longtime admiration for illuminated manuscripts, with their quirky page compositions and distinctive margins. She has an enduring affinity for sewing and calligraphy as personal forms of expression and uses layers and veils to imitate parchmentlike vellum. All of those elements, and countless others, have been assembled, blended, and significantly edited to create this ethereal, wall-hung composition. Every inch of the mixed-media hanging reflects hidden stories and significant patterns, and Ellen's collections emerge throughout the handsome surface, forming a "cultural compost."

"All artists are slightly neurotic," she says. "The refusal to let go of some resonant scraps often leads us to epiphanies of sorting, rearrangement of information, and a new perspective of old assumptions."

Past Imperfect

An exquisite handmade wedding dress, created in the mid-1800s in Switzerland for a diminutive bride, was entrusted to Ellen by a former patron and kindred textile conservator and collector. Although now damaged beyond repair, the gown's ghostly presence has followed Ellen through various studios and at least one artist residency, providing evidence of the fleeting nature of perfection and the richness of decay. Nearby, an openwork metallic basket holds a ticker tape–like bale of significant but shredded personal correspondence, conveniently at the ready whenever a touch of meaningful history is needed.

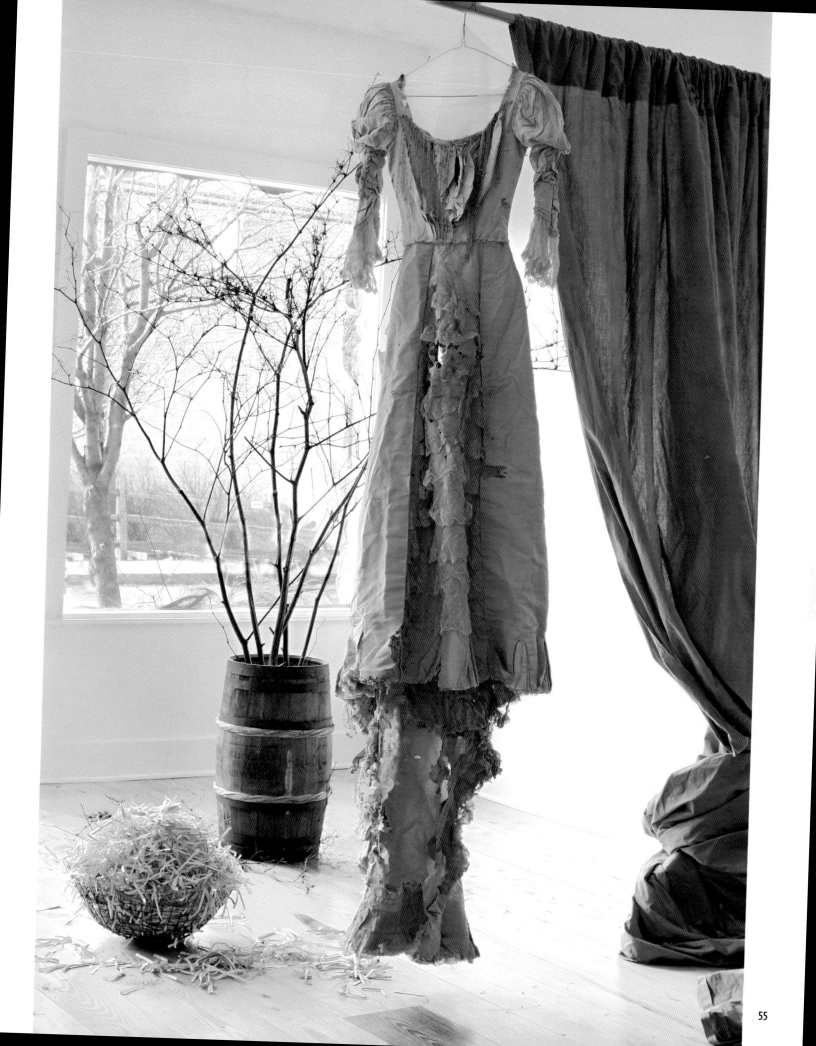

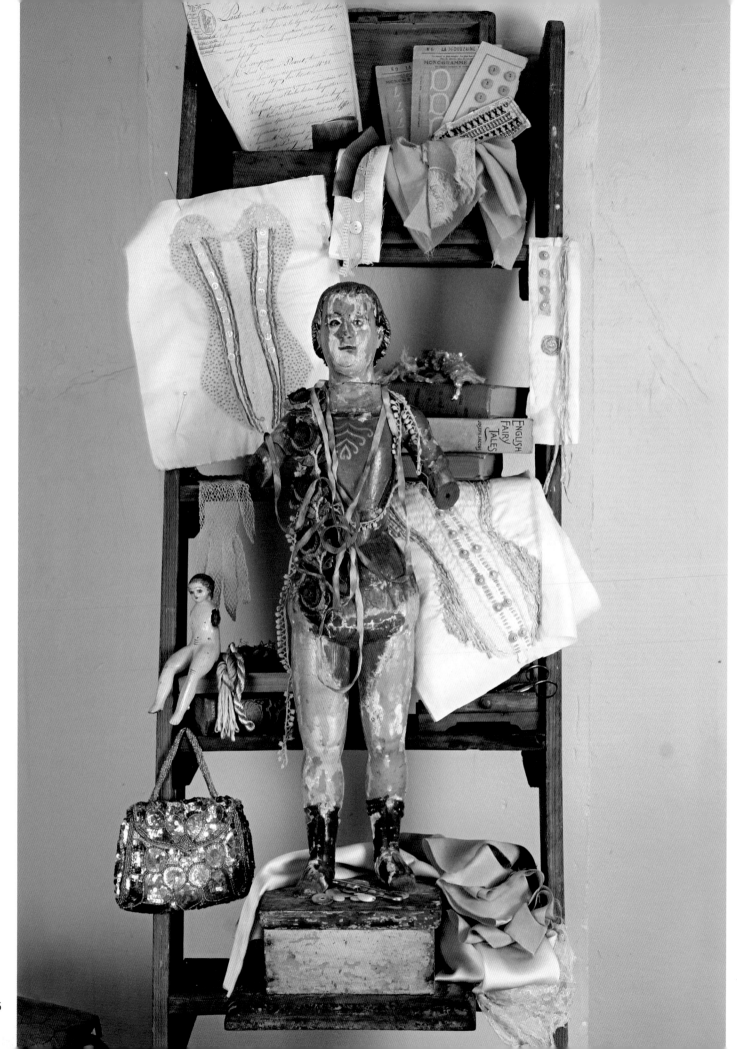

Couture Culture

Pages in progress of Beryl Taylor's unique *Corset Book* are displayed among a tempting array of her favorite collections, including vintage beaded evening bags and scarves, old lace (the more worn and torn, the better), gloves, cards of antique buttons and trimmings, plus stacks of quirky old books, and decorative boxes of old postcards. Tacking up the sampler panels of the book allowed her to visualize the final outcome of a book made primarily from finds discovered at London's inimitable Portobello Road flea market. A segment of the market is specifically dedicated to vintage silk undergarments, nightdresses, dainty camisoles, and lingerie—all perfect findings to execute Beryl's vision of a book in the shape of an elegant vintage corset.

"Whether we realize it or not, most of us collect things. I think the joy comes when we realize that we have started a collection and then anticipate how to enhance that collection through the gathering process."

—BERYL TAYLOR

The interior pages of the fabric book are as soft, pliant, and touchable as a garment from a floral-scented lingerie drawer, with surface details of embroidery, tiny buttons, and lace embellishments. The covers were created by collaging and stitching papers and fabric to a rigid substrate for more stability, and actual fiber laces were added for more tactile interest and fascination. ▸ ▸ ▸

The completed *Corset Book* becomes a sampler of Beryl's many ongoing collections, which include buttons, ribbons and woven tapes, beads, eyelets, delicate fabrics, embroidery thread, and tiny shells. Each page invites an intimate, lingering look that leads to the discovery and appreciation of her expert needlework and intricate design.

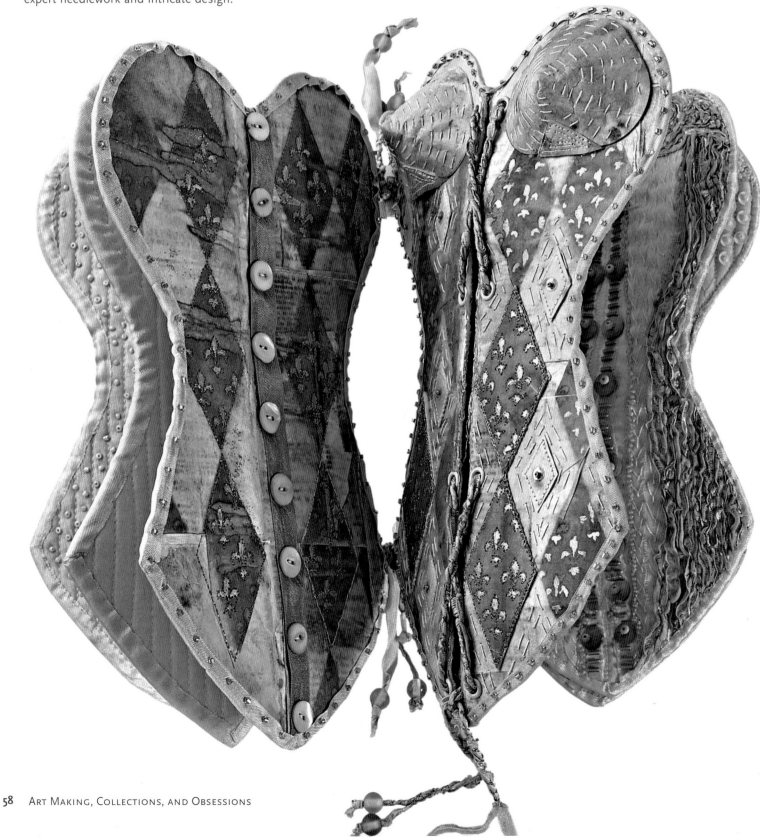

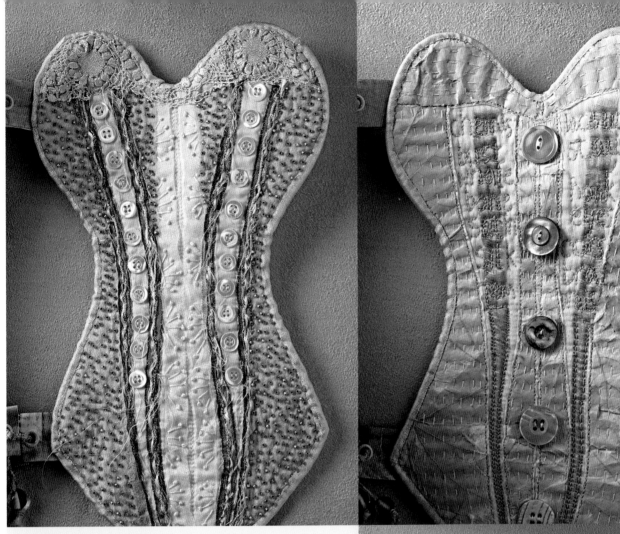

"Closer inspection of my pieces tends to be a discovery process, in which the observer continually finds things that might not have been instantly obvious."

—BERYL TAYLOR

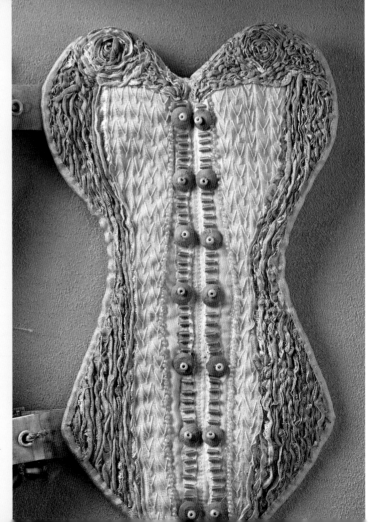

GRACEANN WARN

Numbers Don't Lie

Slide open the narrow oak drawers in Graceann Warn's studio, and you uncover a secret language comprised of numerals, symbols, scrambled letters, and game pieces. Her ongoing collection springs from a fascination with mathematical equations and inscribed lists and charts, as well as remembrances of her father, an accountant with a strong facility for numbers. This encaustic collage echoes traditional accounting paraphernalia and ledgers from an earlier time and makes visual reference to obsessions with numbers, calculation methods, and units of measure.

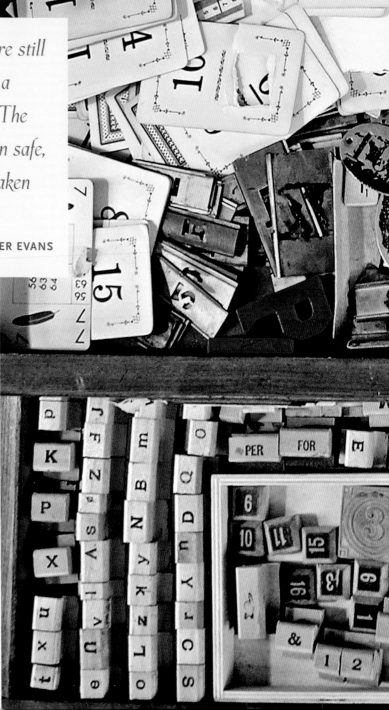

"But the rest of the grand old office trappings are still to be found here and there, in any city that had a commercial life through the nineteenth century. The rolltop desk, the scrolled and lettered black-iron safe, the padded and studded swivel chair, the high oaken bookkeeper's perch."

—WALKER EVANS

▾ *Small Cypher*

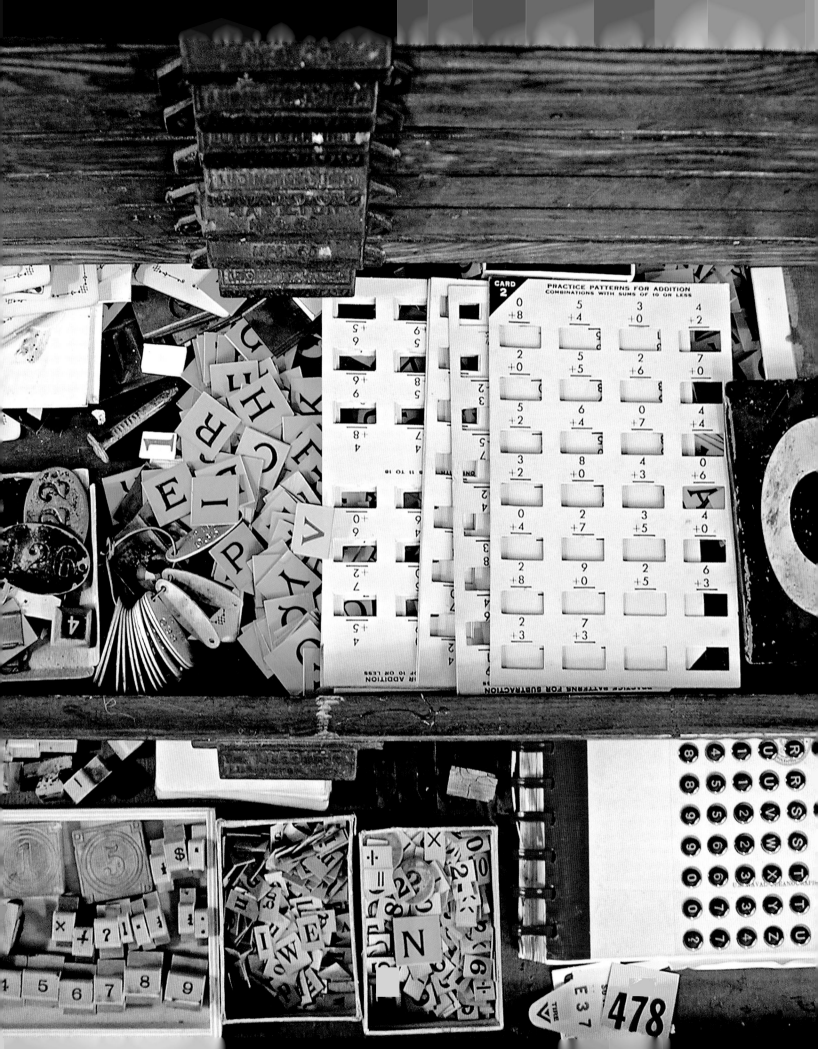

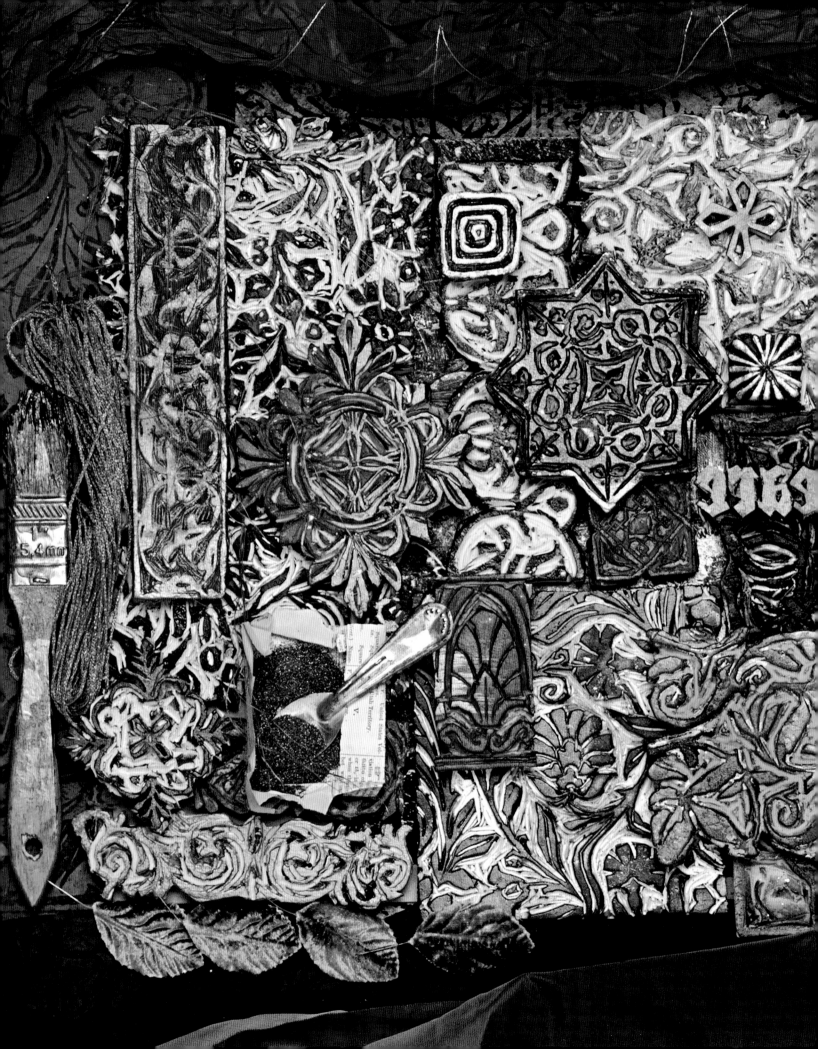

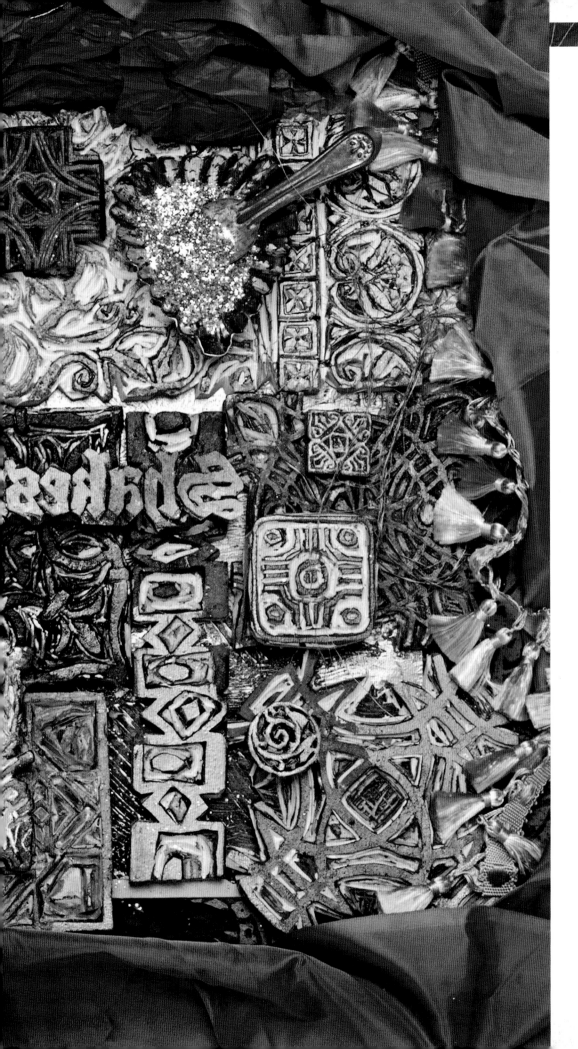

Carved Opulence

Anne Bagby rejects the notion that her own magnificent, hand-carved pattern stamps are a collection. Rather, she prefers to think of them as tools. Either way, her ability to carve any intricate pattern on a moment's notice has given her full command of the lush, layered motifs for which she is noted. Best of all, each pattern she translates into a hand-cut stamp becomes her own. As she brainstorms her next painting, part of her process involves pulling out anything in her studio drawers that evokes her chosen color scheme— from beads and fibers to her own archive of hand-painted-and-imprinted papers, arranged according to color. ▶ ▶ ▶

Harlequin

Anne Bagby proves the theory that artists can also be archivists, informed and inspired by their collected reference materials. An inveterate collector of research books and exhibit catalogs on motifs, patterns, and ancient costume design, Anne's hands-on knowledge of these topics becomes crucial as she creates a growing resource of exquisite, hand

> *"He is a chameleon which takes on every colour. He must excel in impromptu, and the first thing that the public always asks of a new Harlequin is that he be agile, and that he jump well, dance, and turn somersaults."*
>
> —JEAN-FRANCOIS MARMONTEL

carved stamps that she uses and reuses in her mixed-media artwork. Her carved stamps range in size from the tiniest spiral motif to commanding 14" × 9" (35.5 × 23 cm) slabs. Overall designs, borders, two-part motifs used to create positive and negative effects, and even lettering are included in her growing collection of hand carved beauties. (See page 63 for a selection of Anne's stamps.) She considers these stamps a continual resource, finding new uses for them every day. To prove the point, a small box of specially carved stamps accompanies her on trips.

Always eager to find new ways of adding depth and layering to her paintings, Anne uses acrylic paints with her stamps to imprint tissue paper and build layers of images

and patterns. Along with rubbings and imprints made from dimensional wallpaper in classic patterns and borders, Anne's hand cut stencils, made from contact paper, are another way she uses low-tech methods to add rich pattern to a surface. Endlessly curious and enthusiastic about pattern, Anne brings that exuberance to every new research topic that captures her interest.

Her fascination with vintage European clowns, jesters, Punchinellos, and *commedia dell'arte* characters seemed a perfect match with her affinity for elegant pattern and historic costume research. The subject has become an enduring motif, explored in Anne's personal process sketchbooks, as well as in art journals, collaborations, and (most recently) a series of imposing large-scale paintings. She took her sketchbook drawings of clowns to a local copy center, where they were enlarged to larger-than-life-size. She then transferred them to canvases, which were mounted on hollow-core doors. The depth and richness of the paintings results from the cumulative layers of Anne's painting techniques, collage, stenciling, and imprinting with her stamps, as well as an intricate web of lines created with paint in tiny squeeze bottles. Anne's series of large paintings revives the ancient traditions of *Le Theatre Italien*, bringing the characters back to life with a sense of pageantry and vivid color.

> *"The commedia dell'arte is not only a study of the grotesque and facetious, . . . but also a portrayal of real characters traced from remote antiquity down to the present day, in an uninterrupted tradition of fantastic humour which is in essence quite serious and, one might almost say, even sad, like every satire which lays bare the spiritual poverty of mankind."*
>
> —GEORGE SAND

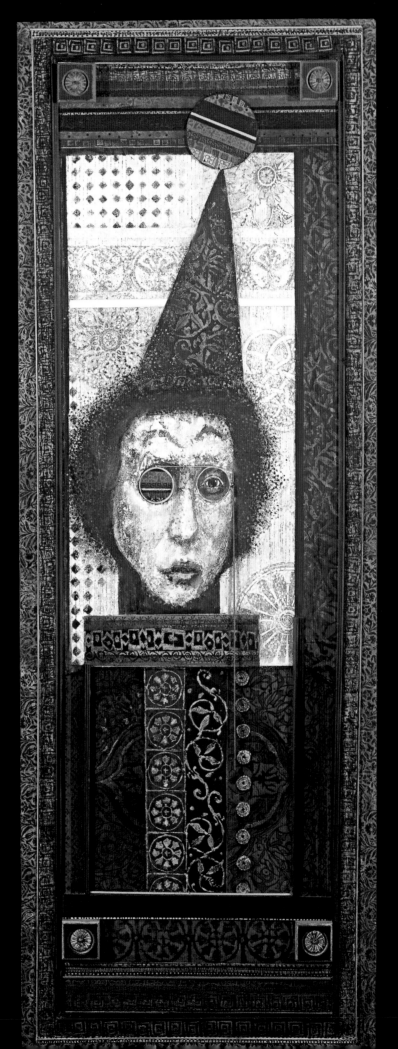

Pilgrim's Passage

An outdoor flea market in Kyoto, Japan, is a constant source of fascinating finds. Local merchants set up temporary outdoor stalls called Shrine Sales to accommodate local villagers, who, on designated days, visit shrines and shop for household provisions.

"On a very dark night, it is delightful when the aroma of smoke from the pine torches at the head of a procession is wafted through the air and pervades the carriage in which one is traveling."

—SEI SHŌNAGON

Gail Rieke has learned how to navigate the fascinating markets, searching for old books, letters, and textiles—especially Pilgrim jackets. The jackets, made of serviceable cotton cloth, are worn by travelers making pilgrimages to Shinto shrines and Buddhist temples. At each destination, the jacket is stamped and dated until it assumes the appearance of a wearable passport—quite literally, a garment bearing the collected markings of numerous spiritual journeys. Part jacket, part evidence journal, the jackets are not easy to find, because many owners choose to wear them into the next world, during cremation.

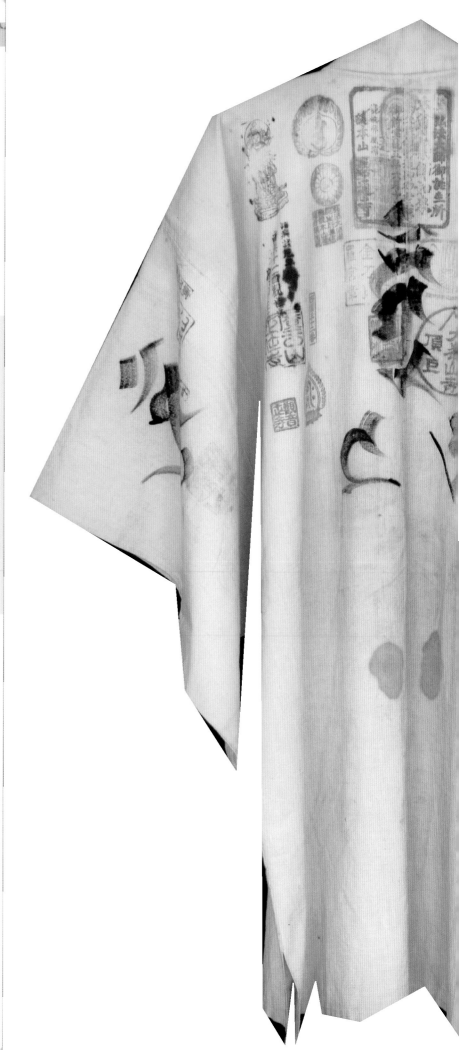

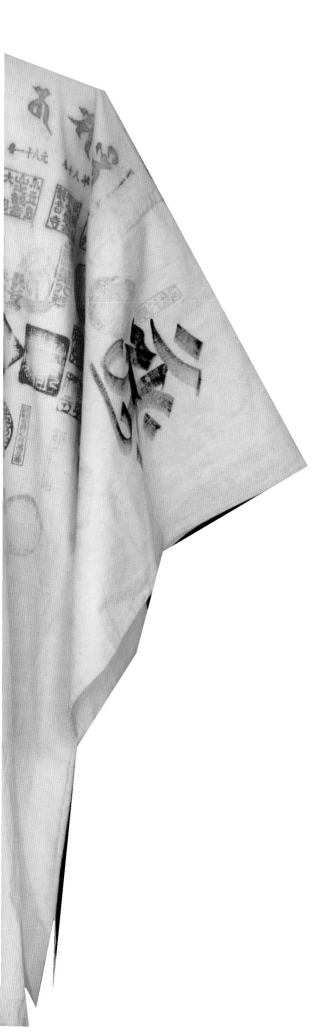

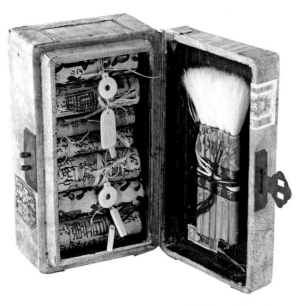

My interest in Oriental seals was sparked in the mid 1980s, when a friend traveling in Beijng, China, brought back a soapstone seal inscribed with my name in Chinese. It was the first inaugural item in what was to become an extensive collection of Asian-themed rubber stamps, wax seals, and unique signature chops and piqued my interest in Oriental calligraphy, scrolls, and packaging.

Raiding my collection of old document boxes, I found a vintage leather box that looked well traveled and enigmatic and was, already imprinted on the outside with a "leisure seal," a square carved stamp that symbolizinges a favorite poem of the owner's. Using many of the handmade Asian papers in my drawers, I created a grouping of imprinted scrolls tied with raffia and string and coated in melted wax and installed them inside the box. Faux ivory embellishments and tags were added to each scroll, a reference to another of my favorite collections, vintage ivory *netsuke*.

A simple bamboo and bristle brush glued inside the lid of the box acts as a reminder of how functional items can have great visual beauty.

Netsuke are intricately carved toggles, usually of animals or people, that came into being as utilitarian objects because the traditional Japanese costume, the *kimono*, did not have pockets. Important carry items, such as tobacco pouches or writing cases, were attached to long cords, and netsuke kept the items from slipping through the *obi* sash. However small, each netsuke is a wonder of Asian aesthetic sensibility.

Safe at Home

One of my favorite ways of brainstorming and generating ideas is to bring some of my favorite collections and relics into the studio and work with them in temporary installations. This wall-hung assemblage resulted when I came across a handmade embroidered cotton christening dress that has been in my husband's family for generations. I was captivated by the dress and the beautiful details and used it as the centerpiece of this mixed-media hanging. Using a wooden skirt hanger wrapped in soft strips of cheesecloth, I started composing, using anything that seemed to work with the dress, including a necklace of silver baby spoons, a cabinet photograph of a Neapolitan ancestor, and a glass cup that belonged to my mother as an infant. I temporarily

attached small, painted coin envelopes, embellished with more small treasures, to the hem of the dress and tucked notes inside. The process of gathering the items and placing them together in visual harmony became a meditative way of considering family history and creating a narrative.

My friend Sarah Blodgett maintains a collection of lace, embroidery, crochet, and old gloves, which are stored in a big hatbox in an upstairs closet. One day, during a photo shoot for this book at her house, I discovered the cloud-like tangle of soft trimmings and remnants and spent an enjoyable half hour exploring the collection. Each bit of lace seemed like a memory marker to some earlier time or special occasion—all that was left of a wedding, church social, or harvest ball.

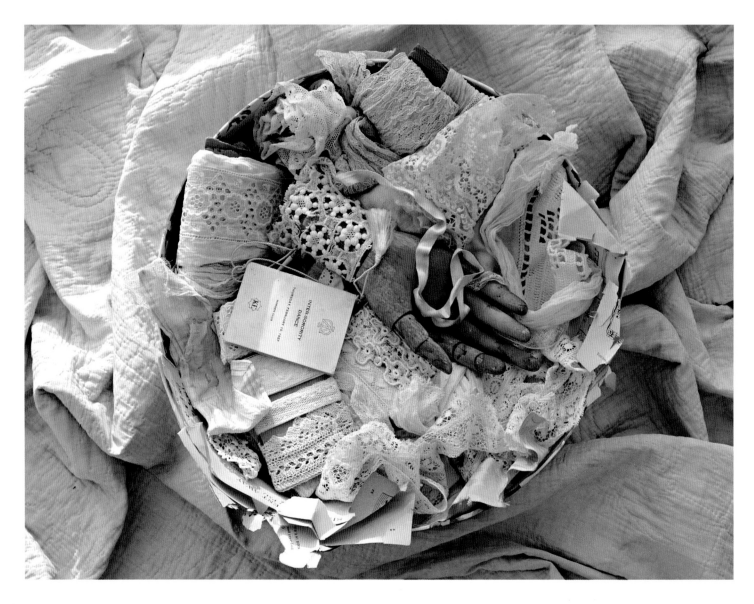

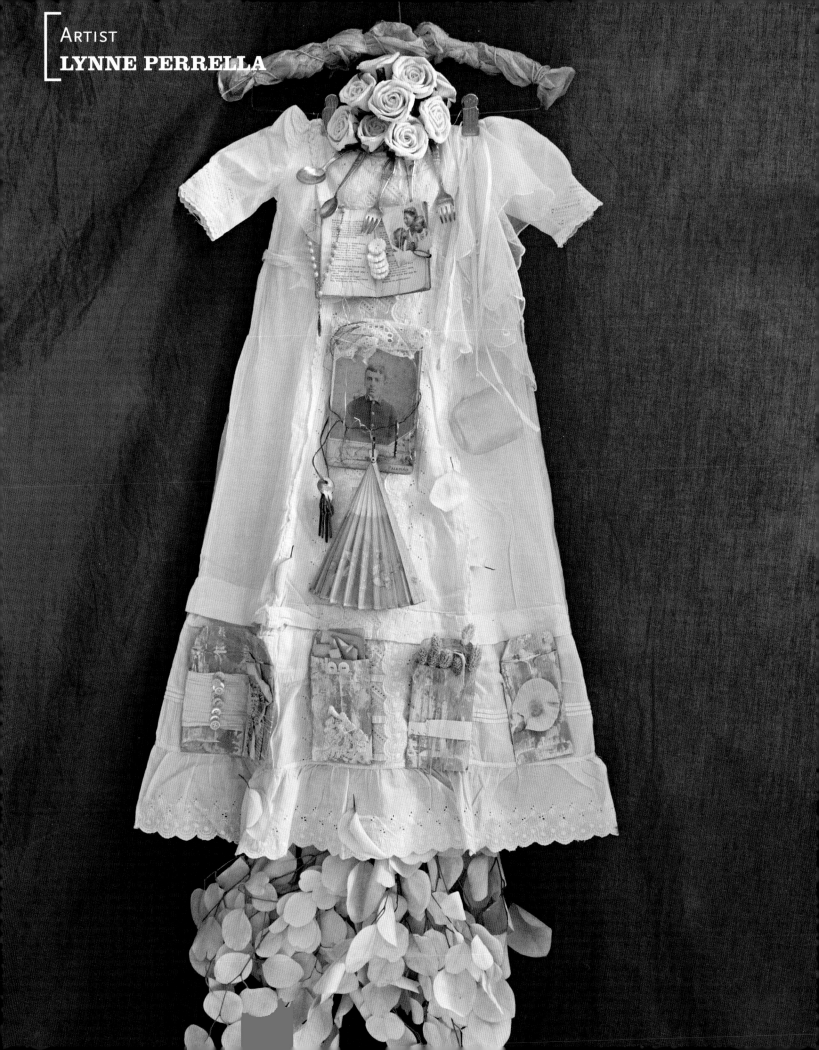

RARE EARTH

From the natural world, the great outdoors, inspired by nature, rustic revival

Look up. Look down. Train your collector's eye to spot the bottomless variety of nature, most of it free for the taking. In this chapter, we meet artists who are endlessly inspired and informed by nature. They are hunters and gatherers, who have maximized their penchant for carrying home a smooth stone, a pearlized shell, or a curl of birch. Their works of art remind us to slow down and study the intricacies of a delicate insect wing or observe the graceful bend of a sycamore branch. Subtle and sentimental, rough and raw, weatherworn and outward bound—the reference point is this good Earth, and the compass always points true north.

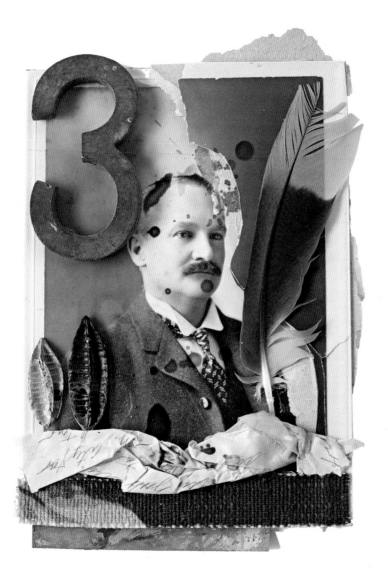

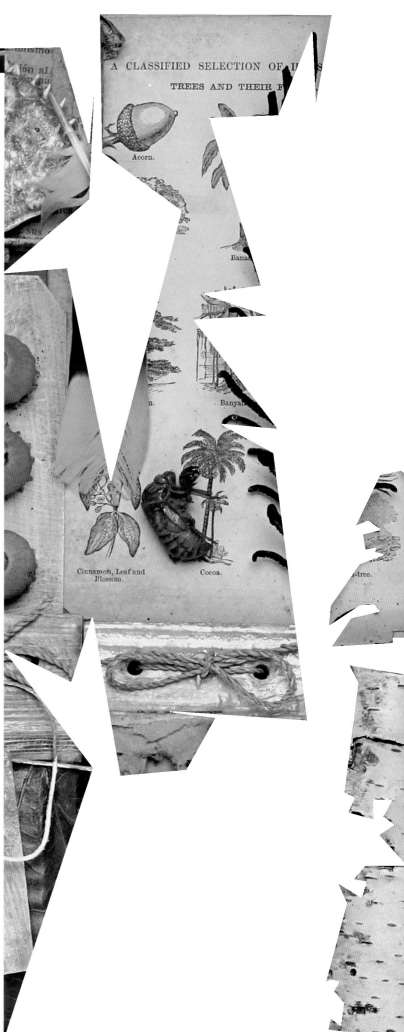

A CLASSIFIED SELECTION OF
TREES AND THEIR F

Acorn.

Bana

Banya

Cinnamon, Leaf and
Blossom.

Cocoa.

-tree.

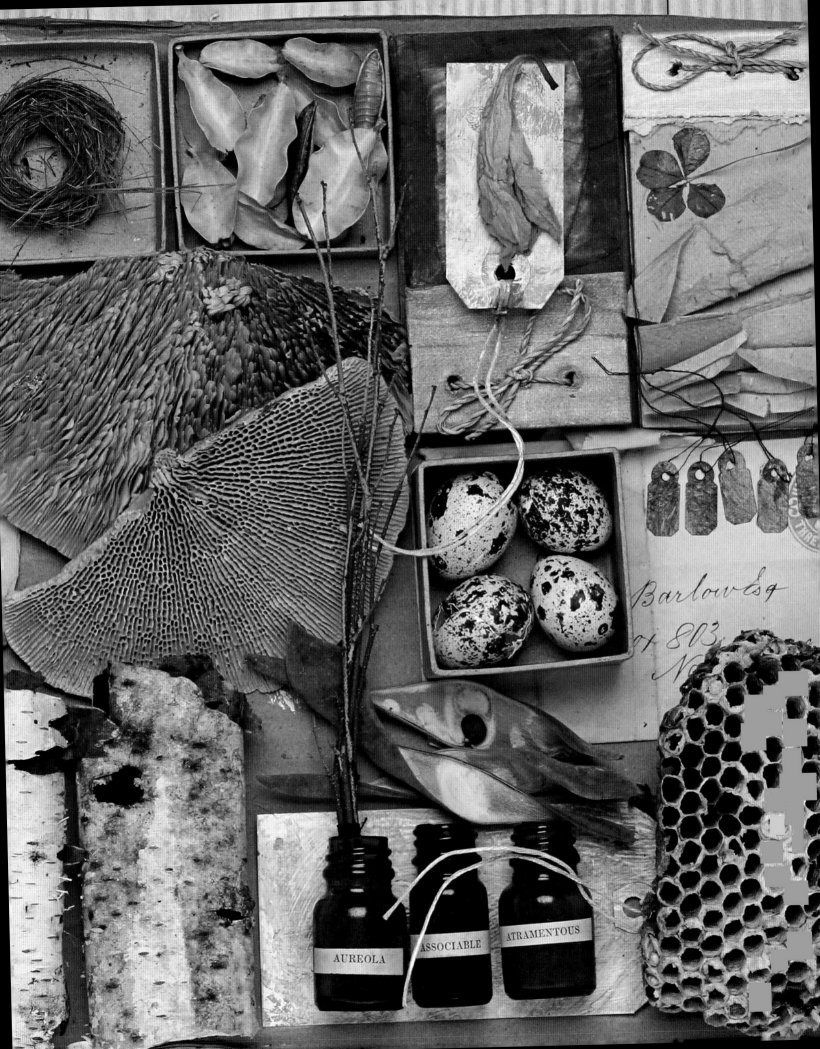

AUREOLA

ASSOCIABLE

ATRAMENTOUS

Barlow Esq
N 803
N

Take the Leap

The inspirations for this mixed-media assemblage were unconventional and off center. The first was a large horsefly that visited Jane Wynn's studio one hot summer day and remained long enough for her to inspect its exquisite wings. The second was a humble plastic figure of a diver. Finding the small action figure set Jane on a journey to create a set of wings for the jumper, and then concoct a dwelling in which to contain the composition. An enclosure of soldered metal was made, to provide a secure, strong, and distinctive surrounding for the intrepid figure. She worked with paints and sawdust, applying them to the metal surface for an organic look. A tiny, painted thimble gives a hint of the miniature scale of the composition.

> *"More gorgeous than anything the mind of man has yet or ever will imagine, a moth, yalophora cecropia, in the first morning of its long death. I think of Thoreau's description of one he found in the Concord woods it looked like a young emperor just donning the most splendid robes that ever emperor wore. . . .'"*
>
> —MARY OLIVER

"I make art to help me process my life," says Jane, a collector of insects, who appreciates and reveres their colors and fragile wings. "Art helps me understand the stark realities of the world around us. My work always has a deeper story inside. Sometimes, my voice is a whisper, and other times it is deafening. Whatever the final outcome of the work I make, it brings me closer to finding the answers I seek."

When asked if she ever receives donations to her collections from others, she laughingly admits, "I seem to receive some rather strange items. I mean, I don't get things that are normal, like buttons, or vintage valentines. People send me bones, bugs, and teeth! I am grateful for the people who care enough to send me things. It truly motivates me."

The Careful Jumper ▸

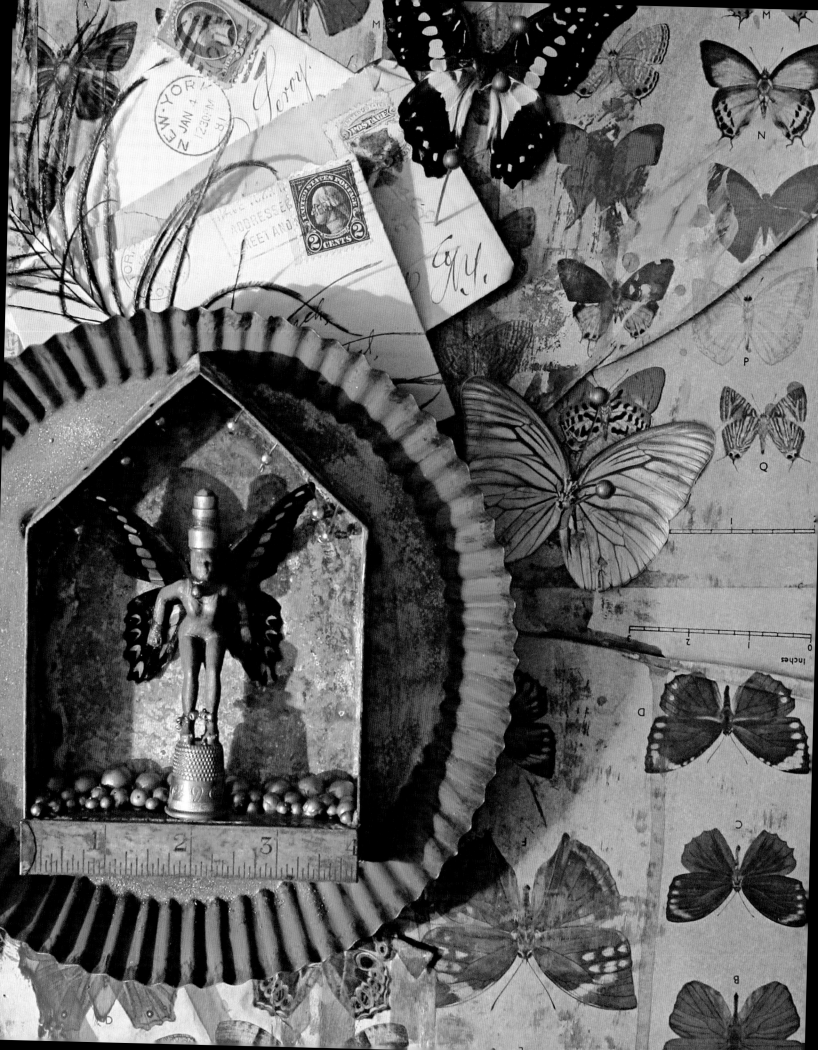

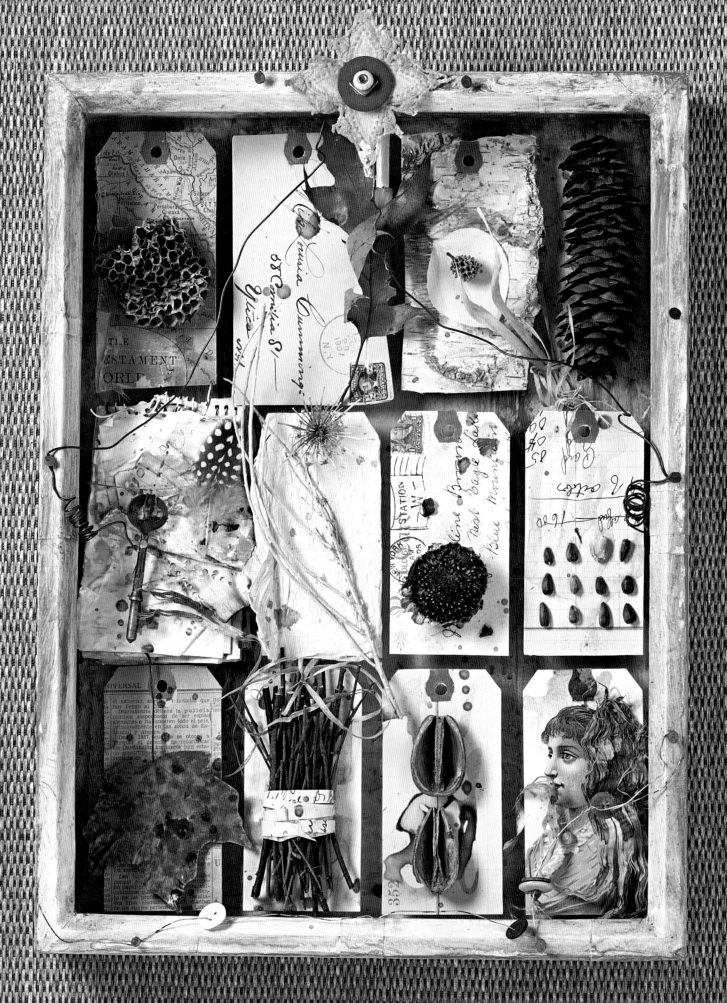

Field Trip

In contrast to all the various collections that have accumulated inside my studio, I recently challenged myself to start noticing the abundance of intriguing things to be found just outside the studio door and beyond. In my travels to recent workshops, both in and out of the country, I promised myself that the souvenirs I brought back home would all be "naturals": a seedpod from Taos, a smooth stone from Puerto Vallarta, a bit of rusted wire from a Seattle street. My biggest challenge was to concoct some way to organize the items, so each could be appreciated for its individual beauty and fascination. By placing the items on shipping tags, inside a collaged and painted shadowbox, I tried to create a visual inventory of each find, no matter how whimsical or momentary. The items became more beautiful as a result of being gathered together and given a handsome protective enclosure.

> "We need stones around us to echo the substance of our own lives—hard, solid, heavy, timeless, and subtly hued."
>
> —THOMAS MOORE

design/provenance

Whenever I have enjoyed making something, my thoughts invariably turn to creating a series. In this case, it seemed like a natural impulse, given the completely endless availability of natural artifacts, not to mention the continual enjoyment I would have collecting and gathering the objects. I pictured a whole wall of nature-themed shadowboxes and was reminded of a grouping of large framed botanical etchings I once saw in the home of a friend—an incurable collector. An intrinsic part of collecting is visualizing ways to display and enhance my finds, despite my recurring dilemma of "where am I ever going to *put* all this stuff?"

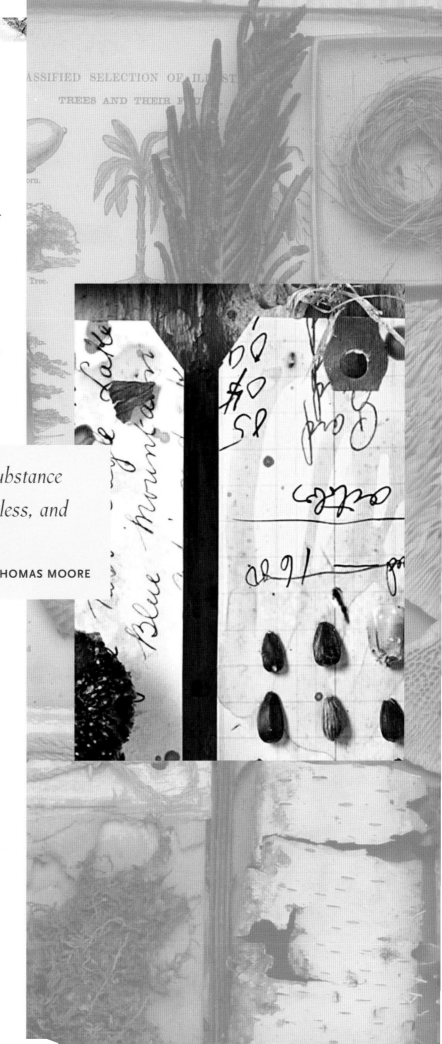

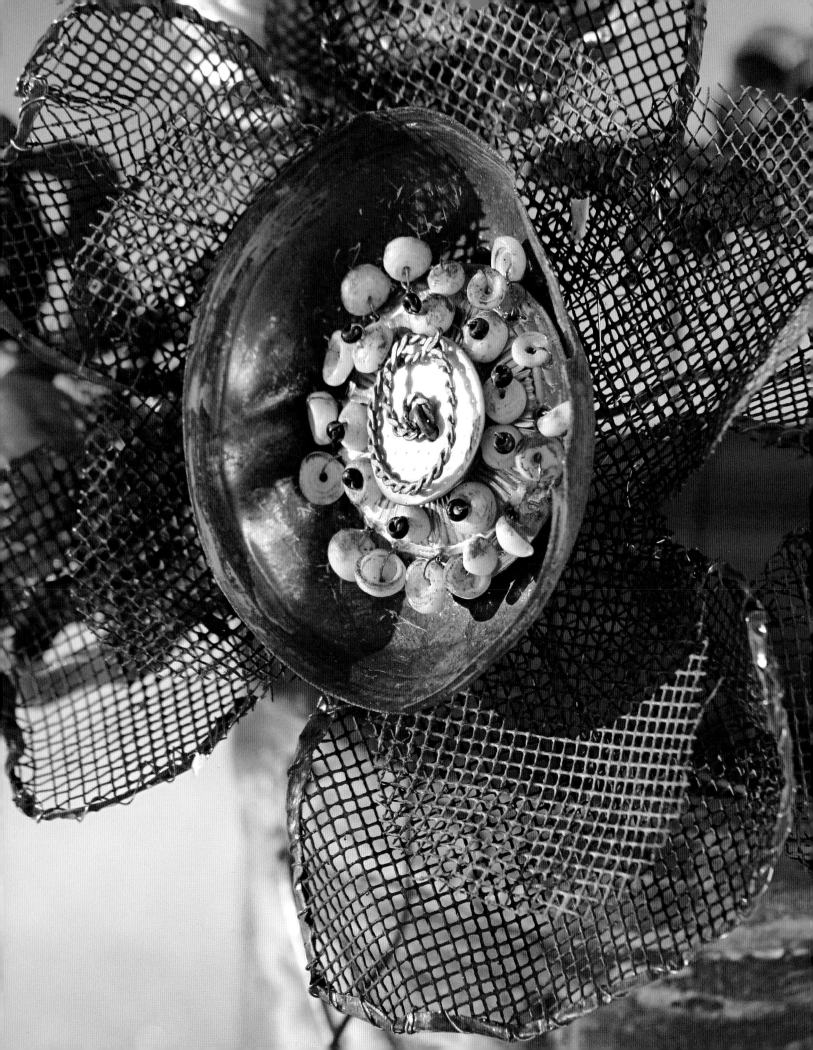

Botanica Detritus

Expert gardener and playful mixed-media artist Monica Riffe found the perfect way to bring a touch of summer to wintry Colorado ski country. Working with anything at hand in her workshop, she fashioned a bouquet of "junk flowers," made mostly of wire, metal, and tin. This grouping of flowers has all the variety of her own floral cutting garden, with a wonderful, made-by-hand look. Peer closely at the centers of each flower, and you'll discover rusted bottle caps, old painted spigot handles, and rusted nails pounded into a wooden core. Pliable petals of metal screening look amazingly like the real thing. An artist who lists lumber scraps, sea glass, tin cans, Mexican reliquaries, and broken pottery as favorite collections, Monica's strong suit is creating engaging, unique, and strangely elegant works of art using the most ordinary outdoor finds. "I am particularly aware of stuff on the ground

"The challenge is to create with bits and pieces. A dab of paint goes a long way to incorporate various elements and serves to repeat a color seen elsewhere in a piece."

—MONICA RIFFE

in parking lots," she says. "Smashed things have great texture. When I am on vacation, found object hunting takes on a new level of magic, since these discoveries double as souvenirs/mementos of the trip."

Monica uses her "left brain filter" when reviewing items earmarked for the landfill: "Can I paint it? Can I cut it up, or felt it . . . and *then* cut it up? Does an ugly necklace have some useable parts?" She prefers to let her ideas spring from the objects she collects and fills boxes with potential fodder. From time to time, the collections are auditioned or set aside to await some better assignment. Days or years later, each thing finds a perfect use. A broken bird feeder found in an alley was brought home and became the base for an assemblage.

Although a well-meaning contractor working in her home once offered to take Monica's stash of precious art fodder and metal screening to the dump, she continues to revel in the offbeat beauty of discarded things.

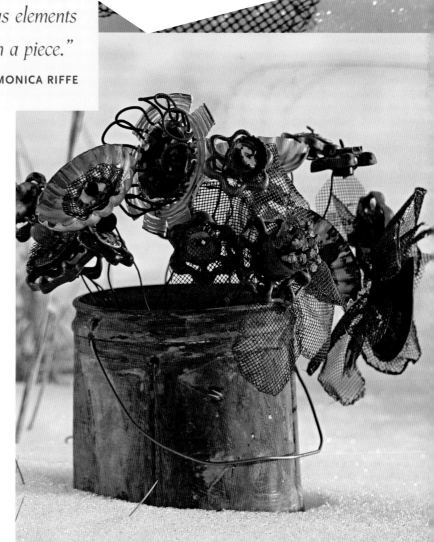

A Walk in the Woods

Location is all, as Nick Nickerson displays one of his magnificently crafted rustic frames on an easel just outside his deep-woods workshop. The frame provides a perfect surrounding for a vintage etching, giving the illusion that one is approaching a river bank through a thick, overgrown forest. A hybrid of sculpture and 100 percent found-object collage, Nick's artwork evokes the traditions of Adirondack rustic makers. However, Nick's description of his artwork provides deeper insight: "I feel my work is a partnership between me and nature."

"I love walking through the woods, searching for hidden finds. It might be a large deadfall birch, with its pure white bark tattooed with distinctive gray markings. Taking my razor–sharp pruning knife, I'll straddle the tree and make one long straight cut the full length of it. The act of creativity, using one's hands, mind and heart, is one of the greatest, most rewarding things a human can do."

—NICK NICKERSON

He begins by hanging the art he is going to frame on the shop wall. Once a subframe is built from rough, cut pine, he ventures out to his "stick barn" (see left), for a selection of potential natural materials to use: branches, twigs, bark, tree fungus, pine cones, acorns. Whether it surrounds a vintage painting, print, or mirror, or it is left empty to be enjoyed as art in itself, each frame becomes a vivid statement about Nick's love of using natural materials to create art.

"My collections *are* my artwork," says Nick, a constant collector, who also lists old oilcans, hammer and axe heads, pocketknives, pitchforks, bottle caps, burned wooden matches, animal bones, and rusted machine parts on his list of preferred favorites. "I'm just there watching them come together, coming to life right before my eyes." ▸ ▸ ▸

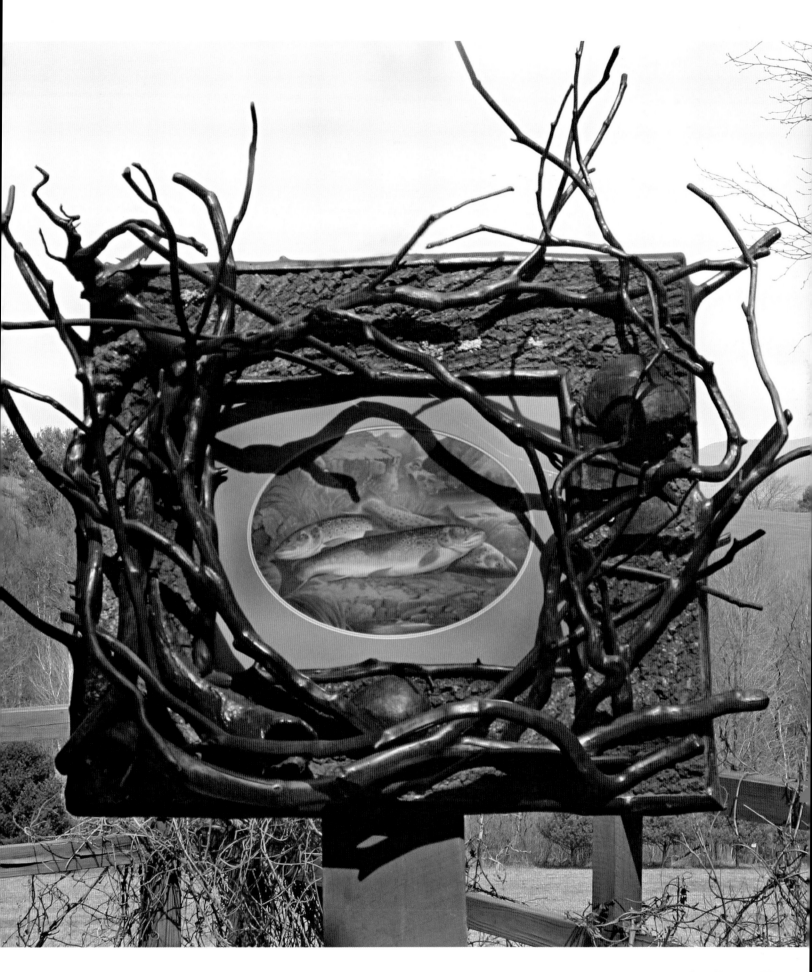

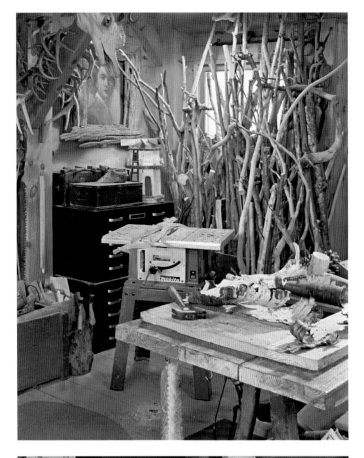

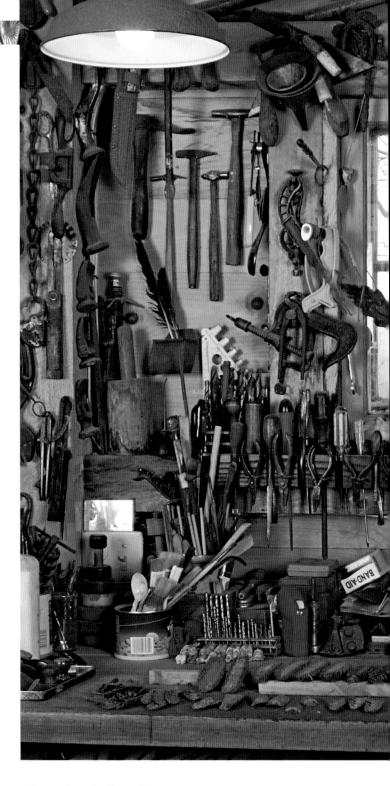

Outside/In

Nick Nickerson's studio barn is a perfect example of how a work environment can so absorb the spirit and intent of an artist that it actually becomes a habitable work of art. Far more than just a workshop, the warm, welcoming barn, located in the deep woods behind his home, is also a place for Nick to commune with his collections and work with a wide range of tools and equipment to achieve his magnificent, rustic frames. "When I open the big barn door and step inside, I

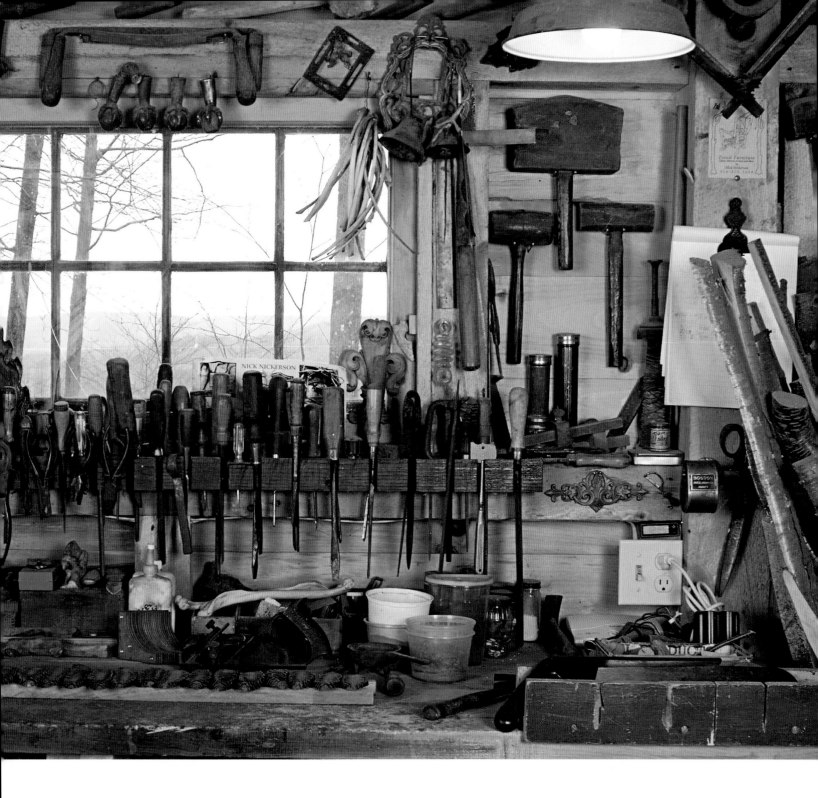

can feel it," he says, "the connection. My collections, my tools, my materials, my work, my stuff."

The morning chill is replaced by the comforting warmth of a fire in the wood stove, and soon the hum of saws, drills, and sanders—the sounds of exploration—fills the small barn. The workbench is both a rustic still life and command center, and the wintry, rolling hills outside the window provide further visual evidence of Nick's belief that, "My art is a process

of evolution, and each new twig or pattern of bark suggests the next step."

Nearby shelves display rows of collected artifacts, as well as small drawers filled with screws, nails, hardware, and contents both useful and mysterious. Every square inch of the workshop rewards the viewer with something of natural beauty, affirming Nick's wise assessment that, "it's a good place to be."

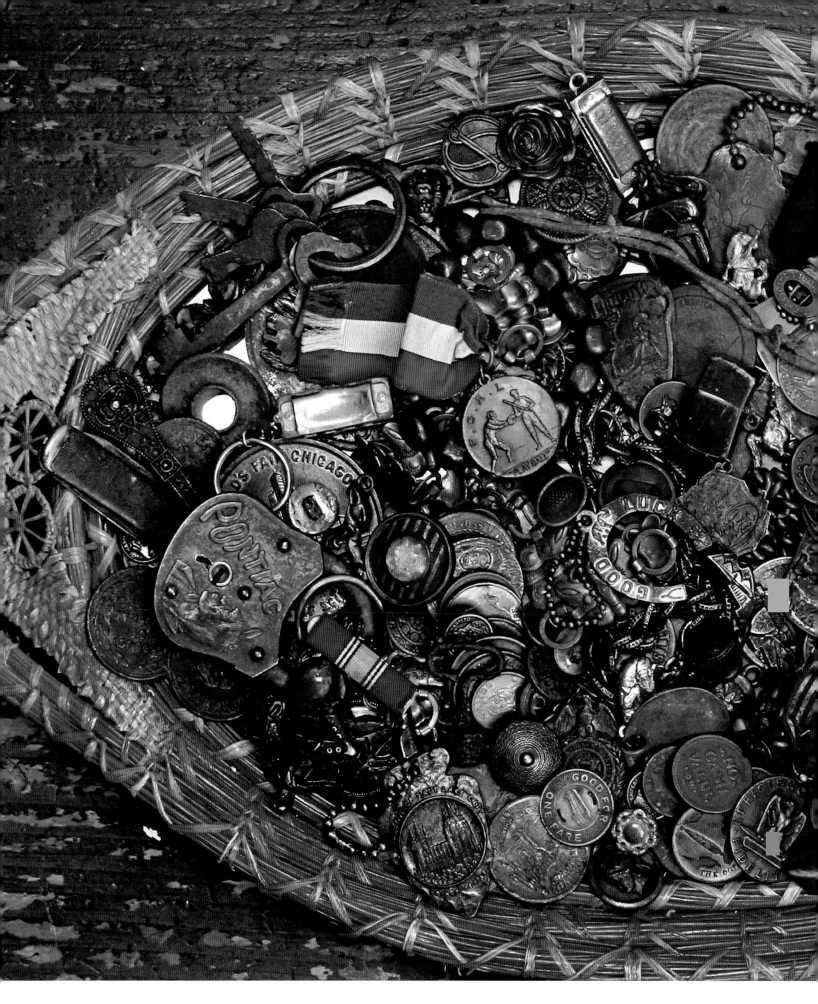

"More is more! This is my life motto and my mantra."

—LAURIE ZUCKERMAN

She's got the loot. Laurie has amassed souvenir key chains, vending machine coins and slugs, arcade charms, ephemeral finds, tourism flotsam and jetsam, and fifties-era cowboys and Indians. All of these retro artifacts will find their way onto her next memory jug, tentatively titled *Tombstone*, a statement on Cold War-era roadside America. She places a riot of kindred small objects on a vintage souvenir tray, and her process of sorting and selecting begins. The abundant collection of tiny items provides endless fascination and memories. ▶▶▶

"To invent, you need a good imagination and a pile of junk."

—THOMAS EDISON

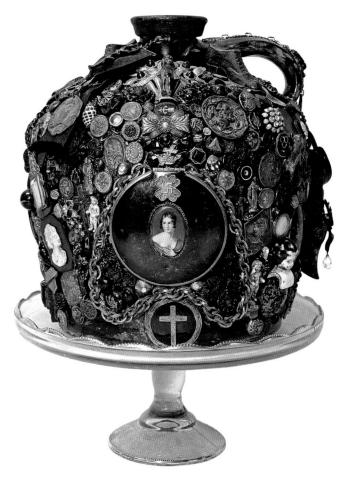

▲ *Behind the 8 Ball*

statement of each jug. Although Laurie insists that each object must be old and authentic, she selectively uses a variety of products (oil paint, shoe polish, furniture stain) to produce a consistent patina over the entire surface of the jug.

Each memory jug relates a different story. *Behind the 8 Ball* (top left) presents a sobering, somber mood, and, although it includes relics from several eras, it references historic traditions of Victorian women and mourning rituals. Vintage faceted jet buttons, cameos, and pins from the turn of the century are balanced with items that recall conflicts and family losses during World War II. *A Shell of Her Former Self* (below) is studded with Egyptian scarab beetles, Chinese jade cicadas, and shells of all kinds; the overall composition is intended to convey feelings of hollowness, disintegration, and decay. *The Party's Over* (opposite) refers to smashing childhood idealism. Digging through a salvage site, Laurie found a small collection of doll-sized tea cups and saucers, reminding her of a set she had as a child. The process of smashing and reassembling the imperfect pieces and applying them to the jug was therapeutic and significant.

Memento Mori

Laurie Zuckerman, a well-known altar maker, spotted her first memory jug at a flea market in Virginia and was fascinated by this enigmatic folk art form. It took several more years for her to finally decide to try making her own versions. She eventually came to think of them as "mini-altars in the round," replete with endless small objects and embellishments that are embedded in cement and tell a collective, encrusted narrative. Best of all, the round shape of the heavy jug ensures that part of the piece always remains hidden from view, a metaphor for the revelatory messages behind all of Laurie's artworks.

She finds her endless caches of small and special things at flea markets, antique stores, thrift shops, bead stores, and online auctions. Every prospective visual element/memory is considered for its potential to add to the overall narrative

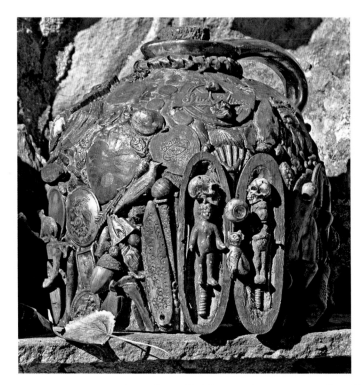

▲ *A Shell of Her Former Self*

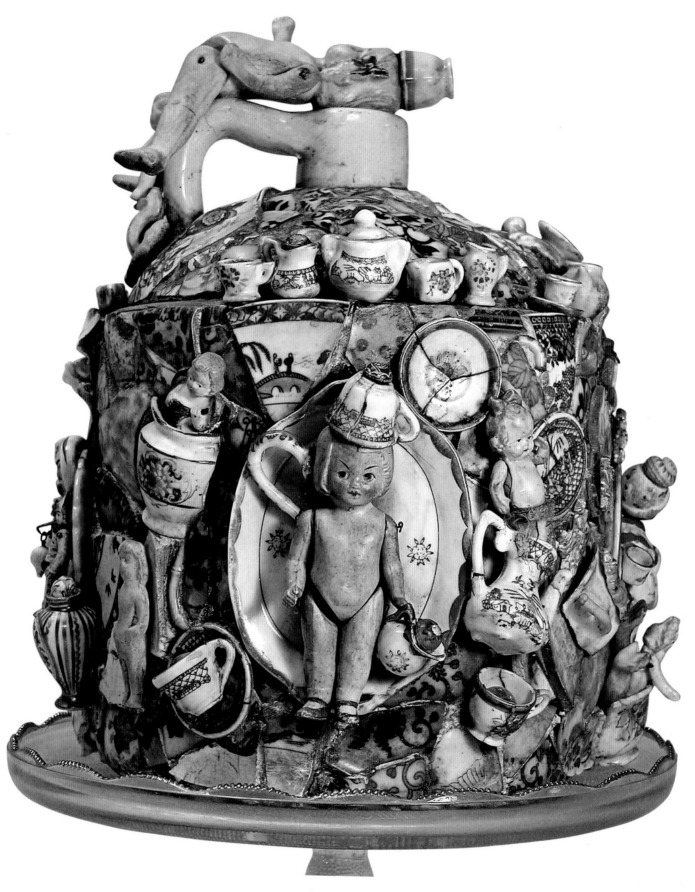

▲ *The Party's Over*

TRACY V. MOORE

"Dials, lenses, apertures, and gears from old discarded cameras. A pair of eyeglasses that had been run over and flattened many times, laying on the sidewalk. Small animal skulls, and creepy, old doll heads." Tracy V. Moore describes some of his favorite finds and inspiring studio loot. Never one to worry about the end use of an item, he collects and gathers with happy abandon.

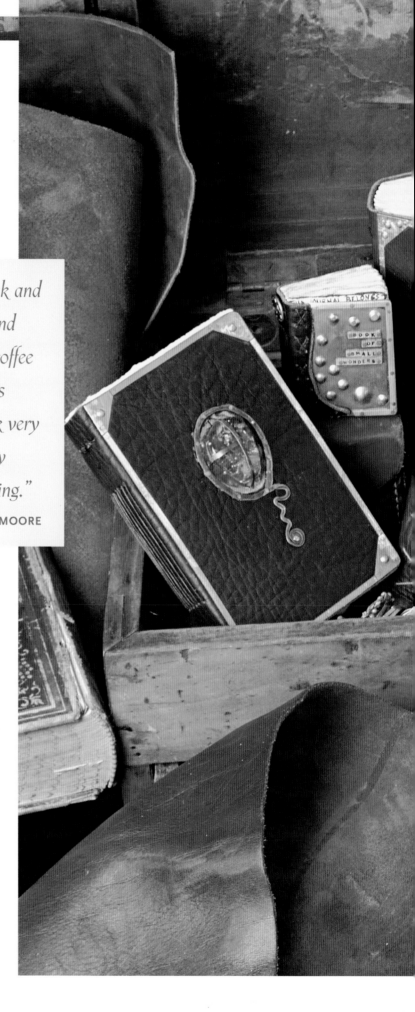

> *"Sometimes, I will take something off my desk and throw it in my journal bag and carry it around with me. Throughout the day, I will stop at coffee houses and begin sketching and forming ideas around it. It is my way of not having to think very hard about how to use objects, just letting my subconscious play while doodling and sketching."*
>
> —TRACY V. MOORE

Object Lesson

By remaining completely surrounded by his collections and his artwork, Tracy V. Moore derives his sensory input from handling items and letting them spark new ideas. "When I'm ready to create something new, I pull out anything that grabs my attention and design around it," he says. With a longtime interest in handmade journals and books, he works with increased abandon, knowing that there will always be a way of including and incorporating even the most outlandish found object into a book cover—in this case, two impressive chunks of copal, found at a rock and gem show, which sat on his desk for a couple of years until the perfect assignment came along. After he was commissioned to make a pair of matching journals for a friend's twins, Tracy wanted to keep working with the theme. He picked up the copal stones on his desk to create the similar, yet different journals shown here.

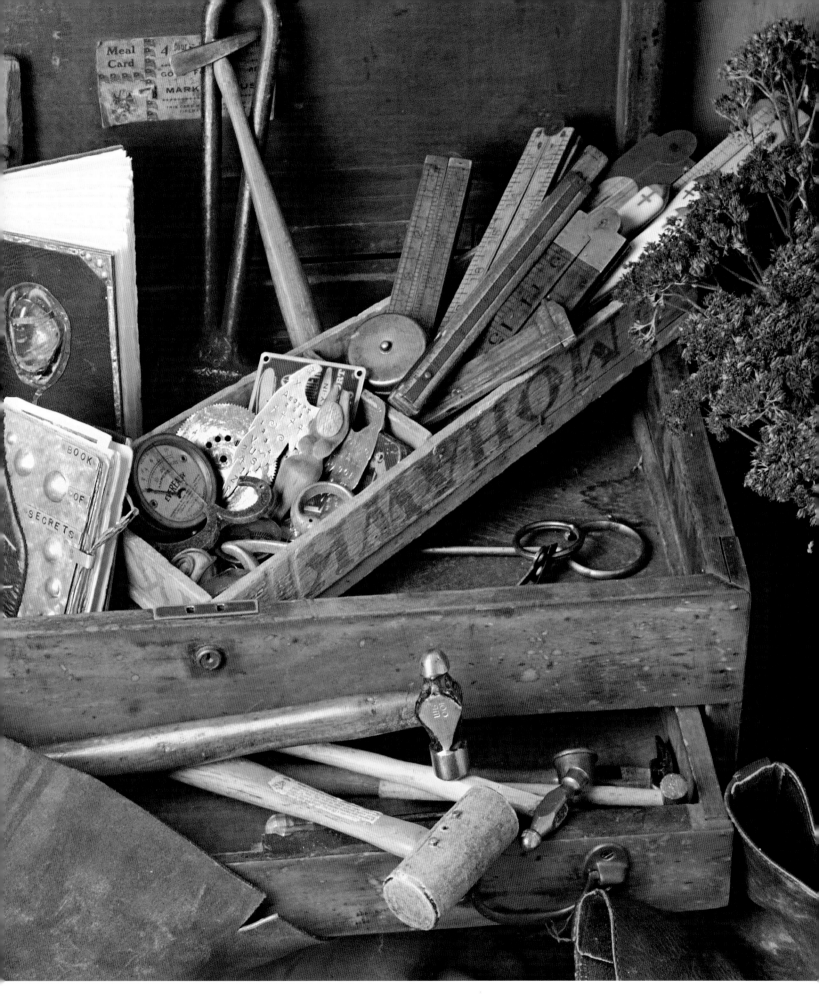

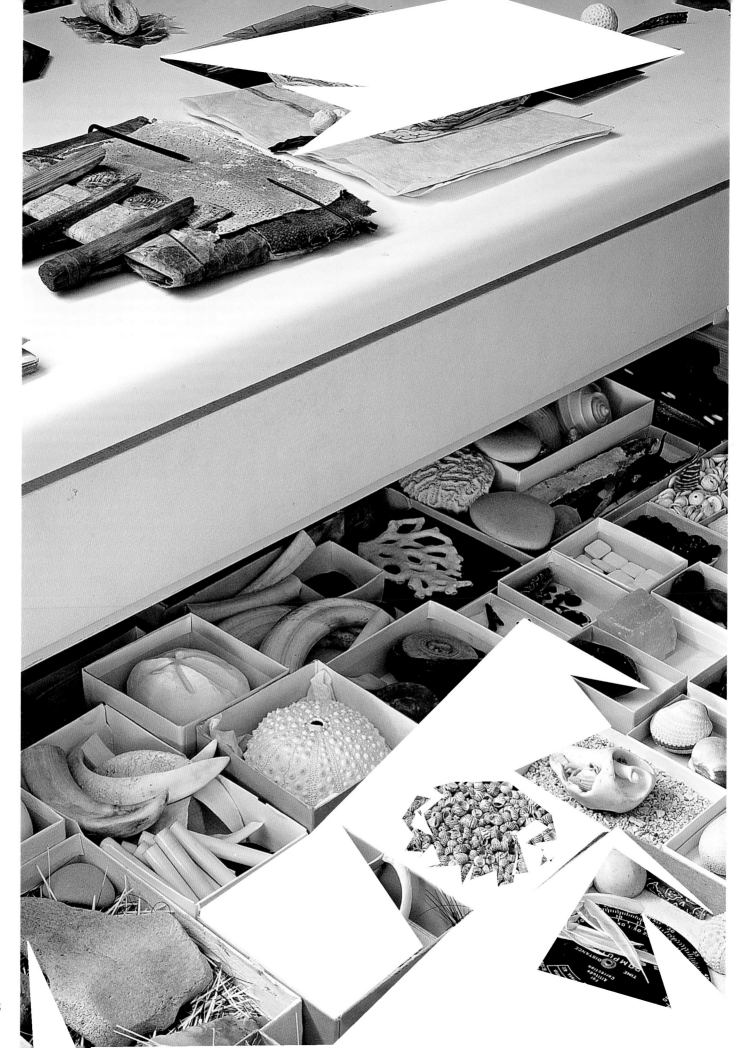

The Acquiring Mind

Gail's collections of black, white, ivory, and gray mostly natural objects await further assignments, while providing a readily available source of strong visual stimulation anytime she slides open a drawer. The arrangements in each narrow, white drawer provide lessons on juxtaposition, composition, and the unlimited joys of a limited color palette. Her emotional connection to the elements she gathers is profound, and her mixed-media piece, *A Net To Hold Water*, is an artful combination of items found at outdoor Asian markets and elements she has had in her studio for years. "I like to collect things that speak eloquently of their history," she says.

◀ *A Net to Hold Water*

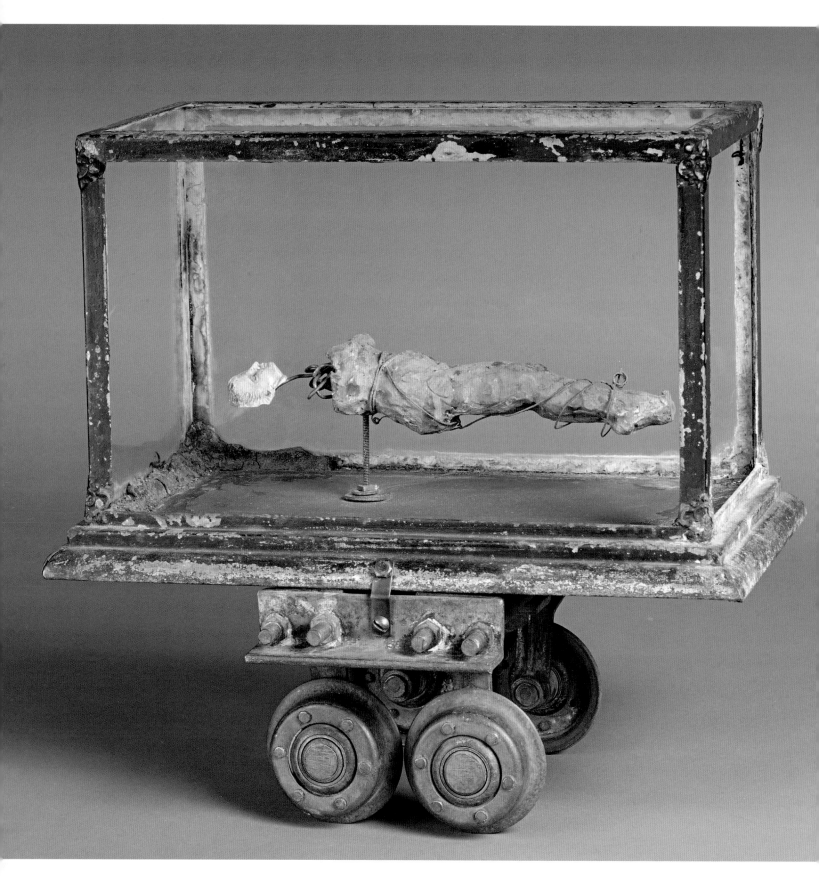

Perfect Balance

James Michael Starr lists as one of his favorite collections classic or Victorian representations of the human figure in mass-produced materials, such as ceramic or cast metal. Most date from before the 1940s and reveal his preference for beautifully aged and patinated figures. However, when he received a clay figure study from a fellow artist, ceramist Susan Giller, it seemed to blend seamlessly with the much older elements in the evolving composition. The unexpected yield of a newly handcrafted object, made by another artist, lead him to question his usual methods and preferences of working and brought new awareness and insights. "I will look closely at the real significance behind the choices I make concerning what I'll include or exclude in my inventory of working materials," James Michael says.

> *"Generally speaking, I derive pleasure as I work from the beauty or appropriateness of a particular object."*
>
> —JAMES MICHAEL STARR

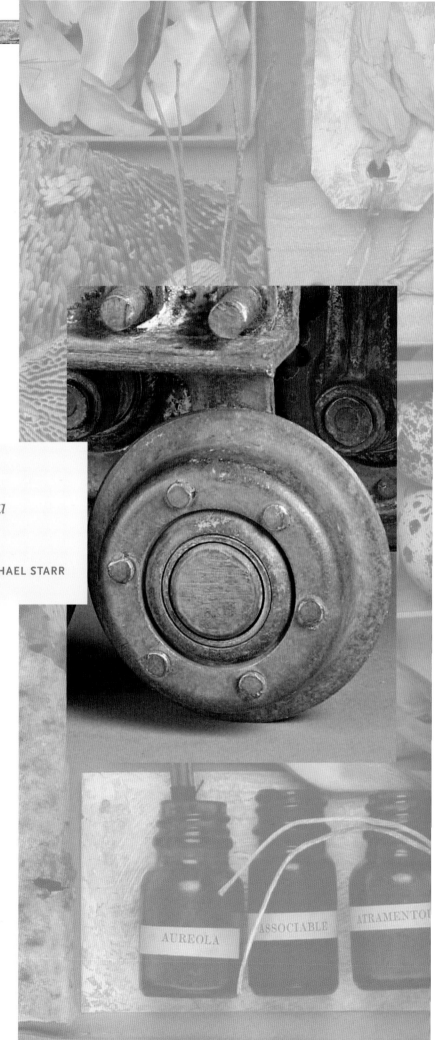

Simplifying and editing his work has become part of his evolving process. He focuses on paring down the number of components and creating maximum visual impact, rather than allowing the sheer quantity of elements to entertain the eye and thus carry a piece. Objects that are too commanding or distracting are set aside, as selectivity and balance become the guiding themes in this artist's work.

"The vast majority of the objects I collect are things that I respond to because I believe I can use them, whether or not I necessarily will," James Michael says. "I have shelves and bins of things that are as yet unused, after years. I avoid starting out with an idea or concept, which I must then fulfill by finding just the right objects. Rather, I select those I think are beautiful, put them on the shelf, and then come back to them later."

Secret Garden

Describing his studio as a cul-de-sac, in which endless paths and impulses converge, Keith Lo Bue thrives on the notion of *terra incognita*, where anything is possible. His joy is in working with entirely diverse objects, such as the wooden and steel shoe trees that play a pivotal role in this regal wearable sculpture.

Taking care that each element becomes part of a coherent entity, he begins conceptualizing, as the piece evolves on his worktable. By working in this organic way, Keith explains, he avoids forcing objects (however magical) to play roles for which they are unsuited. He considers himself a conductor, helping each of the proposed elements lend its voice to a chorus that builds into a finished work.

"One of the joys of working with such diverse materials is that objects can emerge from simply anywhere, often from very unexpected places," says Keith. "The major components of my work were found while traveling."

Apologue ▶

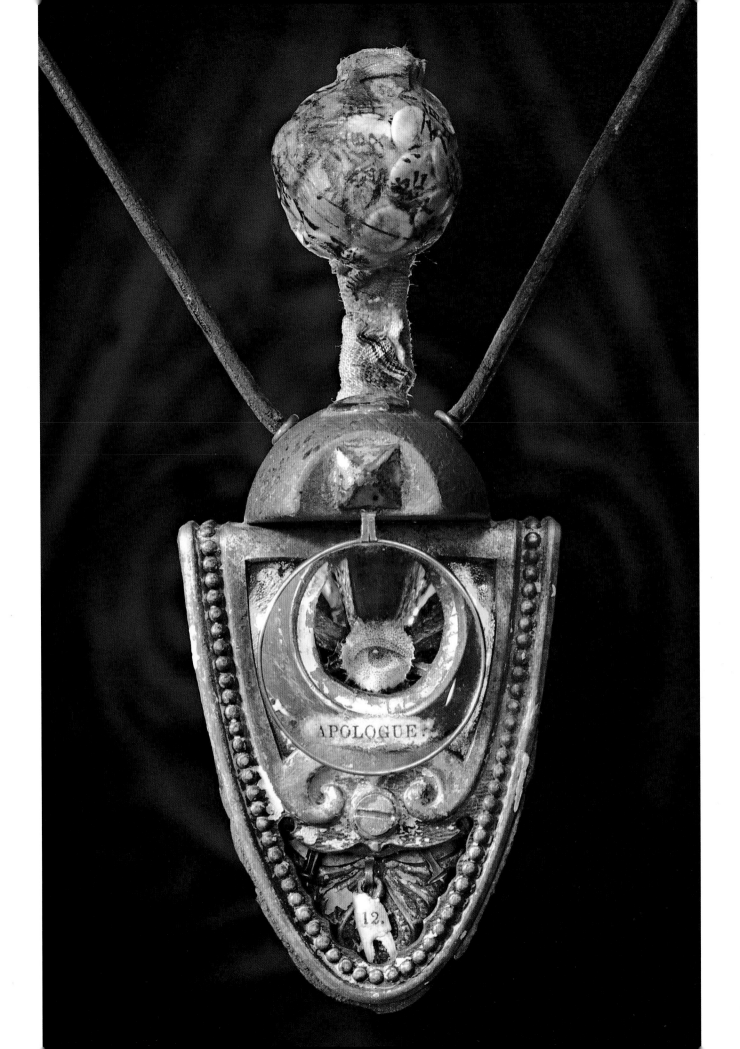

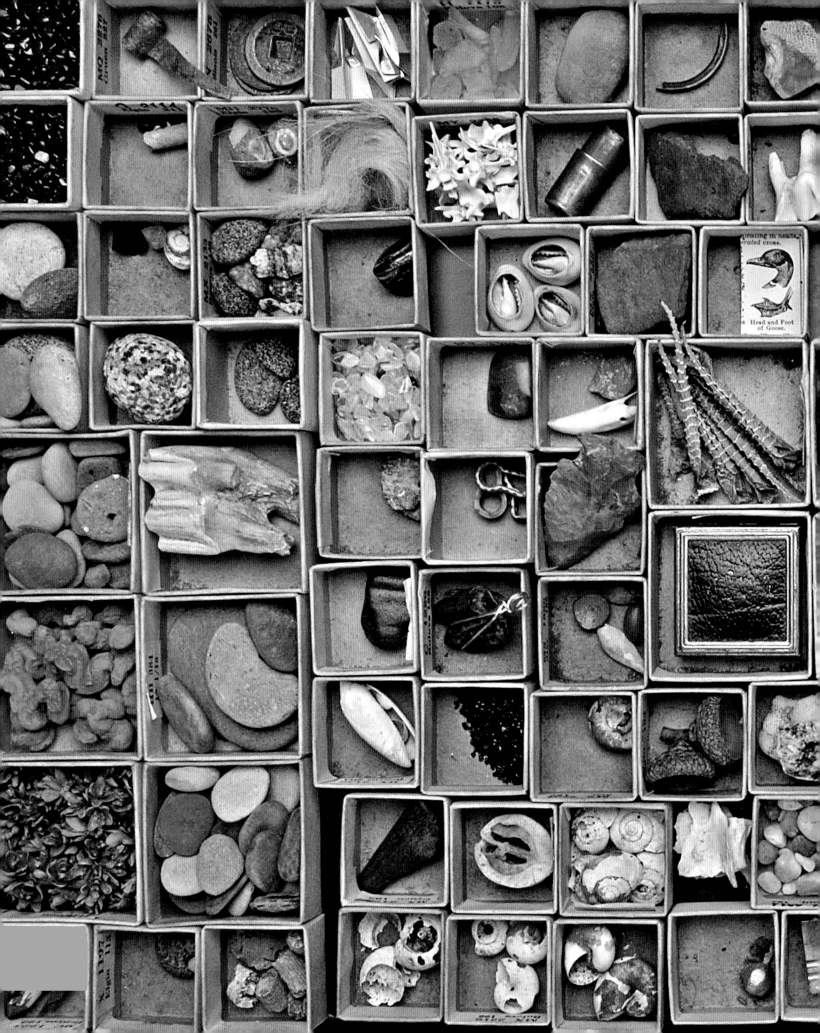

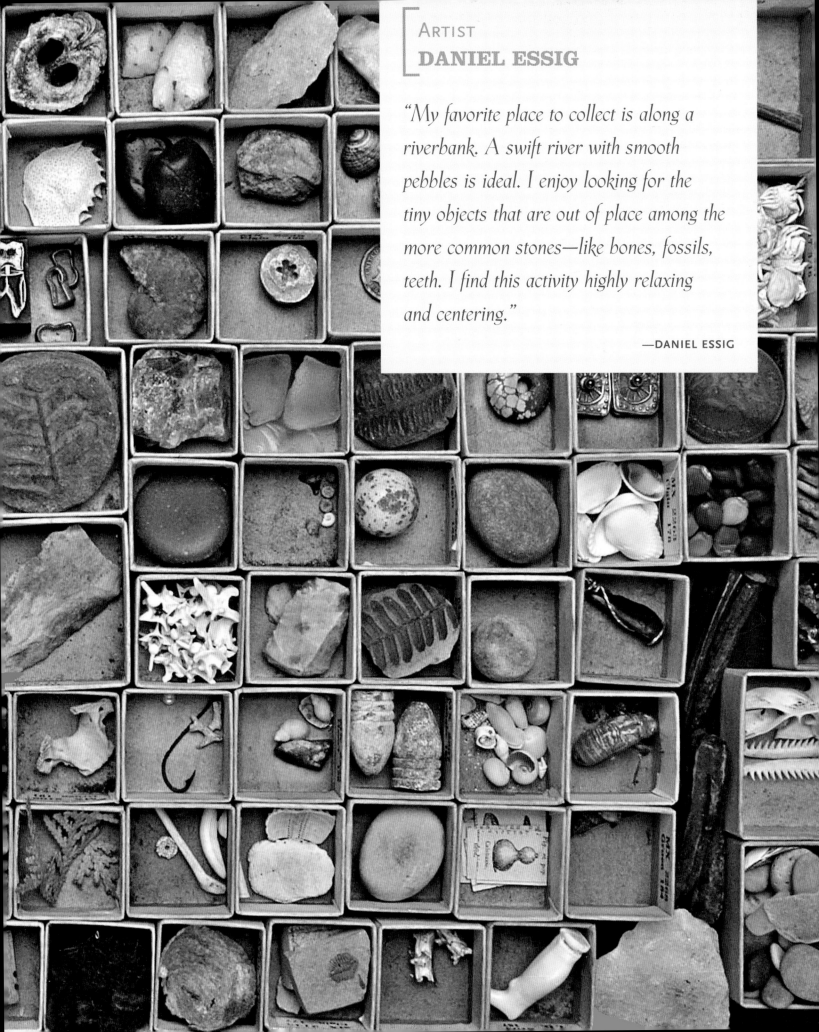

DANIEL ESSIG

Metamorphosis

Collectors often find that friends and colleagues like to help out with the gathering process by bringing contributions to our stashes of loot. At a recent birthday party, Daniel Essig was given a bottle of fossilized shark teeth and a fragment of a manatee bone. "I would rather have a found rock than almost anything that anyone could buy for me," says this well-known maker of exquisite artist books. His collections, stored in forty, narrow, watch crystal-flat files, form their own kind of visual feast for the eyes. More than that, the drawers function as a journal to Daniel, who considers the contents of each segment with regard to the significance, power, and personal connection of each object.

His earliest experiments with photography and box forms eventually led him to investigate book structures, and he con-

design/provenance

Nkondes are African power figures, studded with nails, blades, and rough fabric pouches full of significant amulets and charms.

They are a quintessential example of a timeless ethnic art form still providing inspiration to contemporary mixed-media artists. These figures, created mostly in the Congo region of Africa, are used as powerful protectors of the community, and a mirrored compartment on the chest of each figure is meant to deflect evil. The rituals necessary for creating these figures, as well as the "found" aspect of the abundant embellishments, have a direct connection to many of the works in this book.

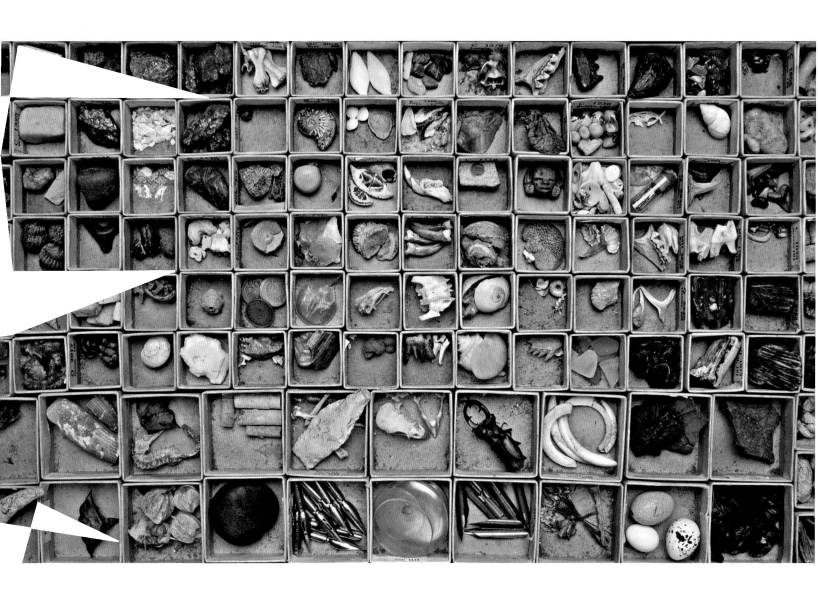

siders the found objects he uses to be the soul of his work. Sometimes an object will ignite the idea for a book structure, and sometimes a work "chooses the object." *N'Kisi Bricolage* (right) is the culmination of his life as an artist and collector. In recent years, Daniel's interest in reliquaries and African *Nkonde* figures have influenced his work and sparked a series entitled *Book of Nails*. This hybrid, a carved figure and artist book form, is the first in a series. The term *bricolage* loosely translates to "collage of ideas," and Daniel's description of the piece reveals a complex and thoughtful process in which many influences, both recent and eternal, come into play. The bird was carved from mahogany, then covered in handmade paper, and painted. Within the chest of the bird are compartments filled with amulets that hold strong significance for the artist: small spiral shells, fossils, bones, stones, and other selections from his drawers. Windows protecting the objects are created from shards of mirror, rather than his customary mica, echoing the traditions of African *Nkondes*. The bird holds an exquisite miniature book, with Ethiopian wooden covers and binding, in its beak, and the small volume can be removed with care for further inspection and insight. Another miniature book hangs around the neck of the bird, which seemingly protects and guards the significant private text within. The richness and mystery of this piece is echoed in Daniel's deceptively simple directive: "Collect what you love."

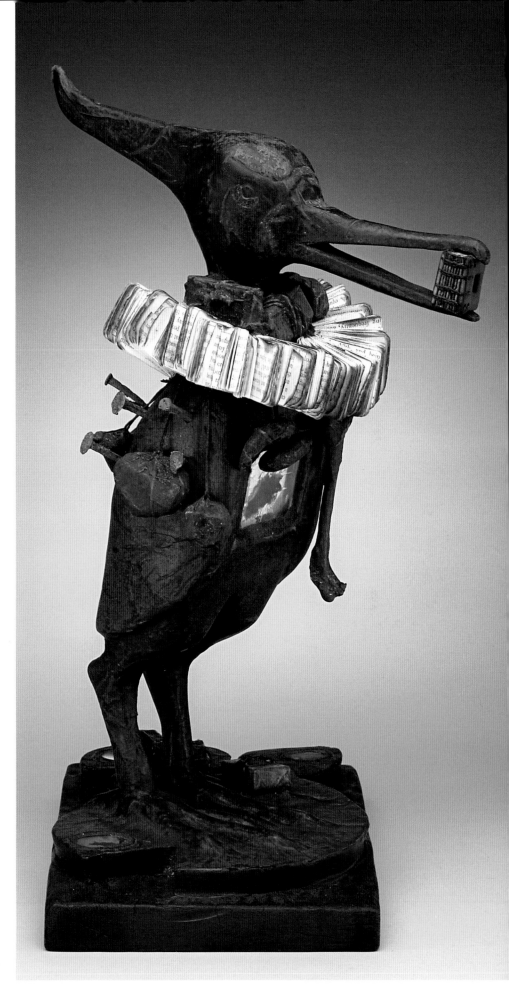

N'kisi Bricolage ▶

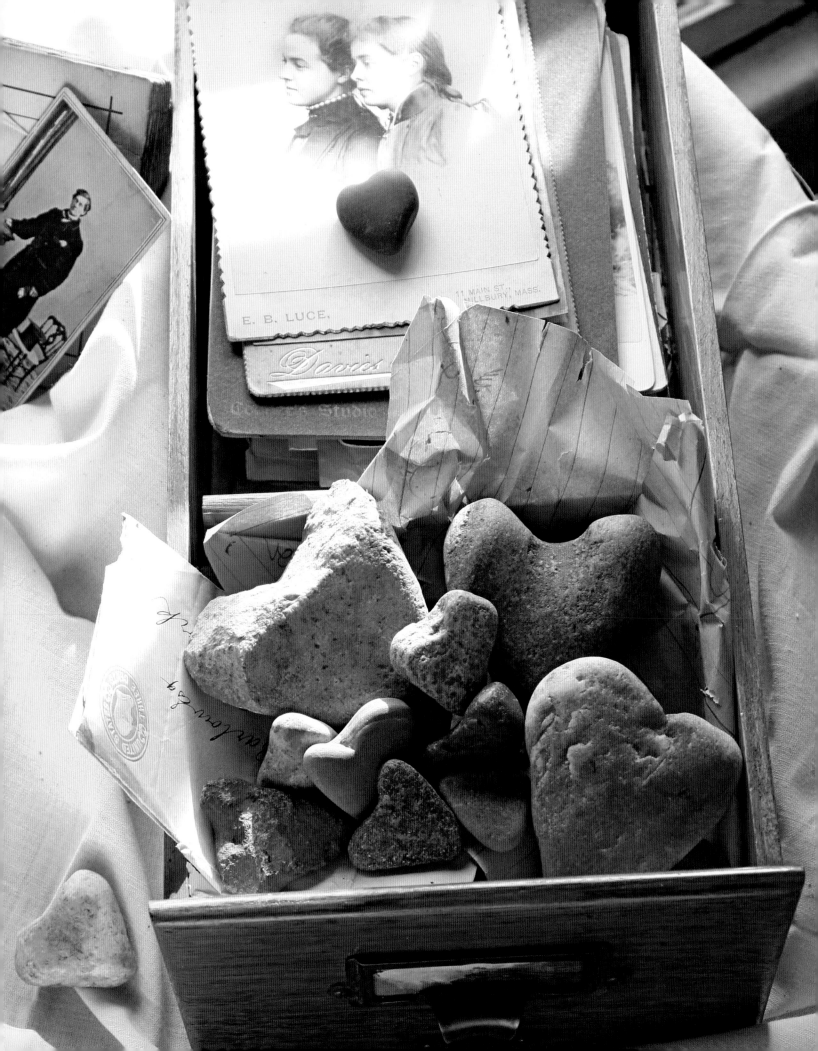

Follow Your Heart

Far more than a mere collection, Nina Bagley's grouping of heart-shaped rocks is her greatest treasure. Presented with pride, many of the most notable stones in this grouping were

> "It is only with the heart that one can see rightly; what is essential is invisible to the eye."
>
> —ANTOINE DE SAINT-EXUPERY

brought home by her young sons, and friends continue to add to the selection. From tiny pebbles found on preschool playgrounds to weighty slabs carted home from far-flung places, Nina maintains a personal inventory of these precious, heavy relics that recalls the special circumstances of each find.

Spontaneity is all for this artist, who prefers to work with what is on her art table. Nina prefers scavenging a riverbank or pebbled beach for finds, letting pure serendipity play an important role in her collecting habits. Her fondness for *taonga*, a Maori word meaning "unknown treasures," is rewarded, as she discovers worn driftwood wands, delicate bird nests, porcelain shards, and beach glass.

These wonders are carried home and become part of the nature-themed tabletop tableaus throughout her home. Stones displayed in wooden bowls, branches propped up in corners, and nests protected under glass domes surround her, as she works on a new line of jewelry or a one-of-a-kind artist book. Sitting with her gathered treasures, Nina will pull an item—a small, framed photo, a silver charm, an ivory piano key, a knob of worn wood—from a nearby stash. She places it with a bit of text, an apt word or two, and the process unfolds. Then, her considerable jeweler's skills come into play, as she

tests her various materials to see if they can be coaxed into becoming part of an evolving design.

Nina's work has a personal vernacular established over many years of searching for her own artistic signature. An artist who reintroduces many familiar elements and touchstones to her work, she is always reinventing and re-enlivening her design process to keep her work distinctive and fresh. One of her "familiars" is vintage barkcloth, so-named for its natural nubby texture. In this artist book (below), a pouch of the fabric for a little note appears on the cover, attached with vintage buttons from a colleague, who was wise enough to rescue her grandmother's button box from oblivion. ▶ ▶ ▶

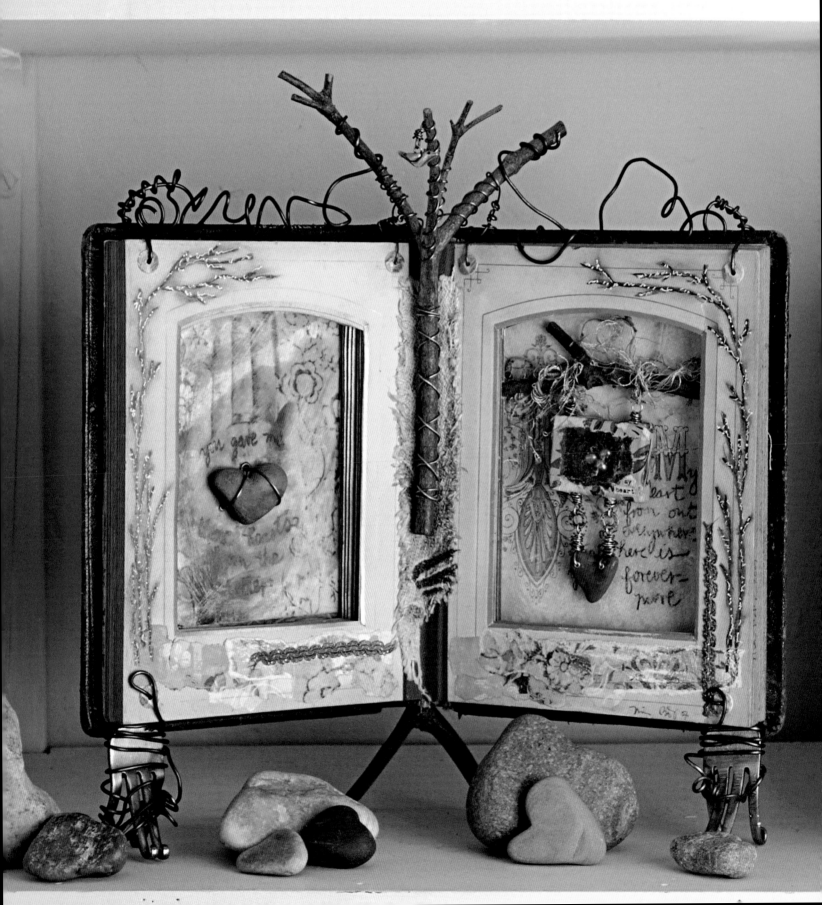

Well Read

The gift of a beautiful antique photo album was the flash-point for this one-of-a-kind sculptural artist book. The thick pages, originally intended to hold cabinet cards, inspired Nina to construct a "shadowbox within a shadowbox." The design of the book incorporates countless natural objects, such as rhododendron twigs, smooth heart-shaped stones, and freshwater pearls, as well as hand-worked metallic elements that echo the theme of curled vines and twigs. The images that appear inside the book consist of a photo of the artist's hands, as well as her handwritten notes and a page from the old photo album. A pair of silver-plated vintage forks, from some long ago dinner service, provide an elevated platform for the book, and a sturdy rhododendron branch completes the tripod.

> *"And what is the use of a book without pictures or conversations?"*
>
> —LEWIS CARROLL, *ALICE IN WONDERLAND*

"My artwork contains a little bit of my soul," says Nina. In fact, each aspect of this artist's book has been carefully conceived and lovingly executed. A small brass picture frame, enhanced with vintage wallpaper and mica, forms one of the shadowboxes, and a tiny nest of tarnished copper wires contains freshwater pearl "eggs." One of Nina's signature handcrafted silver bird charms makes an appearance—the bird is a personally selected icon that she never tires of using in her work.

Nina, a self-described eclectic spirit, affirms that her joy of collecting and zeal for art-making lies in the moment when an unexpected discovery inspires a series of choices and decisions in the studio. "When I look at these stones, nests, and worn driftwood branches," she says, "I am reminded of other places, and other times. I can touch these pieces of the earth and be taken back to those places where my feet once walked. In using these objects, I am rewarded a thousand times over."

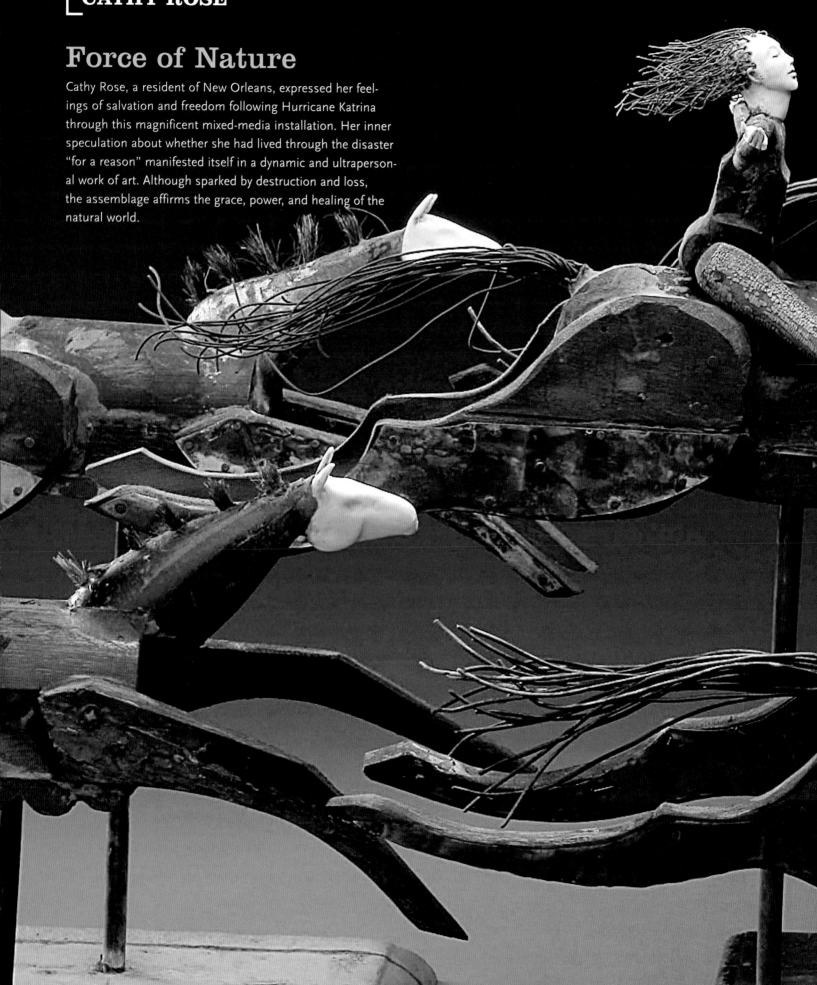

Force of Nature

Cathy Rose, a resident of New Orleans, expressed her feelings of salvation and freedom following Hurricane Katrina through this magnificent mixed-media installation. Her inner speculation about whether she had lived through the disaster "for a reason" manifested itself in a dynamic and ultrapersonal work of art. Although sparked by destruction and loss, the assemblage affirms the grace, power, and healing of the natural world.

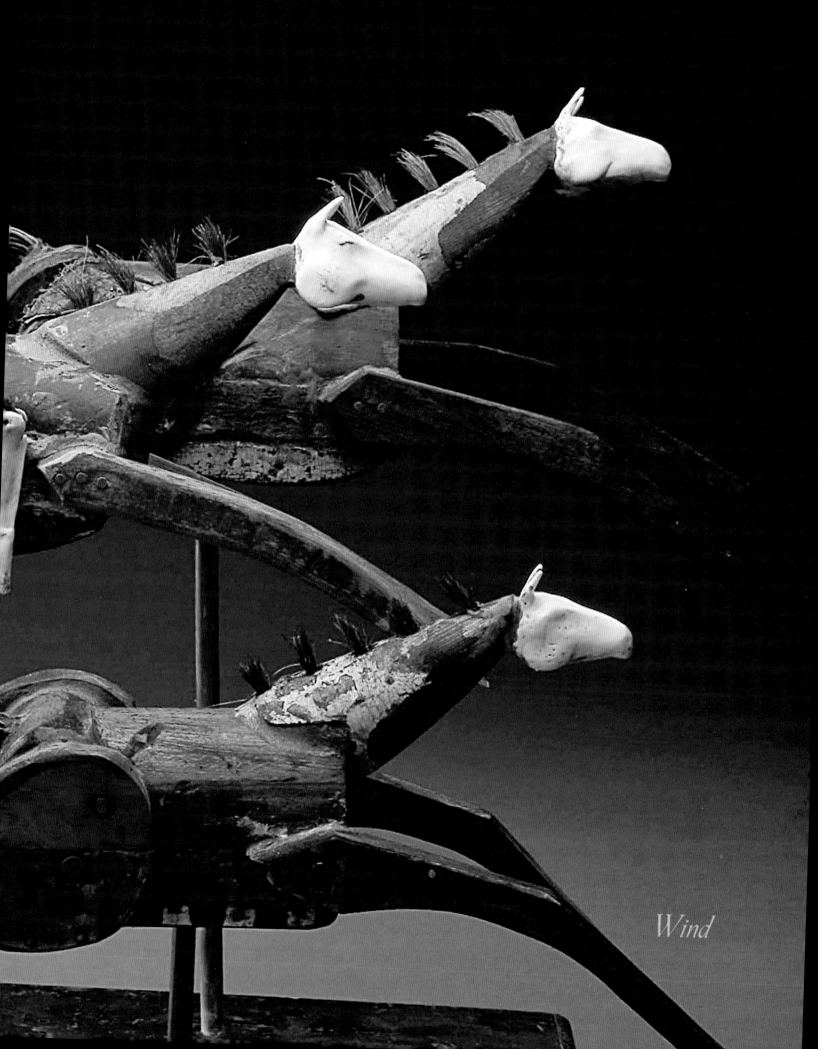

Wind

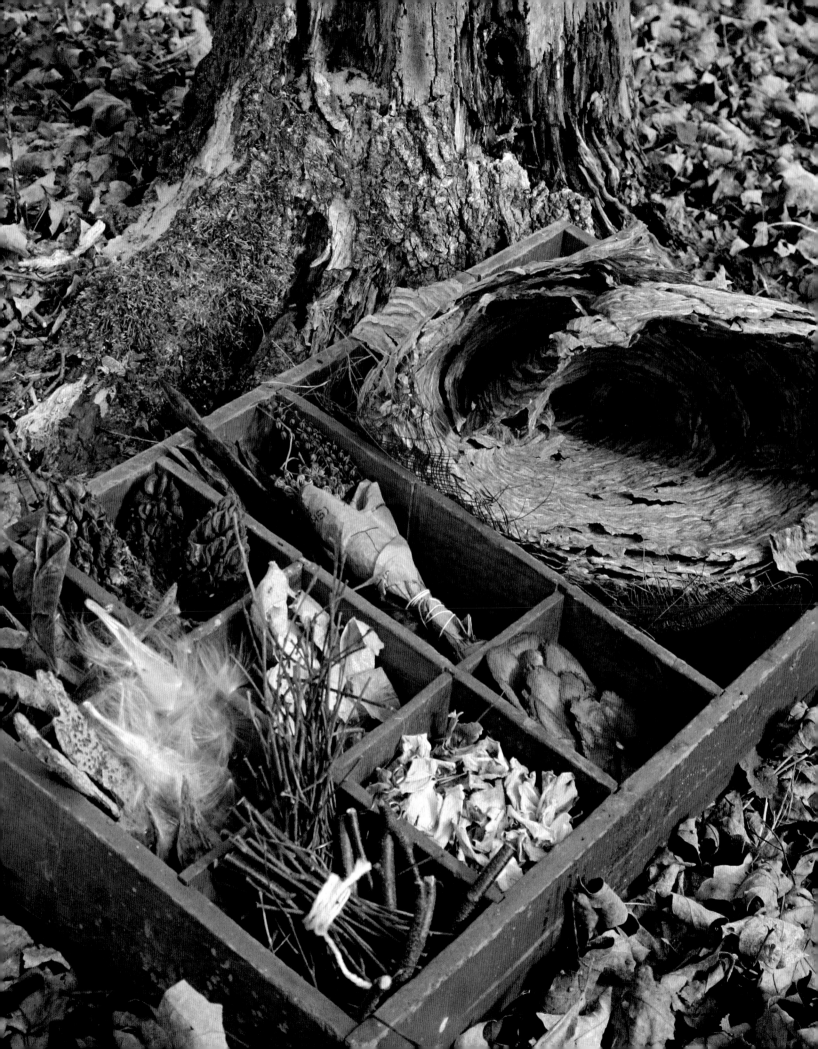

ELLEN KOCHANSKY

Exterior Alchemy

Poke around in Ellen Kochansky's studio, and you will get a strong sense of a textile artist and quilter who regards nature and considers it to be a matchless teacher. "The dynamic storage in my studio keeps generating new art forms," she says, "requiring me to address and filter the various collections." A nearby stack of storage boxes are marked with labels, such as "4-inch twigs." Most of all, she keeps a watchful eye on the scraps that end up on the floor of the studio, convinced that these "surprising nutrients" yield endless artistic (and personal) breakthroughs.

"The eye does not miss a thing," says Ellen, who combined plant materials and travel photographs transferred onto organza, to create this mixed-media hanging. Stitching provided another form of mark making, a meaningful reference to pencil drawings and notations, as well as a reminder of her father's career as an art director. Creating a balance between repetitive tree branches and other natural motifs and personal iconography, Ellen was reminded of

the importance of pagination and signatures in book forms, as well as in quilts, both lifelong fascinations. Like treasures from a naturalist's expedition, a handsome divided wooden box, heavy as a tree trunk, is filled with a grouping of natural finds from Ellen's studio. A splendid paper wasp nest, small bouquets of dried plants, and a grouping of deceased cicadas await further assignment. Ellen cheerfully speculates that her mixed-media artwork allows her lunacy for collecting "to take a socially acceptable form." We understand completely.

Tree Language

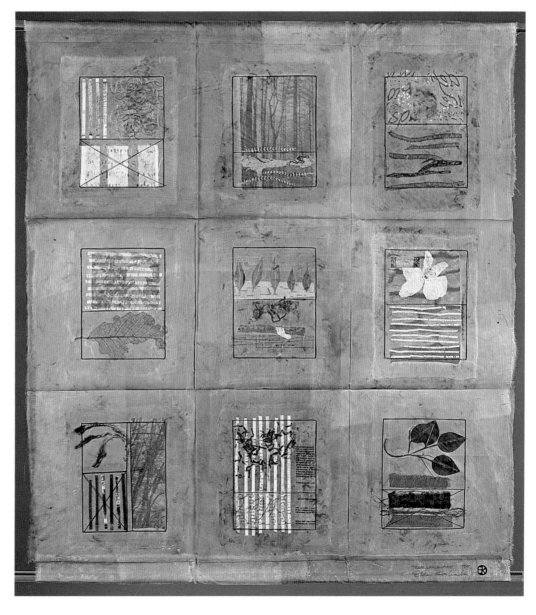

Twice-told Tales

In a perfect meeting of mind and heart, KC Willis works with images of long-ago women of the West and gives them a second life with a trunk full of weathered and worn fabrics, frayed ribbons, strands of leather and suede, and discarded-then-rescued bits of adornments and jewels, all stitched and glued into place.

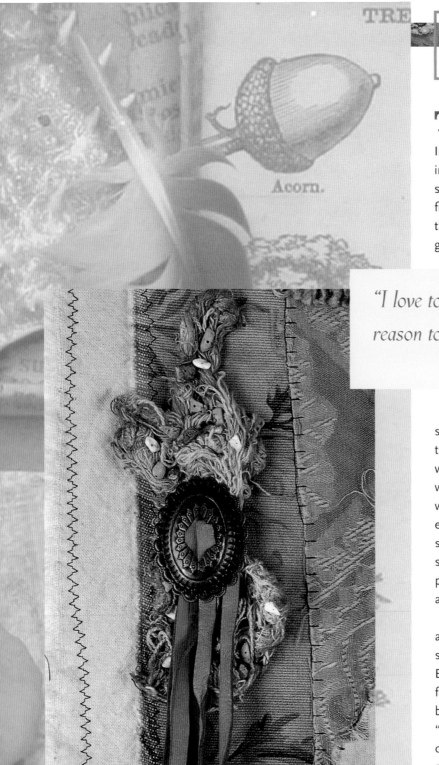

> *"I love to collect, and this work gives me a perfect reason to do it."*
>
> —KC WILLIS

Her purpose is to explore and honor the traditions of strong women, by surrounding their portraits with colors, textures, and surfaces that illuminate and narrate their stories, whether real or invented. Unlike many mixed-media artists, who are cautious about found objects overpowering their work and distracting from the message, KC envisions her embellishments as a way of "dressing up the women and sending them back out into the world." In this case, the strength and dignity of this Native American portrait is complemented and heightened by elements selected for their authentic and earthy appearance.

Sunday drives in the nearby mountains will usually yield a barn sale or two, and artist friends often contribute to her stash with boxes of rusty finds and thrift shop discoveries. Even KC's dog contributes by occasionally claiming a piece of fabric from the studio and lovingly chewing it until it has become a frayed relic, ready to be washed and put to use. "Perfect," declares KC, an artist who likes to work with the concept of opposites: old and new, edgy and familiar, rust and rhinestones.

> *"It must satisfy me visually and emotionally, and when I work in my studio, touching fabrics and gluing down pieces of the past, I am happy."*
>
> —KC WILLIS

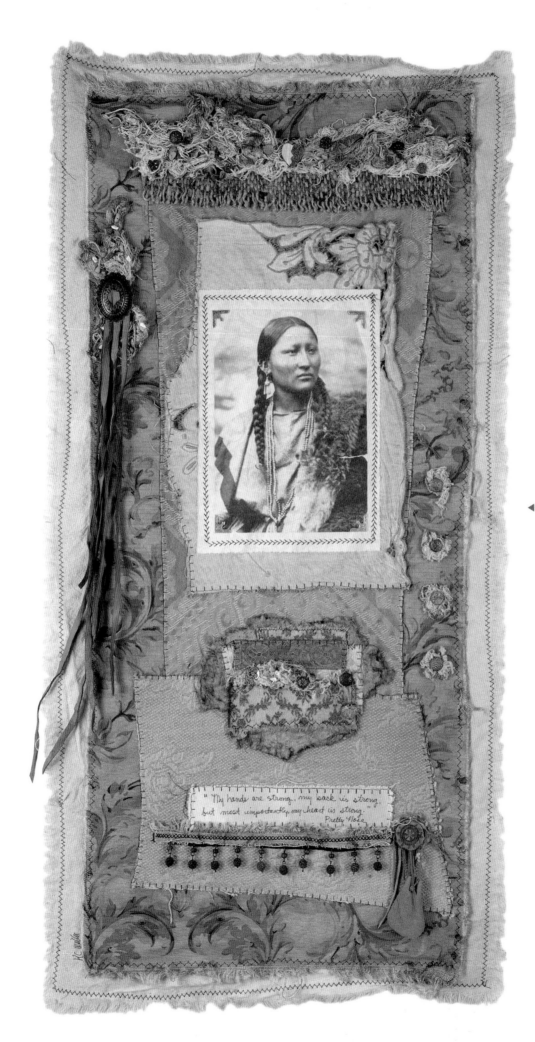

Pretty Nose

"My hands are strong, my back is strong, but most importantly, my heart is strong."
Pretty Nose

HUMBLE PIE

Dimestore cheapo, glorious funk and junk, ephemeral treasures, tattered and true

If you are equally at home in a rural dime store or in a big-city outdoor flea market, this chapter will stir your homespun heart. "Easily amused" might describe those of us who revel in a bale of old chicken wire or a handful of vintage rickrack, but we know the goods when we see 'em. This chapter stands, with flags flying, for all of those simple treasures and more. From carefully saved envelopes of common string to rugged, paint-crusted, canvas work gloves, learn how the innocent joys of simple materials can lead us home to the best ideas.

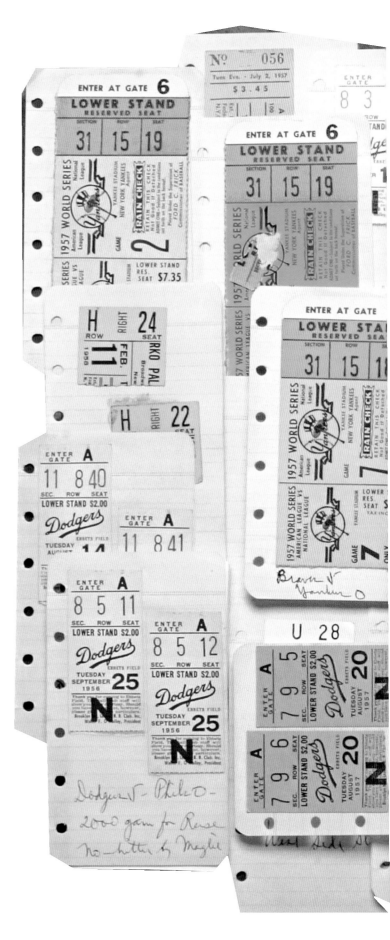

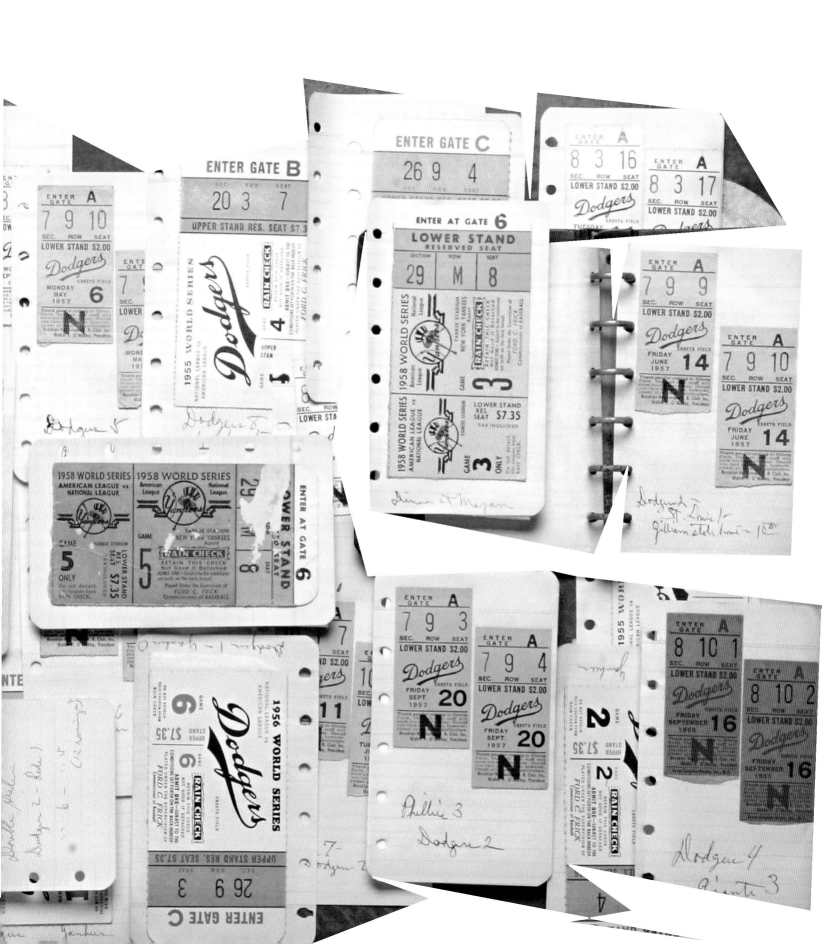

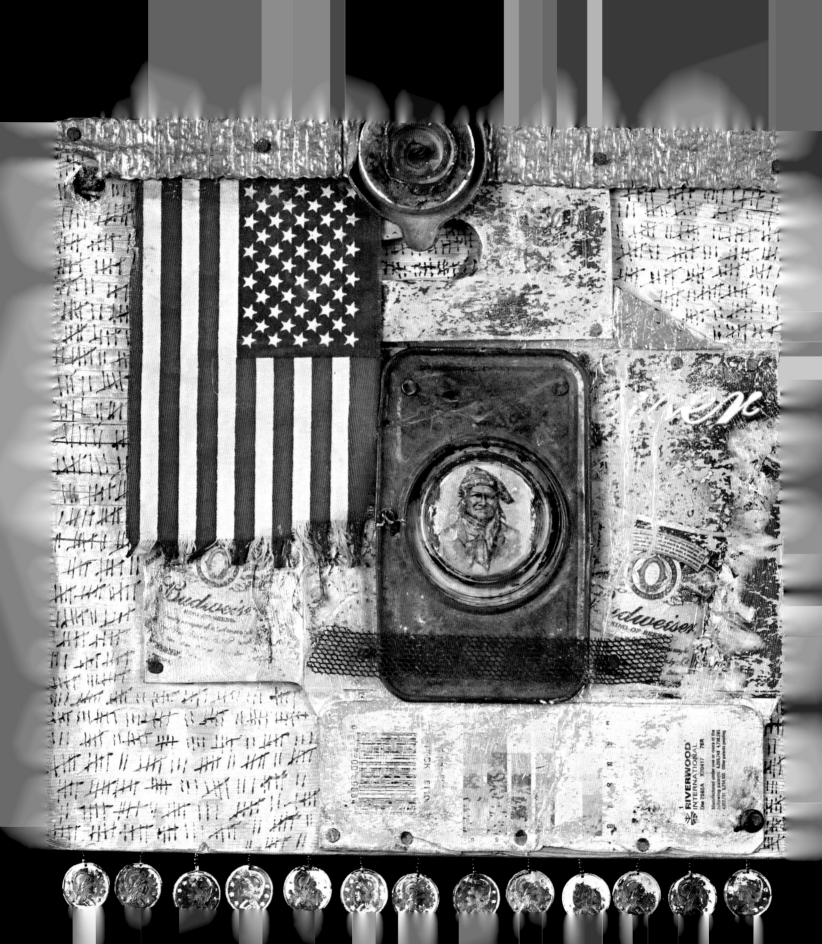

NANCY ANDERSON

What You See is What You Get

During a morning walk, Nancy Anderson noticed debris and litter scattered across a scenic path in New Mexico. Her walk turned into a collecting opportunity, and the gathered items became the genesis for this assemblage. Working with pieces of wood, a six-pack carton, a souvenir flag, and an old gas cap, she challenged herself to make something artful and meaningful from the discarded litter. Combining the cast-off items and elements from her studio, the artwork provides commentary on a throwaway society, as well as on the offbeat beauty of forgotten things.

"My artwork and my collecting are directly intertwined," Nancy says. "One cannot exist without the other. What I seek in my work is a sense of nostalgia, whimsy, irony, and, most of all, a sense of soul." She believes that each found object already possesses its own power and history and that it is the job of the artist to provide a means of expression. "Like a crow, I swoop down on the shiny stuff from above," she admits happily, "but in my case, the less shiny, the better."

Nancy's manifesto? "Be aware of the miracle of life in everyday objects, the places you find them, and the people you meet along the way. Through collecting, combining, and connecting, as well as loving what you do, the ordinary will become extraordinary."

design/provenance

Orphaned objects find a good home at Nancy's. Like many artists featured in this book, she receives donations, left at the studio door. One of the most unusual was a clarinet left in a box of metal bits and pieces. The discarded musical instrument became a candleholder, part of a heartfelt shrine installation. Often asked to reveal her favorite sources for found objects, Nancy's reply captures the essence of collecting: "It is all around us," she says.

◄ *Countless American Deeds*

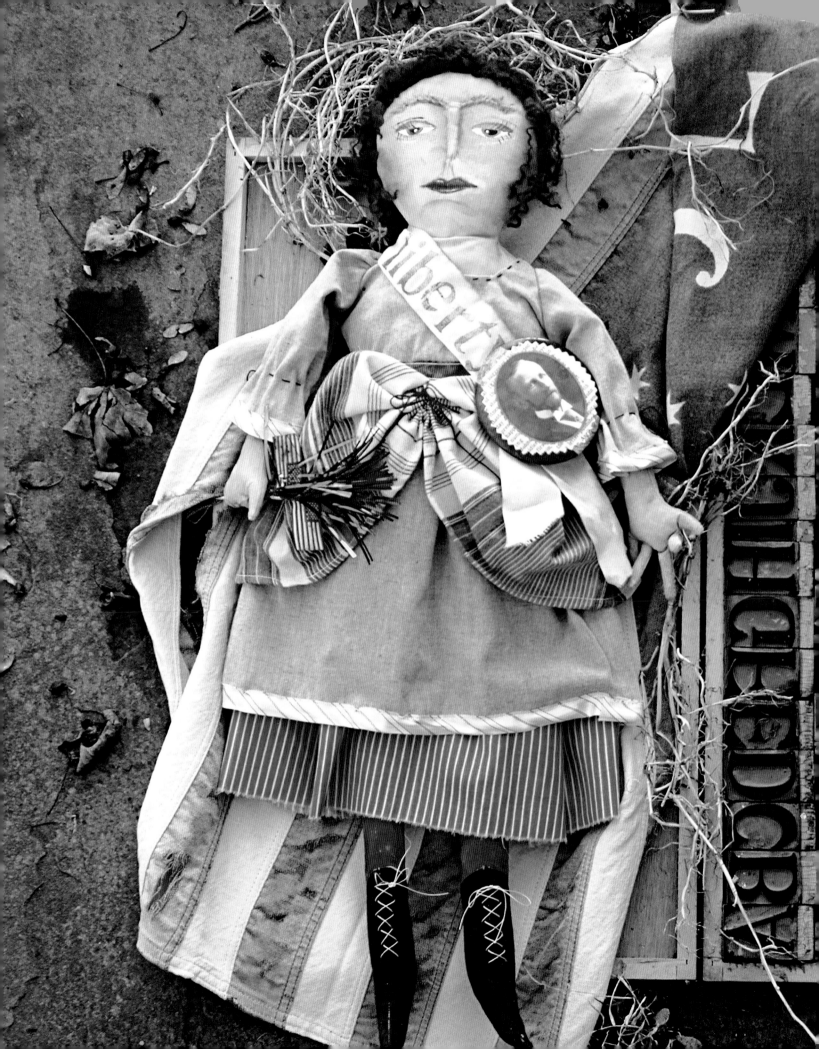

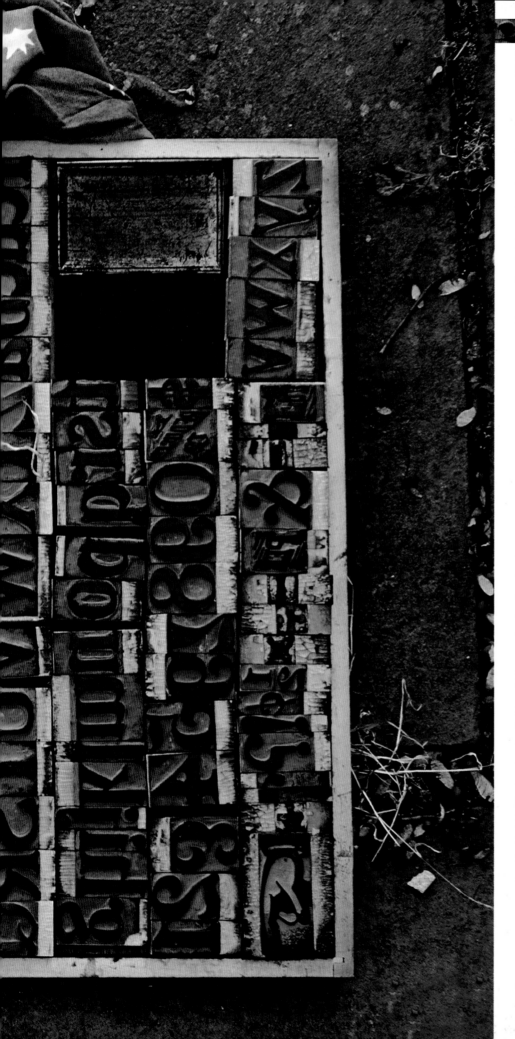

Lady Liberty

As someone who has always sewn and made art, Olivia Thomas is exultant that these two loves have become her "day job." A well-known doll maker, she has a theme or backstory in mind for each of her creations, and her extensive collections of ephemera and found objects play a significant role in her process.

A collector since early childhood, Olivia admits that some of her favorite finds have languished in her stashes for decades, waiting for just the right use. Others are on hand merely to provide inspiration and spur new ideas—a grouping of vintage men-in-uniform photos, for instance, that includes some family members who served in the military. A batch of letters, written to soldiers during the Civil War, are also among a gathering of historic items. When Olivia scored a large campaign button at a yard sale, she became interested in the idea of making a "lovely patriotic gal." Flags, bunting, and Americana have inspired artists throughout history, and the resultant creations have covered the gamut from celebratory to ceremonial to sentimental, and every stop in between.

Olivia's mostly cloth dolls begin with a pattern. She then creates a prototype, which will be fine-tuned and adjusted. The completed doll is painted and antiqued and is then ready for an appropriate outfit. In this piece, a soft, gray cotton dress provides a neutral backdrop for the patriotic-themed additions, including a banner, imprinted with stamped lettering. *Miss Trudie Plum* poses near a collection of vintage rubber stamps, marketed to long-ago dry goods stores to create signage and price tags. Pure Americana.

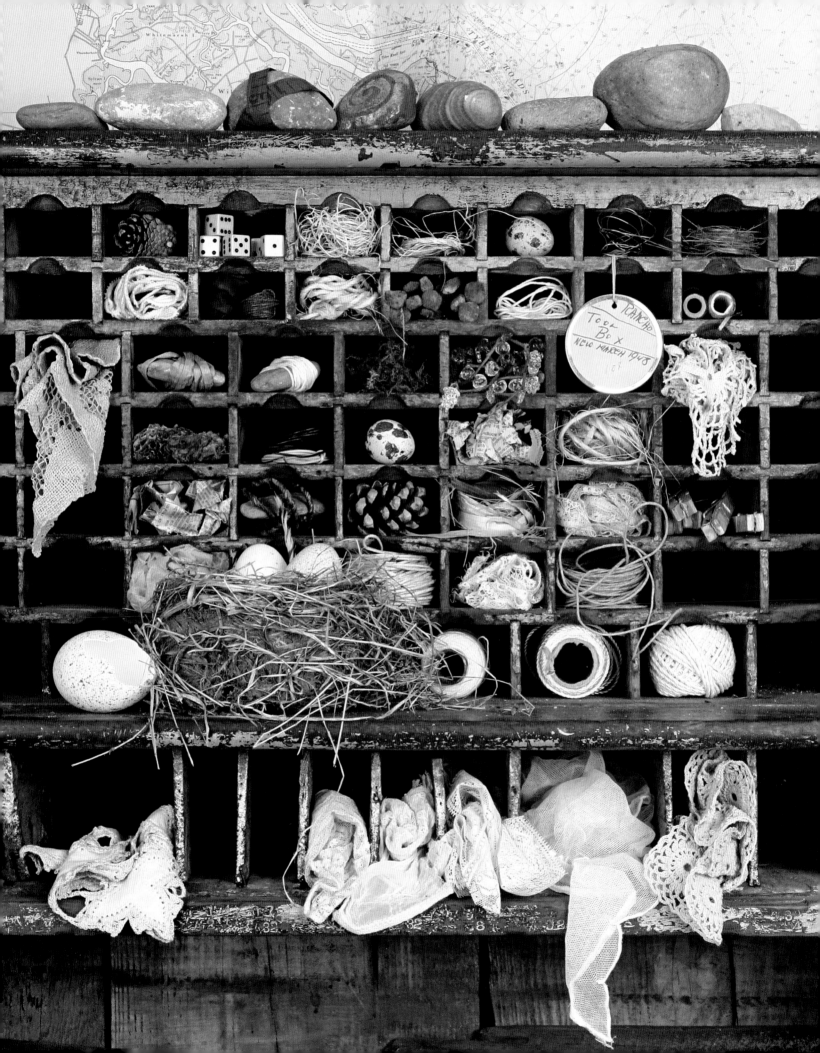

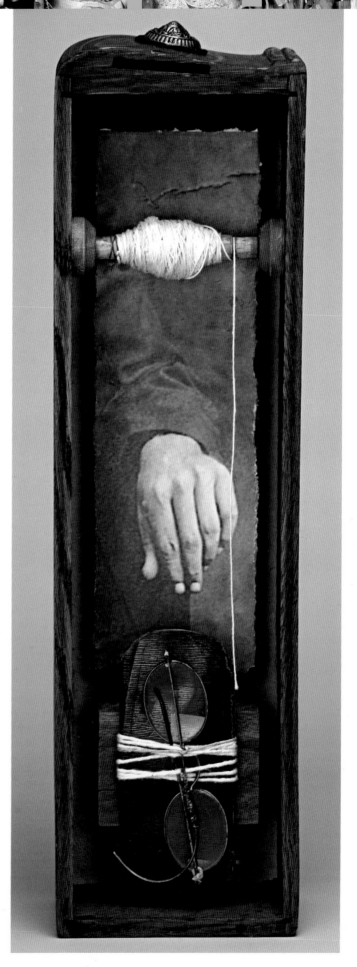

Capture the Moment

Marianne Lettieri confesses that she has often finished up a great day of sleuthing at a flea market by laying out her treasures on the floor and taking a photo, "like a new parent!" Although it prompts some self-effacing humor, the urge to document new finds, as well as begin the process of visualizing their potential use, is a commonly expressed theme.

Marianne prefers reusing forgotten castoffs and ordinary detritus in her artwork as a way of redeeming these humble objects and commenting on modern-day consumerism. She begins with a general idea and makes some preliminary selections of objects and materials, eventually adding, subtracting, and juxtaposing until something "clicks." Often, the completed work has little to do with her initial impulse, because the objects pull her in a fresh direction.

"We are left with objects that have a hollowness that we can fill with our own wonder and fantasy."

—THOMAS MOORE

Marianne created this assemblage in memory of her grandmother, a woman of modest means, who was widowed during the Great Depression and worked hard to raise a family alone. After her death, her family discovered an envelope stuffed with string and labeled "pieces of string too small to use." Marianne was captivated with the idea that someone bothered to save (and label) useless string. Was it a sign of old age or perhaps, more likely, just a *different* age? Using a significant family photo of a hand, and a pair of eyeglasses industriously mended with string, she created this heartfelt shadowbox, one in a series of five assemblages intended to explore the mystery and pathos of the envelope of string.

Seemingly insignificant remnants—snippets of lace and trimmings, old canvas measuring tapes, hardware store string, bits of rusted wire too "good" to throw away—are wound around smooth stones carried home from here, there, and everywhere. Everything is displayed in the multiple cubby holes of an old concierge's desk from a *pensione*.

Diamond in the Rough

Thrift stores and yard sales are KC Willis's preferred haunts for finding broken strands of pearls, rhinestone pins, old fabrics, and frayed quilts. She gravitates toward "familiar old things," and a reappropriated mantle clock became the perfect housing for this shrine dedicated to the spirit and spunk of Annie Oakley.

This collection of KC's fascinating old fabrics came out of the drawer and became part of a still life tableau atop an old cabinet radio. Old books, wrapped in fragments of weathered fabrics, are tied with hardware store string and left in a stack, ready to be admired for their funky faded beauty.

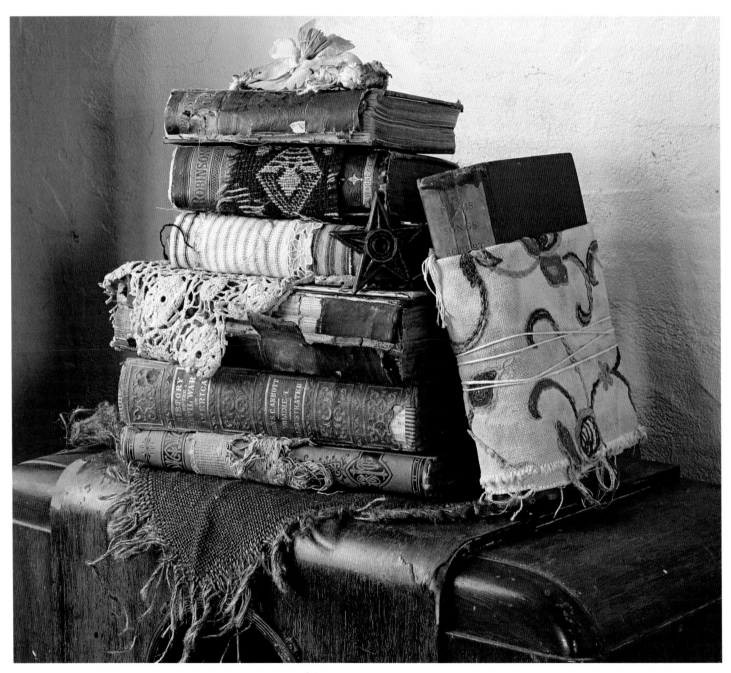

Annie's Altar Ego ▶

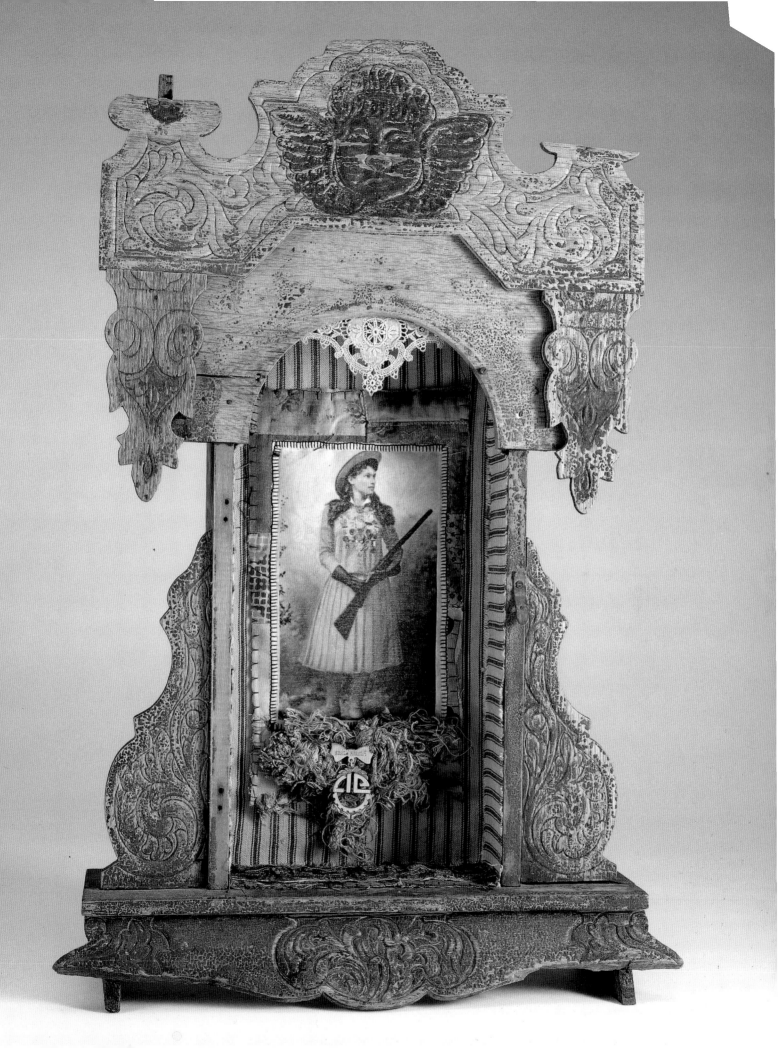

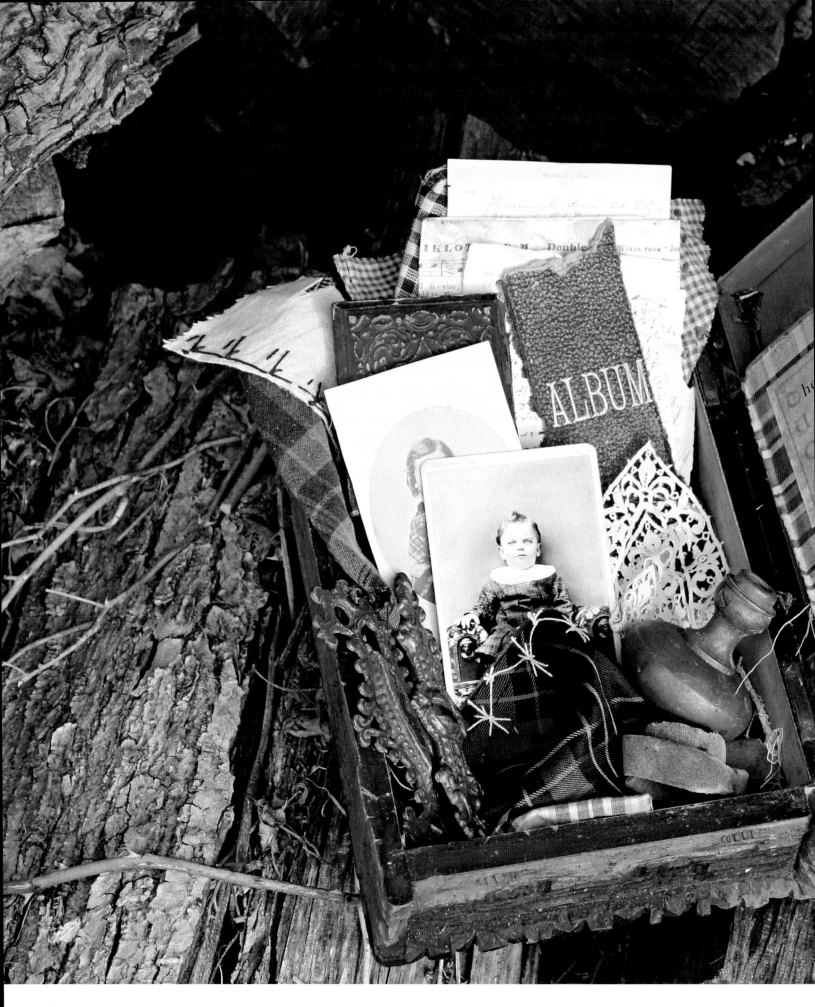

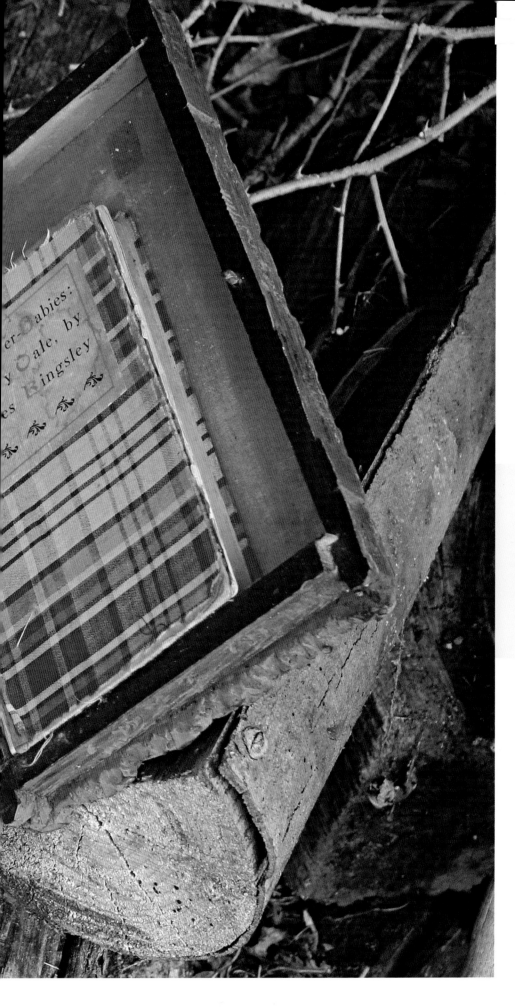

Sorting and Gathering

The selection process begins as the artist builds a nest of possible materials, items that support the mood of the assemblage, whether or not they wind up in the completed artwork. At this early stage of the gathering process, all possibilities are considered: a worn, egg-shaped, brass doorknob, a fragment of a leather book spine that seems to echo the daguerreotype cases, bits of a pieced taffeta crazy quilt. The hunt also leads to a row of old children's books in the studio, and a worn plaid book cover is selected to become part of the accumulated still life that is tucked into a carved rustic box.

"My mother always looked
For dinner tickets
In the breast pocket
Of my grey school shirt."

—PAUL McCARTNEY

With enough gathered flotsam and jetsam for at least three assemblages, Joanna followed her theme of girls in plaid dresses and used square stretched canvases for each dimensional collage. More collected items, including rusted metallic touches, door knobs, metal filigree, and lace, appear in the completed work, shown on the following four pages. ▸ ▸ ▸

JOANNA PIEROTTI

Strength and Fragility

Rough and rusted links of heavy chain coexist with aging, feathery lace, while hand-twisted, expressive wire contrasts with machine-formed, vintage drawer pulls. A remnant of a high-button shoe marks the place, as a collected community of girls in plaid dresses endures. The artist was given a trunk full of vintage lace collected by her grandmother during child-hood, and the urge to "keep going" persists.

Joanna takes satisfaction in engaging with almost-discarded artifacts, the forgotten things from another's lost life. Using old photos of anonymous people gives her a joyful feeling that she is carrying on and interpreting their personal histories. She prefers to work in a solitary environment, enjoying the quiet of the day in her studio. Although she rarely begins her work with a subject or story in mind, she is always rewarded and gratified when a narrative emerges as a result of the selected objects and juxtapositions. ▶▶▶

"I love collecting scroll–like intricate pieces. They remind me of the finer things in life, the things that make life feel full, and of value."

—JOANNA PIEROTTI

design/provenance

Realizing that it is an artist/collector's prerogative to change the size and scale of anything to suit the occasion, Joanna scanned and enlarged a collection of small leather daguerreotype cases to create the generously sized backgrounds of each assemblage. She also proved that collections of objects may be used as intended or as fool-the-eye pretenders, with equal verve. Oftentimes, a manipulated object from a collection will provide a perfect stand-in for the real thing.

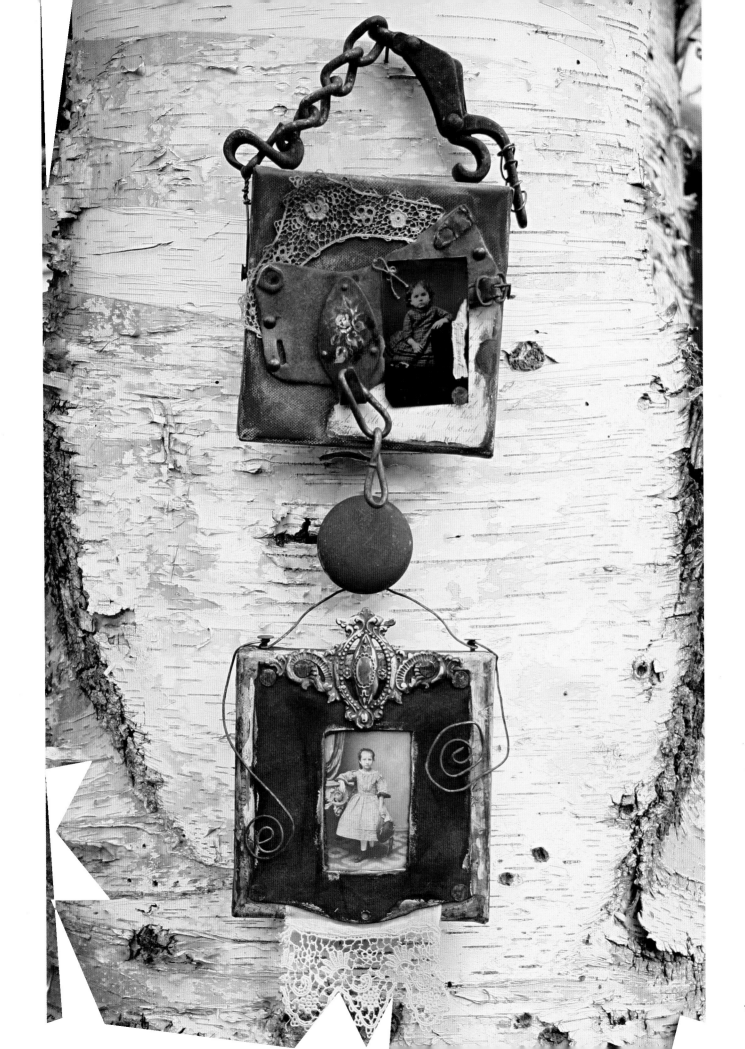

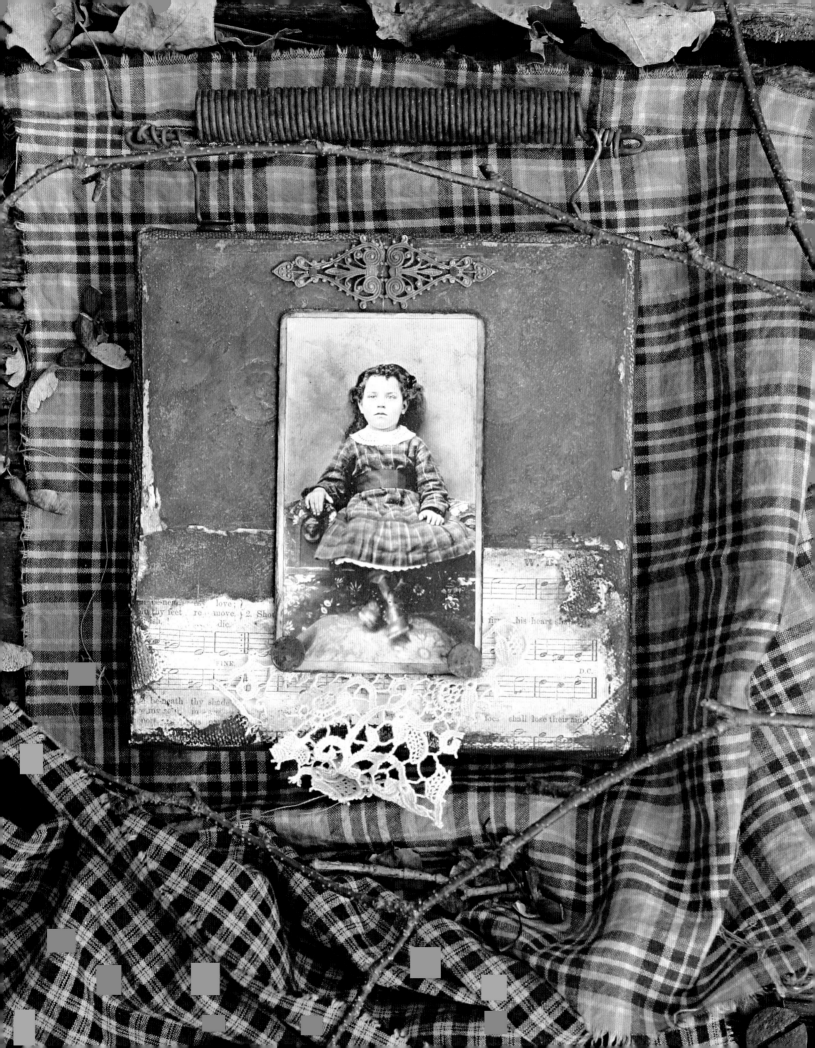

JOANNA PIEROTTI

Recycle, Rediscover, Revive, Revere

"Lace is so delicate yet intricately woven, just like some of us. The 'pretties' make me feel my feminine side."

—JOANNA PIEROTTI

For a receptive collector, one subtle detail from an old photo was enough to spark an enduring, growing collection. It also became the flashpoint for a series of wall-hung, embellished assemblages. The plaid dresses in a group of sepia children's portraits resonated strongly with Joanna, and it seemed only natural to join this recent fascination with her signature fondness for daguerreotype cases, rusted metal work, and delicate lace.

A feeling of nostalgic imperfection prevails, as a rusted handle arches above the square canvas and provides a trusty hanger. Timeless, never-out-of-fashion plaid, a tiny grace note of scrolled metal, and a snippet from an old textbook combine with a wisp of lace from another favorite collection to weave a mood both delicate and durable.

Not unlike many of the artists in this book, Joanna found that one fascination lead to another, and her various collections and interests display a common thread of curiosity, along with a family propensity for "Doing What You Love."

design/provenance

Whether you consider them visual clues or prompts, the descriptive details in any group of old photos can provide the perfect flashpoint for a collage, art journal page, or assemblage. Clothing details, such as the plaid garments in Joanna's photo stash, or period backdrops and outdoor settings from another era or locale are sure to stir ideas and impulses. A stack of "all for a buck" old photos can provide stimulation for a month—or a lifetime.

A visit to her studio reveals someone who is equally at home creating with a paint brush, sewing machine, or hammer and drill. Following in the footsteps of an artistic, encouraging mother, Joanna's early interests in sewing eventually sparked a fascination for painting. A love of found objects and an affinity for anything old and well-loved encouraged her to try her hand at decorative painting, including vintage furniture, metal buckets, and wooden surfaces of all kinds. Art dolls, a special love, provide opportunities to create personas using all of her studio skills—stitchery, found objects, and painted surfaces.

The realm of collage and mixed media was a natural for an artist equally interested in experimentation and visual storytelling, with a strong sense of how to use seemingly disparate objects in perfect harmony. Seemingly small treasures, such as a couple of inches of lace, tiny rusted tacks, and random links of metal chain, play important roles in this series of assemblages, and each plaid-clad child appears to narrate a different chapter of the overall story.

From photographer Susan Sontag:

"Life is not about significant details, illuminated in a flash, fixed forever. Photographs are."

"By furnishing this already crowded world with a duplicate one of images, photography makes us feel that the world is more available than it really is."

"Photographs alter and enlarge our notions of what is worth looking at and what we have a right to observe. They are a grammar and, even more importantly, an ethics of seeing."

"What comes from the heart, goes to the heart."

—SAMUEL TAYLOR COLERIDGE

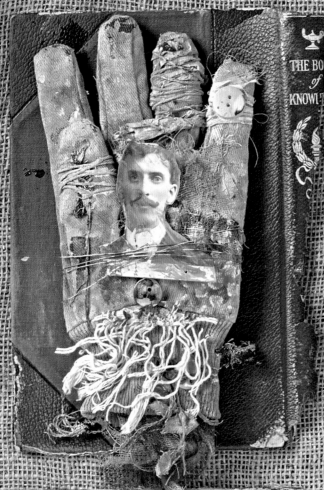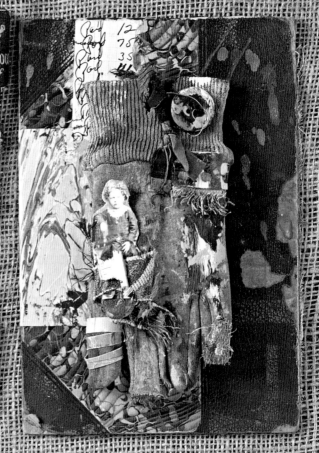
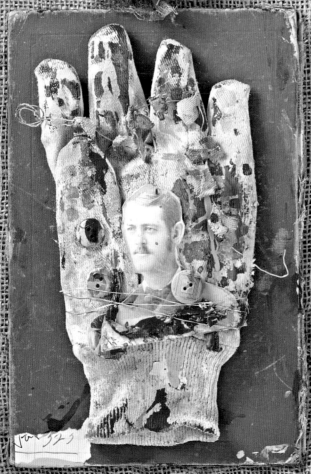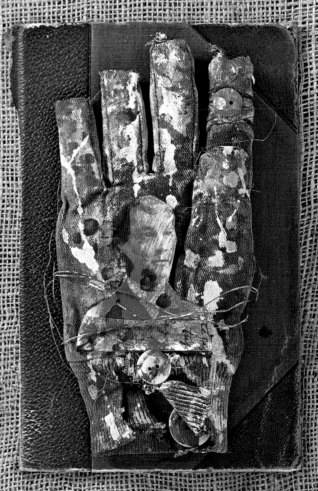

LYNNE PERRELLA

All Hands

The idea of using work gloves as a painting surface and collage support came from a note I found in my purse one day, reminding me to "buy canvas." When my errands took me first to the hardware store, I reviewed an endless supply of canvas work and gardening gloves and realized that these affordable and fascinating shapes would make an ideal surface for doing art. Once I saw the creative potential of the clearly utilitarian gloves, I bought up the whole display and brought them home to the studio. I've been collecting work gloves ever since—and not just the new canvas ones but also leather work gloves that I find abandoned in random locations everywhere I go.

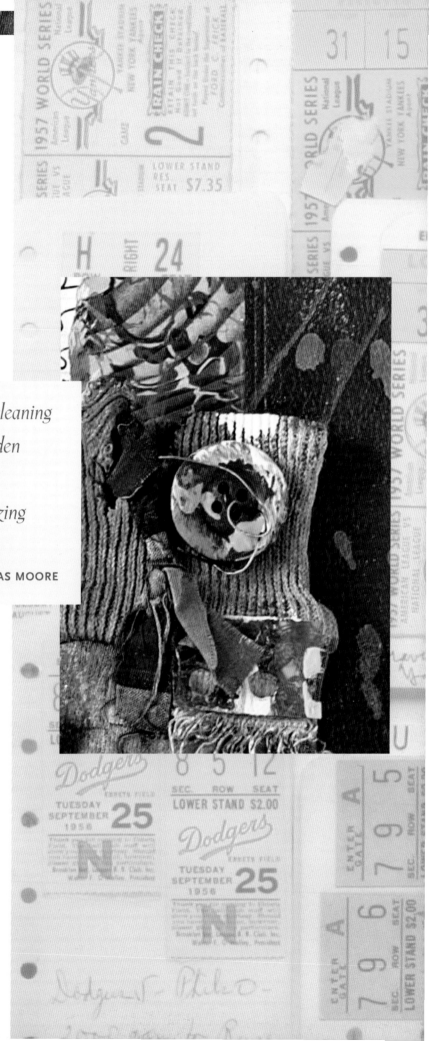

"The sweaty hand working a piece of wood, cleaning a hazy windowpane, or hoeing a patch of garden leaves pieces of skin and flesh of smaller than microscopic dimensions on the work, humanizing and ensouling it."

—THOMAS MOORE

I recently found a pair of discarded gloves, resting on top of a trash container outside of a gas station. They were magnificently worn, distressed, and (best of all) shaped and formed to the hands of the former owner. The ultrapersonal look of these gloves, and others in my collection, have inspired the artwork I make with new work gloves. I try to infuse each glove with a story or narrative, using anything on my art table. I begin by coating canvas gloves with gesso, and then I use acrylic paints, string and twine, melted wax, wedges of cardboard, fragments of old photos and fabrics, buttons, wire, and metal castoffs to embellish each "hand."

GLITTERING PRIZES

Regalia, elegant frills and frippery, jewel–like finds, gem–encrusted finery

Like a trunk full of treasures, this chapter contains luxe and lavish collections, mixed with "just for pretend" faux finery. From history of costume to frankly fake costume jewels, the focus is on glitz, shimmer, glint, and shine. Whether carried home from far-flung journeys or discovered by chance at a local estate sale, the prizes in these collections have spawned works of art that have an extravagantly regal bearing and a mood of over-the-top excess. Encrusted embroidery, faceted stones, a ransom of filigree, posh *passementerie*, and rampant regalia—these are the perfect ingredients for a grand finale.

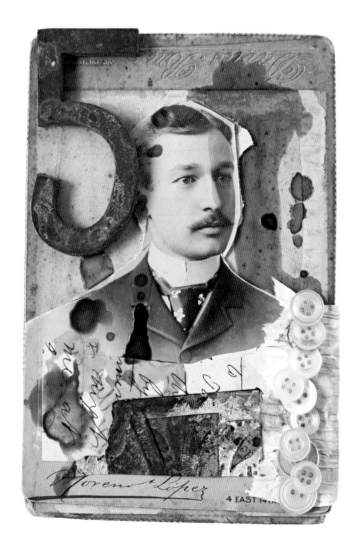

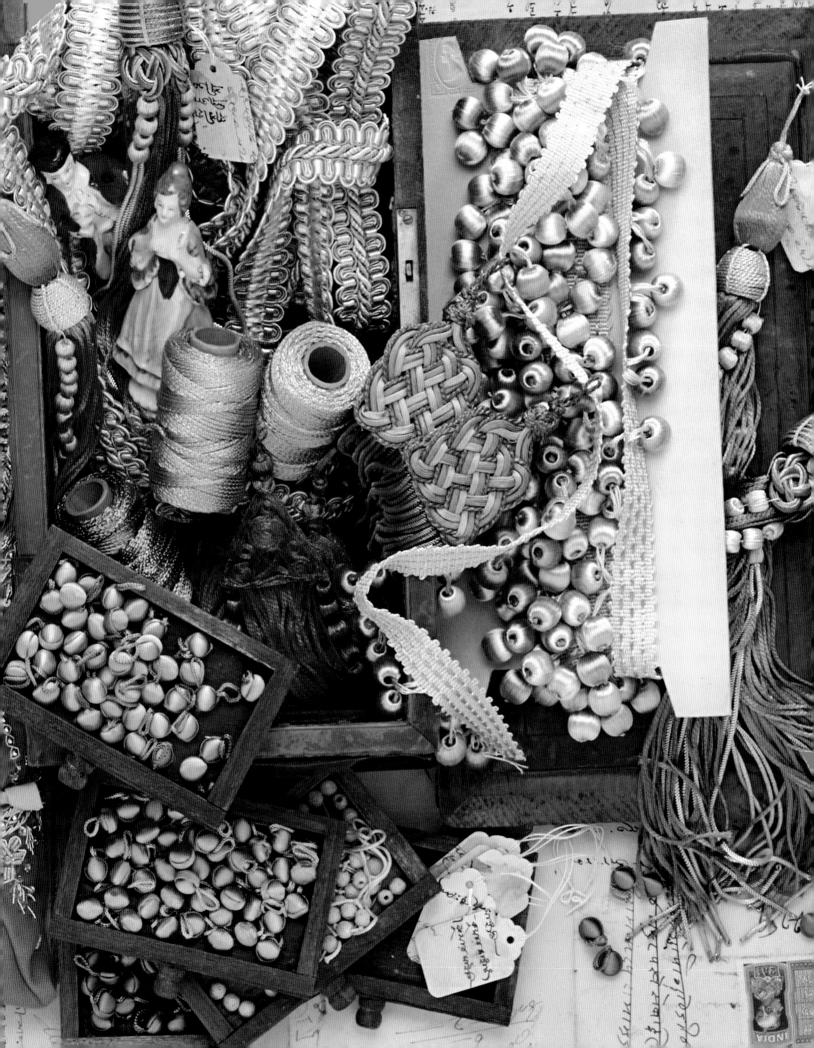

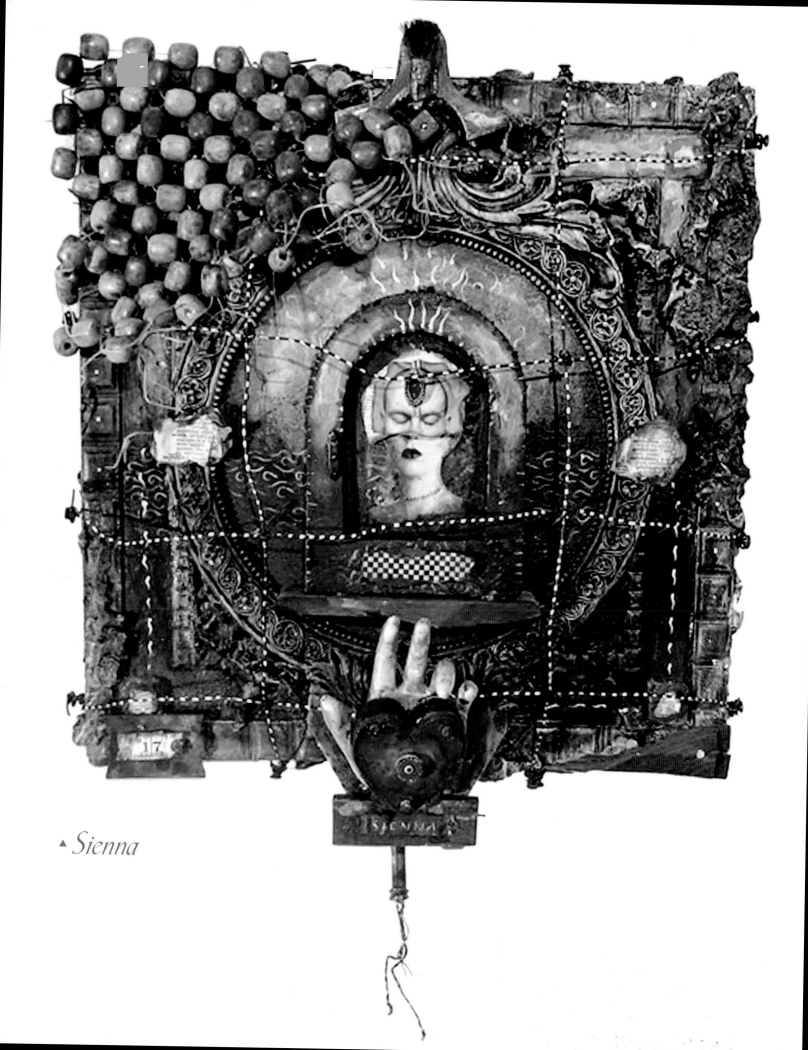

▴ Sienna

Digging Deep

One of the bylaws of H.A.G.S. (Hunting and Gathering Society) is that "Some of the best junk comes from places you'd never thunk." Coming from founding member (and resident wit) Michael deMeng, this is seasoned advice. He suggests that almost any vintage item can be disassembled, providing a gold mine of interesting art fodder. "Ever taken a typewriter apart?" Michael asks. "Amazing what is inside there."

Although he may set out on a collecting adventure with something specific in mind, he depends on serendipity to provide the right thing at the right time. When he finds something with vast potential, hundreds of possibilities flash through his mind, and the visualization process leads to a mix of usable and outlandish ideas—until the moment he starts working and gets his hands dirty. His method is to address found objects for their potential, rather than for their former use. For instance, an iron can be appreciated for its shape and aesthetic attributes and not its function. Michael loves the moment when the viewer observes a shrine he has made, and then suddenly realizes, "Oh my gosh, that was an iron!" Its all about maximizing the form, disassembling items for their best parts and adding to them, until the original object becomes almost unrecognizable.

Michael's regard for Mexican culture, specifically Day of the Dead rituals and traditions, provides an enduring influence on his own work, as he explores concurrent themes of transition, transformation, and celebration. An enormous shrine in his study consists of skeletal items he has collected onsite during Dia de los Muertos observances, and he usually returns from Mexico with at least a suitcase full of objects to add to the growing composition.

"I have always loved the idea of digging up some ancient artifact, wondering what in the world it was meant to be," Michael says. Through his work with found objects, he has become the creator of objects imbued with that same kind of wonder, mystery, and magic.

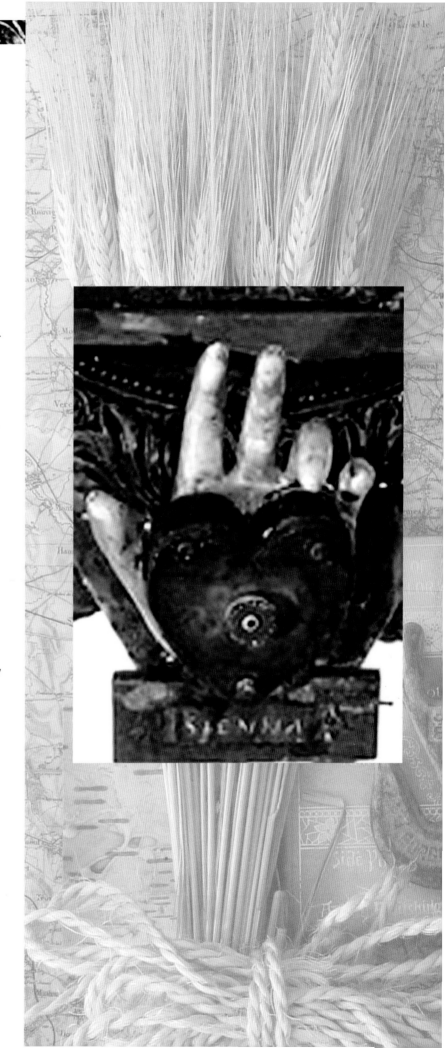

Cake Mix

The embodiments of playful fun and exuberant elegance, Lisa Kaus's towering, box-upon-box, mixed-media "cakes" are pure delight. The artist reveals that she was inspired by the festive celebratory nature of actual (edible) special-occasion cakes and playfully poses the question, "Who doesn't love cake?" Hard to argue with that, especially since Lisa's creations are made to last.

> *"The knot is tied*
> *And so we take*
> *A few hours off*
> *To eat wedding cake,*
> *It's delightful, it's delicious, it's de-lovely."*
>
> —COLE PORTER

Her love of collecting and gathering comes in handy when she begins to collect the "ingredients" for her next cake. Her host of found objects, nonsensical parts and pieces, fabrics, ephemera, and findings are used to embellish and decorate the assemblage. Lisa counts on unexpected quirky finds to inspire all of her mixed-media work, as well as her collages and paintings.

> *"Who doesn't love cake?"*
>
> —LISA KAUS

Collecting, a lifelong fascination, provides spark to her art and life. Some of her signature "musts" in her collective stash are German doll parts, vintage glass glitter, old keys, antique papers and correspondence, die-cut letters, and brass stencils. All are combined to deliver her mission statement: "To create elaborate creations that are beautiful but with a bit of edge to them."

Each of her constructions has a different mood, from a frothy, sentimental "wedding cake," created for a special couple, to a memorabilia encrusted cake that serves as a dimensional scrapbook of recollections. For this cake, she decided to take a festive, circus-like approach, mixing primary colors with fashion-forward shades. Rhinestones, chandelier prisms, die-cut numerals, fabric flowers, faux jewels, admission tickets, and painted polka dots combine to create a Big Top/High Fashion statement. We would hardly expect such an extravagant object to have any practical purpose, and yet the top box flips open, to provide storage for love letters and jewelry—or the keys to the kingdom.

 design/provenance

"Boo was our neighbor. He gave us two soap dolls, a broken watch and chain, a pair of good-luck pennies, and our lives."
—Harper Lee *To Kill a Mockingbird*

Who can read that quotation and not reflect upon a humble scuffed cigar box, full of childhood treasures? Mixed-media artists and incurable collectors seem to have an ongoing love affair with boxes. Whether used as an enclosure for assemblages, dioramas, paper theatres, or shrines—or merely as a place to save our loot—boxes appear on nearly every artist's list of favorite collectibles.

My own tower of gritty and grungy vintage cigar boxes cannot match the fanciful whimsy of the "cake" boxes shown here, but they are equally well-loved for several reasons. First, they remind me that something humble and functional can masquerade as an object of beauty and extravagance. Consider all of that gold trim, embossed paper labels, and elaborate lettering, and the "official" seals, banners, and imprints. Also, they are endlessly sturdy, adaptable, and readily available. They qualify as a cheap studio thrill, since I have never paid more than a dollar or more for any of the boxes in my collection. Providing both mystery and functionality, boxes evoke a mood of discovery and secrecy, reminding us of closed drawers, private letters and diaries, keepsakes, and heirlooms.

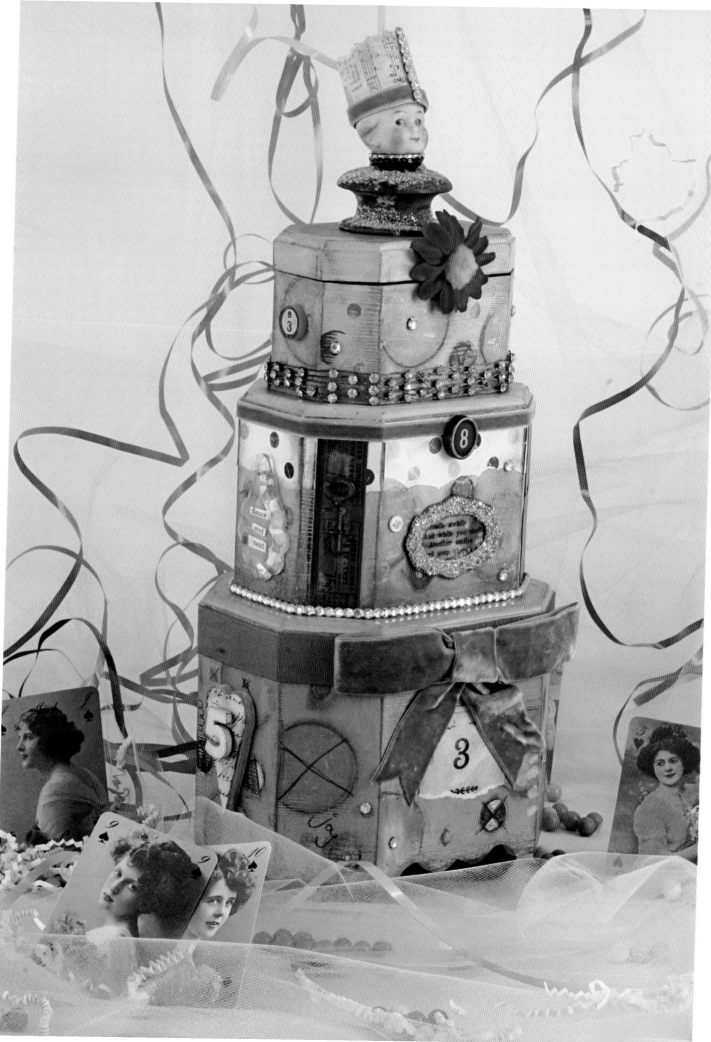

Once Upon a Time

Sometimes an iconic image will strike a chord, inspiring the artist to revisit it, over and over, continually mining it for all of its significance and richness and to find new ways (and materials) for creating interpretations of it. Images of Queen Elizabeth I provided this kind of endless inspiration for artist Linda Warlyn. With her jewel-encrusted gowns, ceremonial doll-like stance, signature ruffled collar, and shaved hairline, Elizabeth seems hand-in-glove with Linda, who declares: "Less isn't more. More is often better, and the age-old need to embellish, make prettier, and embellish some more—that's my way."

> *"Less isn't more. More is often better, and the age-old need to embellish, make prettier, and embellish some more—that's my way."*
>
> —LINDA WARLYN

Like many of the artists in this book, Linda depends on her collections of research material and books on favorite topics to spur and prompt ideas, and she consulted them as she gathered ideas and materials for making a regal, embellished mixed-media medallion. Exploring her books on the history of costume design, she was reminded that Elizabethans specialized in ruffles, impressive voluminous sleeves, and wide collars. These details were interpreted with found objects from her overflowing collections, such as vintage dictionary pages, antique beaded trim and brooches, countless buttons (both common and rare), copper mesh, a discarded typewriter letter wheel, doll parts, and rusted die-cut stars. The central element, a polymer clay ceramic face, pays homage to a queen noted for her white court makeup

> *"All my possessions for a moment of time."*
>
> —ELIZABETH I

and dramatic, mannequin-like presence. A locket for the Queen was fashioned from a tiny matchbox, edged in doll house trim and festooned with small gold and silver charms. After studying etchings of the Queen in her court regalia, Linda also added a celluloid ring, more beaded trims, watch parts, antique buttons, and jeweled crosses, to create a cascade of finery. An artist who describes herself as someone who creates in "joyous, unusual ways," Linda used every item in her collection to dress the Queen.

design/provenance

A pro at spotting the latent possibilities of any found object, Linda used her collection of Christmas tree bulb reflectors from the 1950s to optimum advantage in this assemblage. She picked them up at a sale, mostly because they were a reminder of childhood holiday celebrations, but realized that the pierced-metal reflectors were far more than mere nostalgia when she began including them in her assemblages. Originally manufactured to provide decorative collars for colored holiday lights, the reflectors prompted Linda to use them as a collar and cuffs fit for a queen.

Best of all, the job of cutting and punching designs into the intricate metal was already done. The humble bulb reflectors provide surprising elegance and detail and a reminder of the magic and sparkle of childhood Christmases.

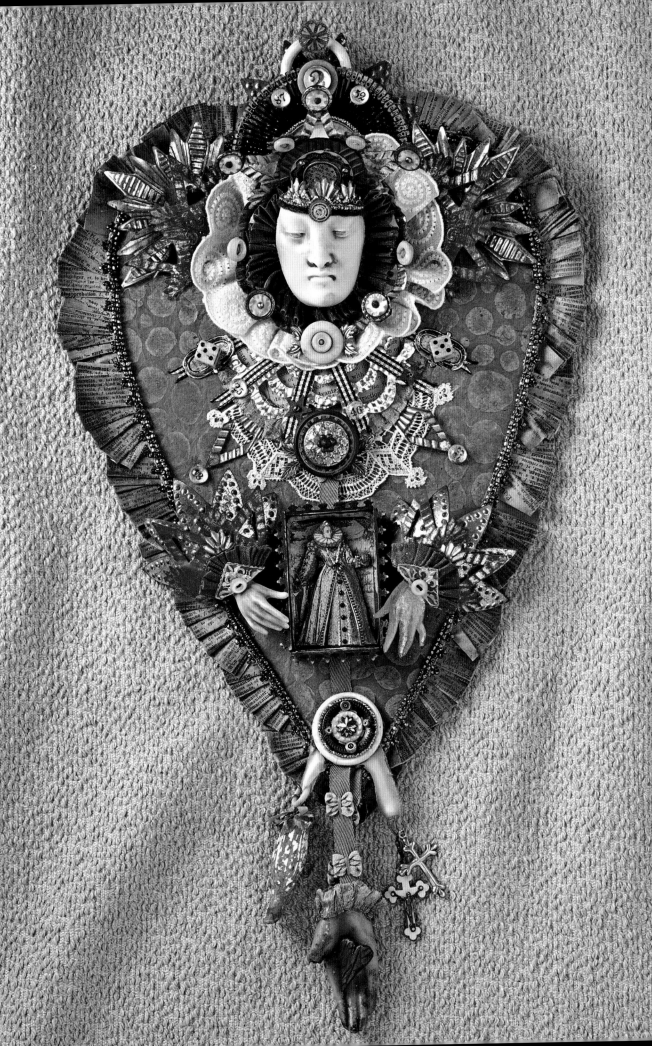

Shoe Shine

"Happenstance is all. I never really have anything in mind when I go on a hunt," says Julie Pearson, who has been known to discover some of her favorite finds in the most surprising places. Whether her latest discovery is wood, glass, metal, or paper, her constant focus is to transform the object and make it her own, allowing each completed assemblage to provoke narrative stories for the viewer. Not unlike one of her important influences, Joseph Cornell, Julie specializes in finding new and surprising ways of using common materials and placing them in distinctive settings. A length of wooden molding, a swatch of cotton lace, a faceted glass button, twirls and twines of silver wire, a mostly quiet color scheme—all are woven together in subtle compositions that invite the viewer to look closely.

Julie's collections and her art are consistently intertwined. Sometimes, small bits are the beginning point for a piece; sometimes, they provide the ideal finishing touch. This process of searching, acquiring, creating, and determining the destiny of an object becomes a continuous labyrinthine path. Julie says that "anything old or beautiful" will capture her imagination, although a strange metal remnant found on a Chicago sidewalk is remembered as being one of her finest discoveries. Humble and rare, it all finds a home.

Look through the inspiration files and reference materials in this artist's studio, and you will encounter saved clippings and photos from European fashion magazines. Haute couture has always provided a strong design impulse for Julie, and the subject is never more apparent than in this grouping

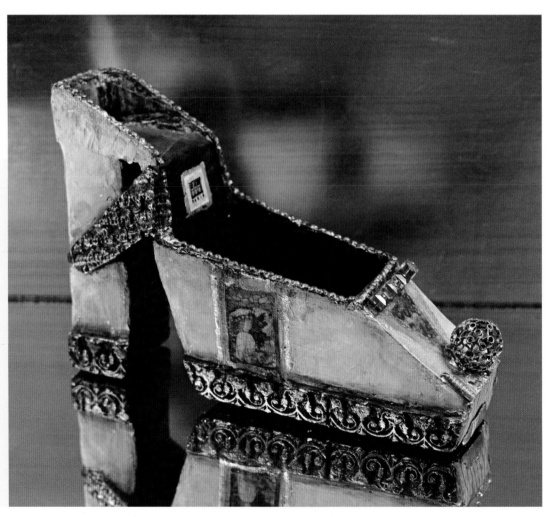

"Her fairy godmother merely tapped her with her wand . . . then she gave her a pair of glass slippers, the most beautiful in the world."

—CHARLES PERRAULT, FROM *CINDERELLA*

▲ *Memories of Florence*

of inventive and magical "homage shoe portraits" of some of her favorite fashion designers. The project began as a commission from Stuart Weitzman to create a series of shoe portraits, and it lead Julie in dozens of new directions in her mixed-media artwork.

Creating each homage was a treat, as Julie was able to take all that she knew about each designer and reinterpret it through her own creations. For example, the kicky exuberance of Betsey Johnson is reflected in hot colors and strong patterns, while the cool, glittering elegance of Oscar de la Renta is echoed in Julie's mostly white and silver assemblage. Renaissance refinement prevails in *Memories of Florence*, making the viewer wish there was a shoe portrait for each of the Medici princesses.

> "More than anything else I have a weakness for pretty feet and pretty shoes."
>
> —RESTIF DE LA BRETONNE

Each shoe began with a wire armature, to which polymer clay was added, along with plaster bandages, spackle, gesso, paint, and other materials, to create a preliminary surface suitable for embellishment. The shoes owe their sparkle and zing to the fancy bits plucked from the bottomless stash in Julie's studio. An anonymous paper bag, filled with odd bits and pieces, was discovered in her mailbox. Within was a damaged vintage glass flower—the perfect finishing touch for one of her shoe portraits. The overall mood of this unique collection of shoes is unquestionably "pure Pearson," as Julie tips her hat to some of her important design influences.

▲ *Homage to Oscar de la Renta*

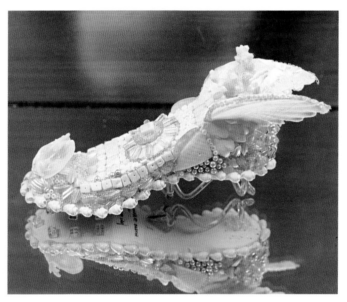

▲ *Homage to Jeanine Janet*

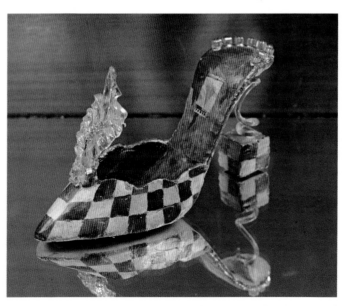

▲ *Homage to Betsey Johnson*

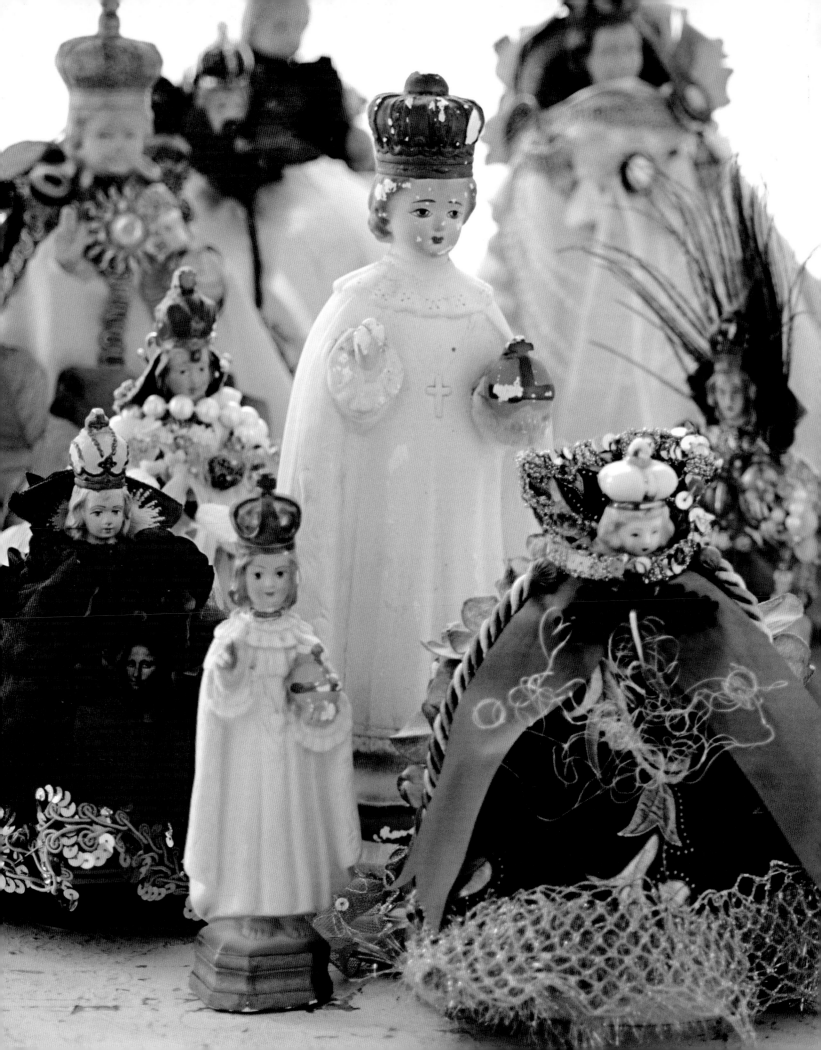

Divine Excess

"I just like to look at stuff," says Melissa Sorman happily. Her carefully crafted vestments for a series of Infants of Prague pay ample tribute to her love of form, texture, color, line, and knowledge of opulent costume. Not content to merely collect the figures, she raided her endless trunks of vintage satins, silks, and brocades and found bits of feathers and fur and costume jewelry to create the cloaks for each statue. One collection prompted another, as the statues provoked her to find new, unexpected uses for finery she had been collecting for years.

"My collections are all worked into my home, and I love it when first-time guests come here," says Melissa, a landscape designer who creates seasonal still-life tableaux by placing the elaborate Infants amid ivy, curly willow, forsythia branches, or majestic paperwhites. The groupings of her collections, combined with the cuttings from her gardens, communicate a strong sense of home, in which shelter and sanctuary are one.

> "Who shall say I am not the happy genius of my household?"
>
> —WILLIAM CARLOS WILLIAMS

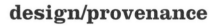

design/provenance

As a collector of ceremonial altar figures from various cultures, I was fascinated to learn about the rituals and traditions behind their costumes and vestments. Figures were often handcrafted by the men of the community, and the women were assigned to taking care of the figures, making their changeable clothing and human-hair wigs, and attending to the jewels, capes, and ritualistic finery. These chores bestowed importance and prestige on the women, acknowledging their special talents of needleworking and tailoring, and the job of caring for the statues was often passed down through generations.

In her novel, *Death Comes for the Archbishop*, Willa Cather further illuminates the traditions of altar figures and the women who tend them: "She was a little wooden figure, about three feet high, very stately in bearing, with a beautiful though severe Spanish face. She has a rich wardrobe, a chest full of robes and laces, and gold and silver diadems. The women loved to sew for her and silversmiths to make her chains and brooches. She was their doll and their queen, something to fondle and something to admire."

▸ *View From A Halting Place*

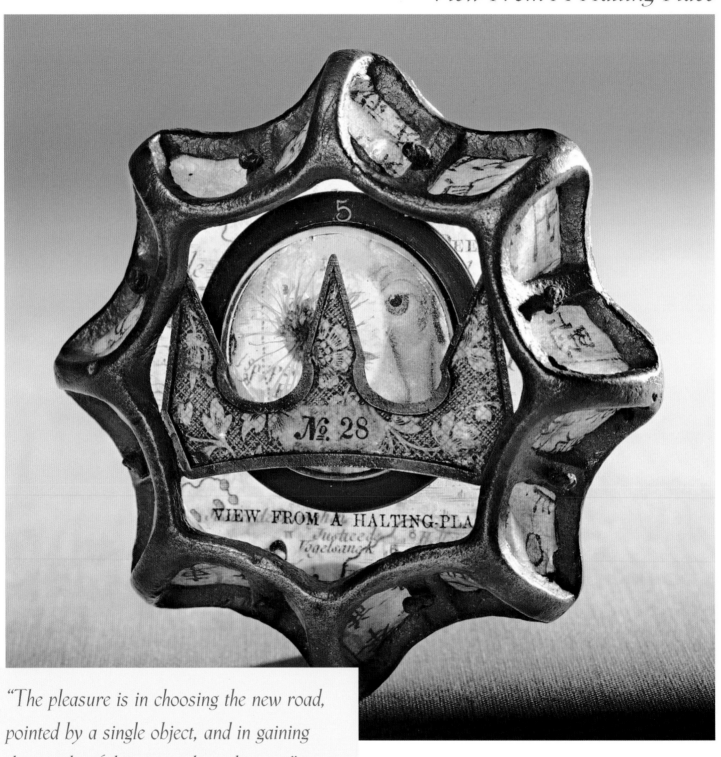

"*The pleasure is in choosing the new road, pointed by a single object, and in gaining the insight of discovery along the way.*"

—KEITH LO BUE

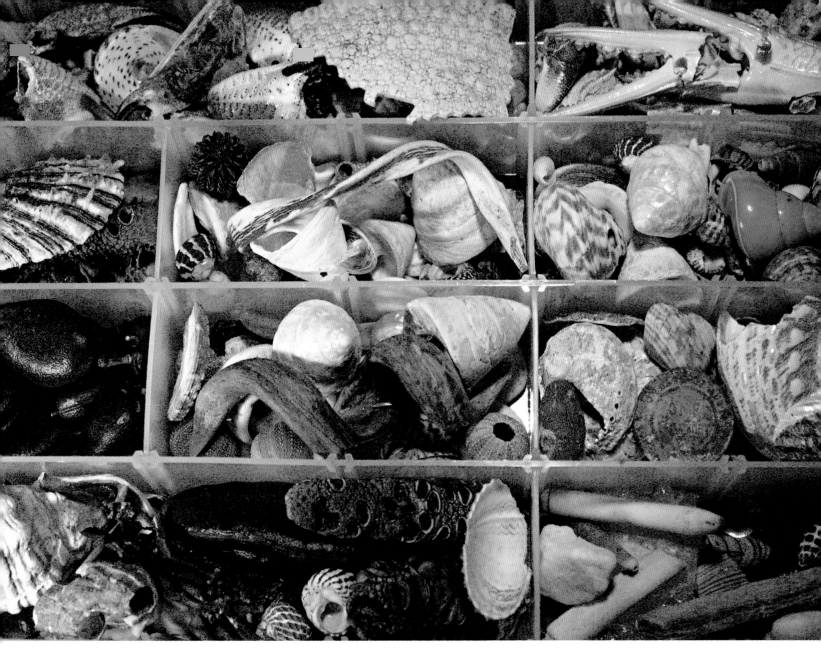

True View

He's always been a collector. Before starting his vast collections of art fodder and remarkable stashes of found objects, Keith Lo Bue honed his collecting instincts by seeking out music of all genres, from all time periods and all parts of the world. Eight thousand recordings (and counting!) later, he is still at it, refining and adding to his hard-to-define, "monumental tapestry" of sound. He considers his music collection to be a meaningful underpinning for his visual work, and the sounds he enjoys while at his jeweler's table become an integral part of each creation.

Keith spies the latent potential of each object he finds along the way, often marveling that it was not snatched up with relish by anyone else. And yet it's hard to imagine anyone who would have his genius for turning offbeat materials into singular wearable works of art. *View From A Halting Place* reveals Keith at his shining best, fashioning a brooch from a Georgian pocket watch crystal, the image of a compelling face peering from behind the fence-like finials of a sheep-shearing blade. The interior of the brooch is continually transformed by a dance of light entering and moving throughout, and a vintage spigot handle provides an able-but-unusual scaffold for the piece. "Was I the first person to give this object its due?" Keith wonders. "Did anyone else catch their breath on sighting it?"

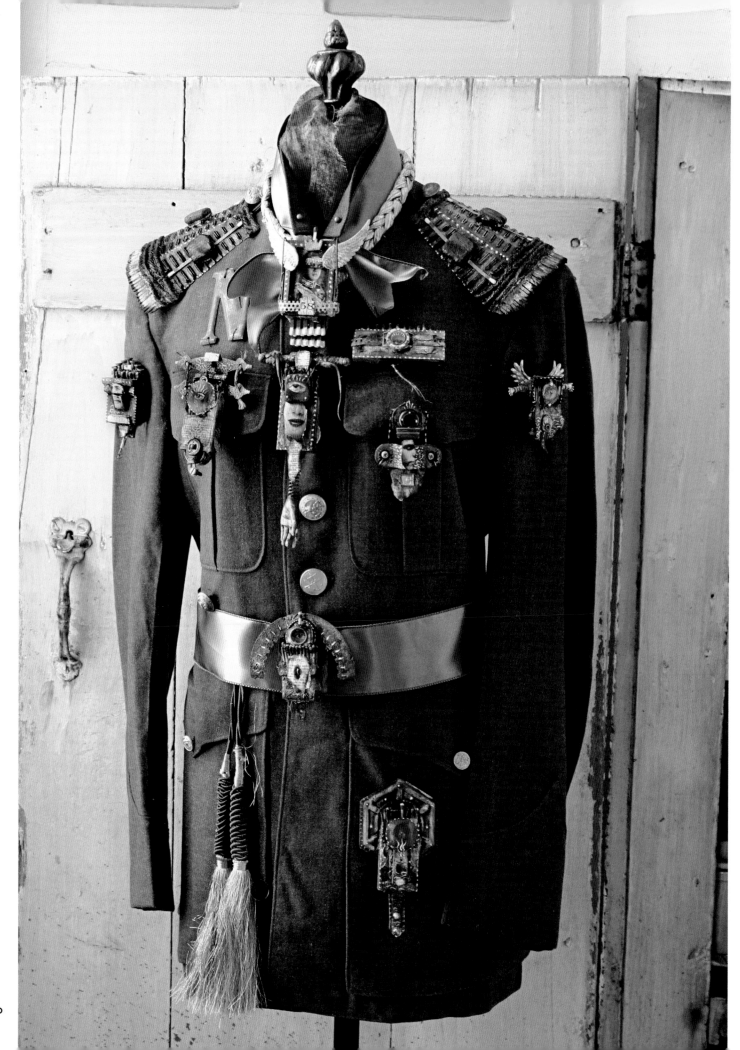

Reigning Regalia

He surveys his kingdom with a secret subliminal system for cataloguing all finds. Michael deMeng can typically find anything in his "piles of junk" at a moment's notice. And he is constantly on the hunt for new loot, welcoming any unusual finds that might turn up on the side of the road, in the woods, beneath a house—wherever.

Although known as the Wizard of Rusty Things, Michael melds objects as disparate as plastic, wood, metal, and paper, using distinctive mark making and paint to add a cohesive web of color and design to his various constructions. Elements are seldom allowed to remain intact and recognizable, and he prefers breaking them down or adding to them to obfuscate their original purpose. Whether transforming an imposing but kitschy wall clock rescued from the 1970s or working with a row of just-purchased-at-the-convenience-store Pez dispensers, he has quite literally become the Alchemist and the Archivist, all in one grand stroke. Liquid Nails, his adhesive of choice, is always at the ready, either in a tube for small projects or loaded into a caulking gun, for big ventures.

"When I first put this uniform on
I said, as I looked in the glass,
"It's one to a million
That any civilian
My figure and form will surpass."
Gold lace has a charm for the fair
And I've plenty of that, and to spare
While a lover's professions,
When uttered in Hessians,
Are eloquent everywhere!"

—GILBERT AND SULLIVAN

Michael's continuing series of matchbook shrines began as a commentary on the tenuous, temporary nature of things. ("One wrong move and—whoosh—up in flames.") And yet, this array of wearable shrines has the historic look of regal badges and ancient Royal Orders, worn with swagger and complemented by a pair of made-by-deMeng epaulets trimmed in burned wooden matches.

 design/provenance

"Glittering in golden coats
like images;
As full of spirit as the month of May
And gorgeous as the sun at midsummer."

—WILLIAM SHAKESPEARE, *HENRY IV*

Before a workshop with Michael (we spent an afternoon altering Pez dispensers with the most amazing results), I viewed an array of his artwork spread out before me on a side table. There were groupings of his lightbulb sculptures, matchbook shrines, and a couple of other larger constructions. I was captivated by how good it all looked together, and a couple of years later, I had the pleasure of receiving dozens of his wearable shrines in the mail, which I used to create this mythic uniform. The impulse to create a uniform originally came from my feeling that Michael's shrines/badges look very much like the regalia of ancient Samurai warriors, with intricate patterns and traditional colors of black, crimson, gold, green, purple, silver, and white. The uniforms were not only designed for protection but also to strike awe in an enemy. As it turned out, my awe of this impressive group of badges did not lead to a Samurai treatment, but it did lead me to present them as a form of emblems and regalia. Best of all, it satisfied my original urge to see an impressive display of his work together for maximum visual drama. *Excelsior!*

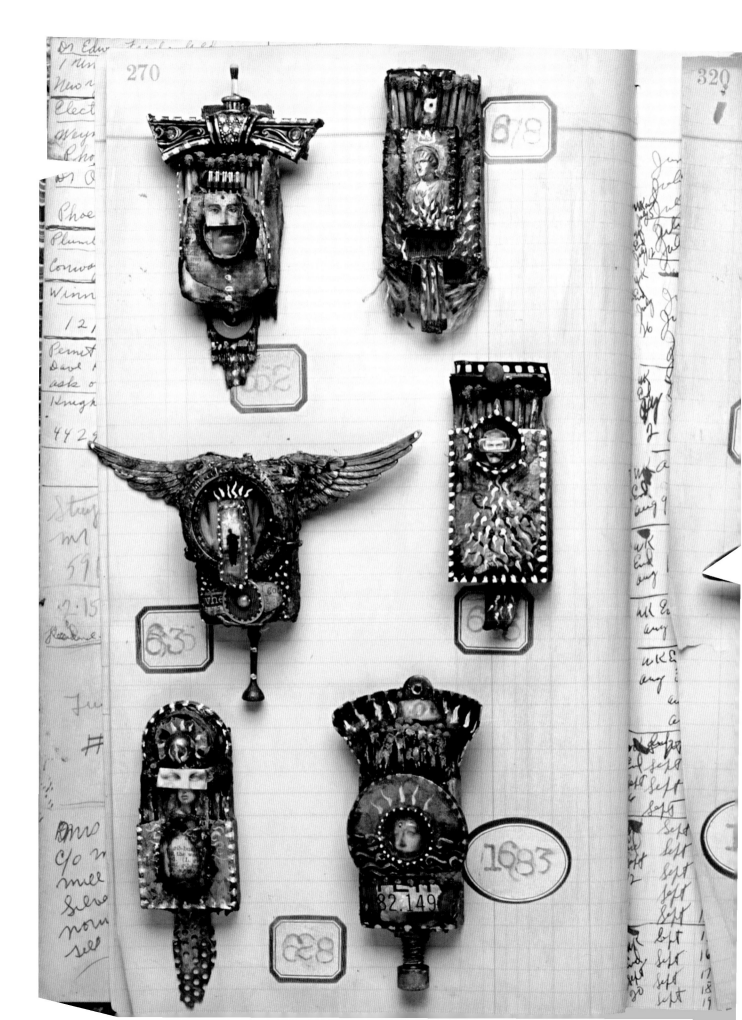

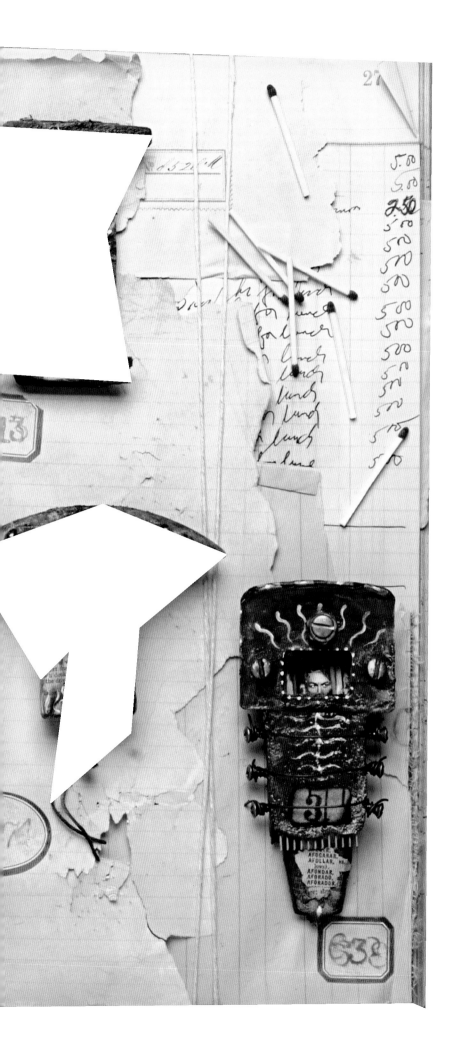

Take Your Pick

A crimped tintype, a broken length of wooden ruler, a numeral from a long-lost appliance, a coil of brittle wire, a pair of gilded wings: Michael sorts these questionable treasures and provides each relic with a stellar new life. "It is a way of transforming the discarded into something sacred," he says. A selection of his matchbook shrines, presented for your consideration, hints at the endless possibilities of small forgotten things and the endless joys of scavenging, collecting, and reusing.

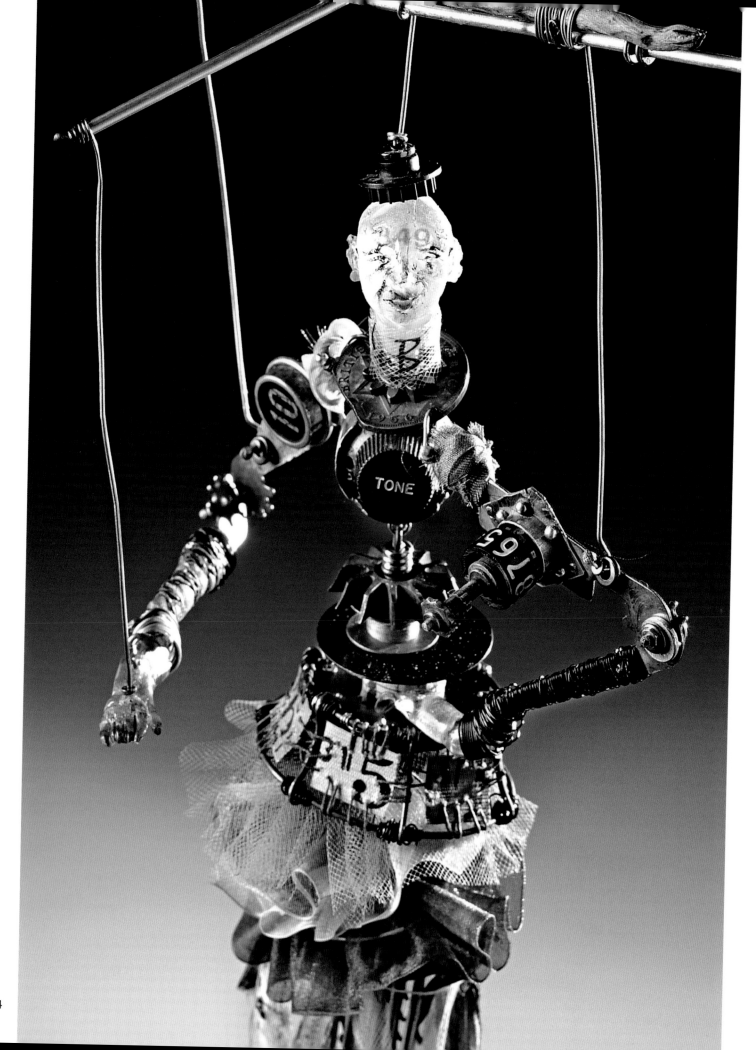

Center Stage

By juggling several ideas, impulses, memories, and influences at once, Susan Lenart-Kazmer is able to take the richness of each and mine it for its maximum goodness. In this jewel-like articulated marionette, she was reminded of a favorite artist, Henri Toulouse-Lautrec, and her childhood trips to Las Vegas with her father. The marionette, part of a series of circus figures, reflects the artist's fascination with the sometimes-gaudy and flamboyant world of performers. Not unlike Toulouse-Lautrec's work, the figure, made from sterling silver, base metals, and transparent resin, has pathos and unique, elegant style, representing Susan at her best.

Susan insists that found objects used in her mixed-media work be subtle; they must also become an integral part of the overall design. Her role as artist, jeweler, and designer is to create "talismans, costumes, and adornment," concurrent with her role as storyteller and narrator. A self-described "builder of artifacts," she is continually surrounded and influenced by various collections of ethnographic artifacts and costumes. Her home and studio are decorated with manuscript scrolls, tassels, handwoven fiber clothing, and religious figures from various cultures, as well as a beautiful and bountiful array of metal bits and shards with multiple colors, surfaces, and patinas.

When Susan travels, she hunts and gathers as a way of creating a tactile memory of the location. Another way for Susan to relate to those experiences and responses is by making a talisman, or "token of memories," from these collected fragments. Whether they are smooth river stones from Vermont, discarded beer tops, or shreds of discarded clothing found in a big city, Susan's collections provide visual flavors, hints, clues, and prompts of her travels. Should a recently collected object appear in her dreams, she awakens with the perfect idea of how to work with it, "to it's best."

> "With me it was really pretty simple: love of the objects came first, and there was absolutely no other criterion for collecting. What concerns me is an object's intrinsic value. And collecting for that reason is very different from acquiring things as if they were currency."
>
> —ALEXANDER GIRARD

design/provenance

Study the exquisite nuances of the jewel-like marionette here, and savor how each tiny detail of cloth measuring tape, brightly colored netting, or mysterious gear from a forgotten appliance adds to the overall exuberance of the figure. Although she focuses on transforming the ordinary, mixed-media artist and jeweler Susan Lenart-Kazmer, who is anything but ordinary, observes: "When you close your eyes and hold an object in your hand, you can feel whether the user has enjoyed, neglected, or cherished it," she says. "My job as an artist is to take the found object and present it in a new and unexpected way."

The Vaudeville Marionette

Reliquary
Reverb

Light bulbs rescued from a broken strand of holiday decorations form a significant visual element in this stunning necklace. With her jeweler's eye for detail and her collector's appreciation for offbeat materials, Susan realized that the fragile, burned-out bulbs could be carefully removed from their outer casings and fashioned into ornamental talismans. Finding joy in reusing materials that have endured "wind and rain, wear and tear," Susan creates necklaces replete with findings that include dominos, pencils, rulers, Monopoly game pieces, shredded caution tape, beach glass, wire, and more.

> *"People tell me that my work reminds them of ancient relics."*
>
> —SUSAN LENART-KAZMER

Years ago, during a trip through a series of small villages in Mexico, Susan encountered a home festooned with exuberant homemade decorations. In spite of a language barrier, the home owner invited Susan to come inside and share a meal. "Poverty had not inhibited this woman's creativity," Susan says. "She cut and twisted soap wrappers and colorful cereal boxes into a continuous garland that transformed her yard into a blaze of color and texture. Though poor, this woman saw beauty in what others considered throwaways. This inspired me to work with found objects. I like to put these castoffs into a dignified setting and surround them with unexpected materials like brassiere hooks, stitched threads, snaps, bingo cards, and mica."

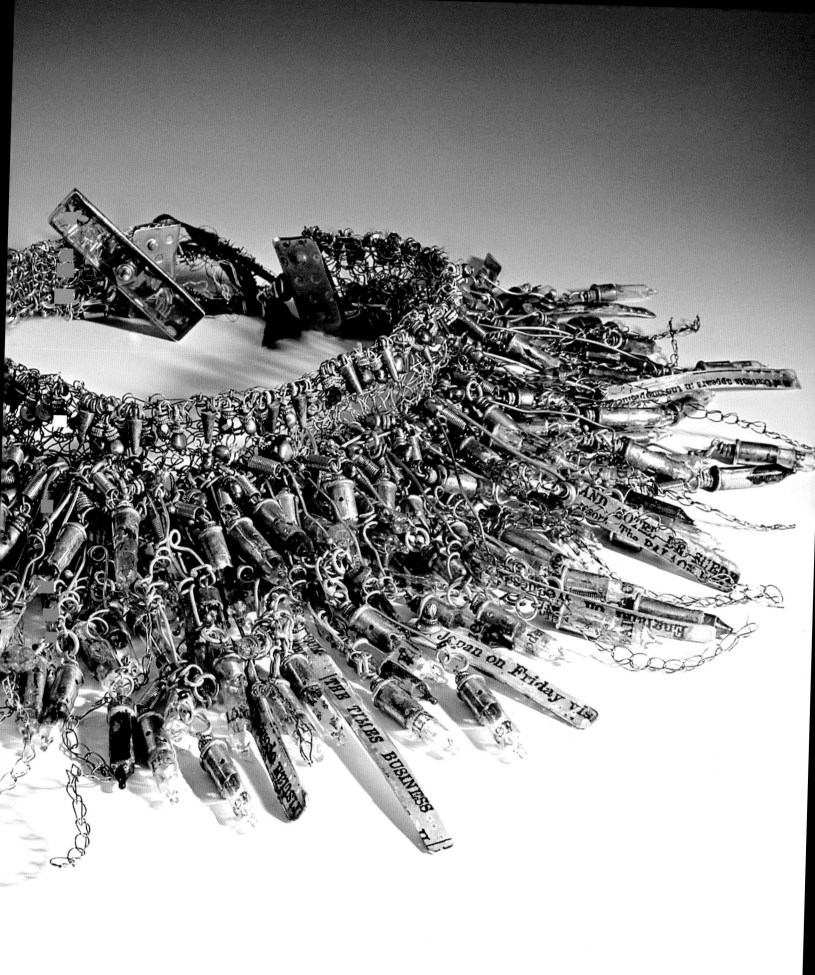

LYNNE PERRELLA

Ivory Archive

Color—or, as in this case, the absence of strong color—can provide a foolproof way to spur ideas, as well as prompt an ever-growing collection. In theory, one could spend a lifetime focusing on items of a single color palette and never run out of possibilities.

This still life of mostly white objects started out with vintage documents and maps but soon grew in size and texture, as surprising additions were added—some from the natural world, some found objects. As I walked through my studio, gathering anything that was white or nearly white, I free-associated about what to use in an assemblage. The experiment, to only work with similarly colored objects, freed up my usual thinking about how to design and compose a shadowbox and triggered fresh choices. Once again, I was reminded of the endless variety of white.

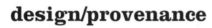

design/provenance

One afternoon, over thirty years ago, I sat at the counter of a no-frills workingman's luncheonette in Lower Manhattan, New York. As I waited for my lunch, I passed the time by studying the various details of the restaurant. A time-worn blackboard announced the daily special sandwiches, soups and stews. A scrubbed, clean, yellow-flowered oilcloth was thumb-tacked to a wooden work table. Large black cast-iron kettles and skillets sat atop a massive stove, below a canopy of huge ladles, slotted spoons, and spatulas. Eventually, my eyes rested on a large off-white ironstone mixing bowl full of eggs, sitting in a shaft of afternoon sunlight. For whatever reason, the image of the bowl of eggs has stayed with me all these years, and remains vivid and enduring. I think that moment was the beginning of my love affair with the color white. Of all colors, it seems to be the most eternal, the most adaptable, and the most confident. Not to mention pure, complex, classic, mysterious, elegant, understated, dramatic, nostalgic, modern, and bottomless.

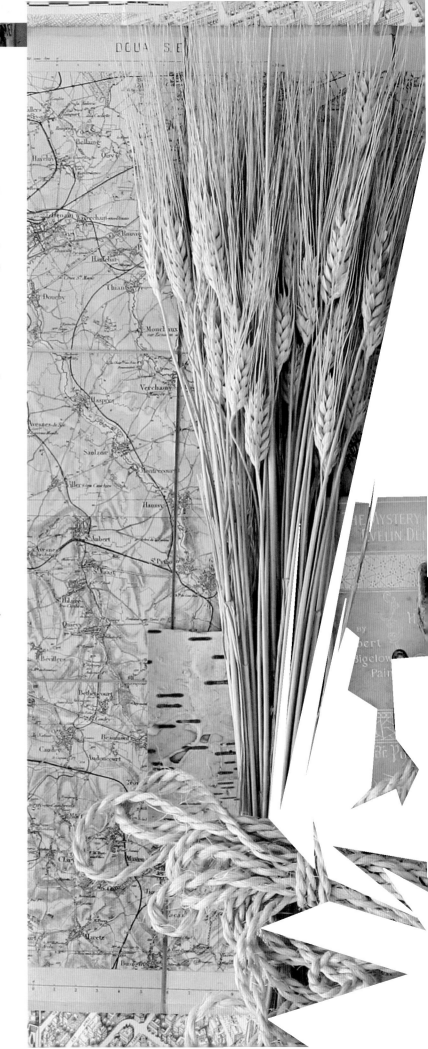

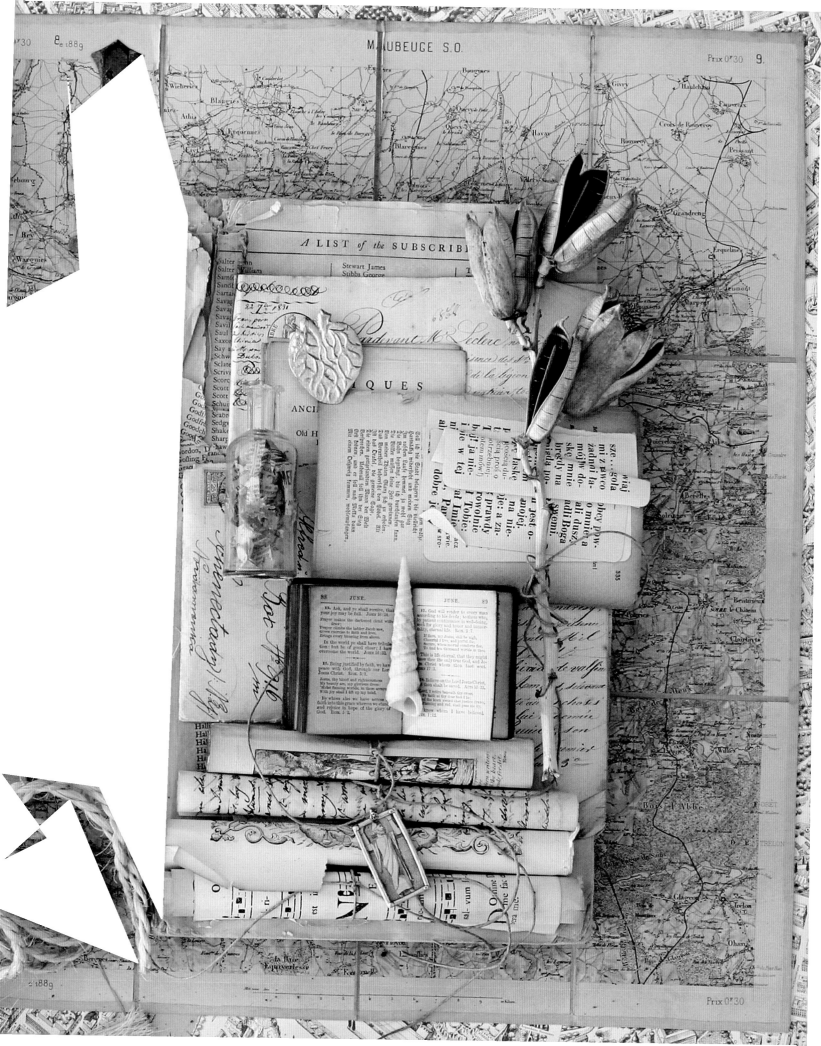

Deeper Still

A previous career as a graphic designer shines through James Michael Starr's wonderfully austere collage compositions, in his use of minimum images for maximum impact. He practices the fine art of selection and appropriation, preferring to use fragments of vintage botany and anatomy books from the late nineteenth century. These beautifully detailed and carefully executed diagrams echo an earlier age and provide surprisingly elegant images of humanity. Working on stretched canvas, he builds his collage surface with successive layers of unprinted book pages. Dipping each page into a solution of acid-free archival white glue and pressing them onto a gessoed canvas, he creates the subtle, pared-down surface he desires.

"In the end, what affects your life most deeply are things too simple to talk about."

—ETTY HILLESUM, *AN INTERRUPTED LIFE*

Defying a recent trend of highly exuberant and lavishly colored collages, he has challenged himself to work with an elegant, hushed color palette, using minimal, classic visual elements to create a mood of examination and introspection. The traditions of graphic design provide a strong support for an artist confident enough to take a "less is more" approach to collage, with stunning results.

"A collection owns a bit more of you each time you add to it."

—JOSHUA BAER

A conscious decision to strip away heavy decoration and allow a minimalist approach to prevail, the emphasis is on strong composition, dramatic placement of elements, and a purity of message. In his dimensional assemblage work, he asserts that "ideas are triggered by objects," and that same philosophy is apparent, as his vast collection of vintage books and steel engravings become an endless font for his subtle collages.

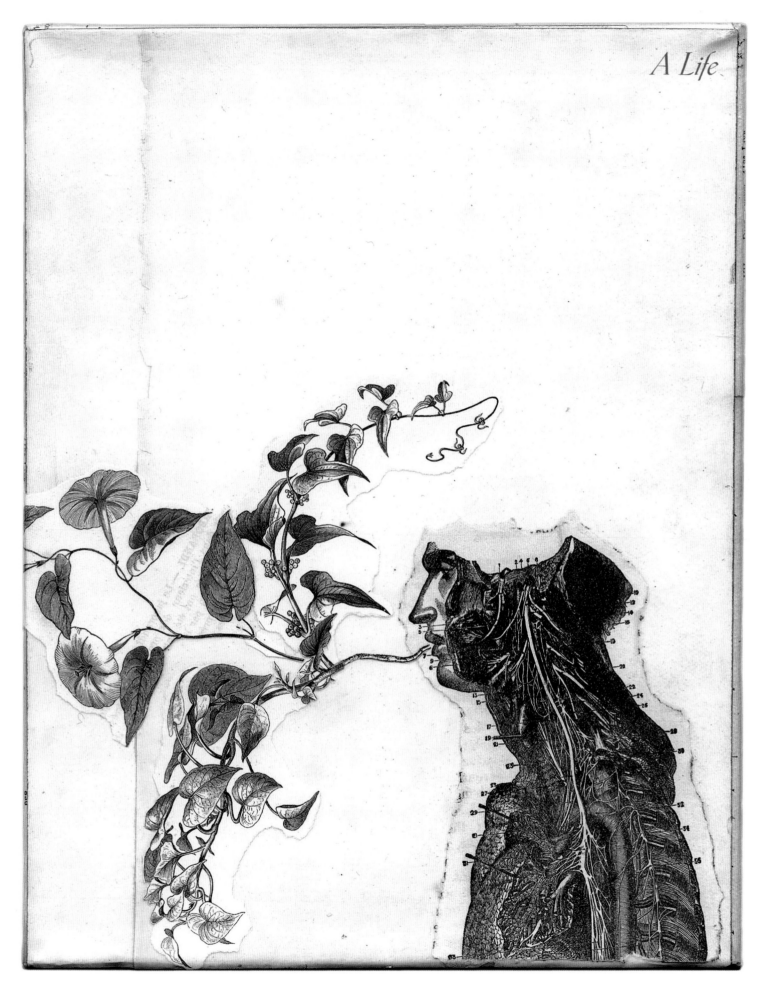

NANCY ANDERSON

Perfect Pitch

Sometimes it all just clicks. Something from a bottomless collection will step forward and become the perfect thing at the perfect time. A luscious, select bit of turquoise inspired Nancy Anderson to work with the stone, literally making it the heart of this assemblage. "It was so beautiful to me that I had to make it a showpiece," she says.

Responding to the color, texture, and shape of the smooth chunk of turquoise, Nancy began planning a sheltering shadowbox enclosure to house the stone and other artifacts. Noting the resemblance of the stone to a human heart, she created a fused-glass backdrop painted with "arteries" and backlit by a red bulb.

Adding a heroic detail to the top of the shadowbox is a figure of a woman from a sporting trophy. "She just topped it off for me, looking so strong and daring," Nancy says.

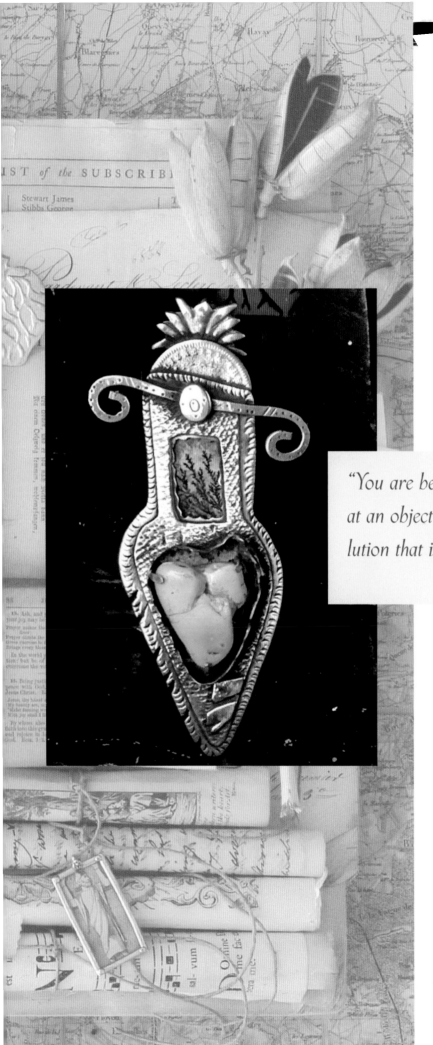

> "You are beginning to cultivate your eye when you look at an object and feel its energy. It is a process, an evolution that is strengthened by trial and error over time."
>
> —LOUIS SAGAR

(See more charismatic figures from Nancy's trophy collection on pages 4 and 5.) Playing a supporting role, antique crystal drawer pulls become the legs of the shrine. Best of all, the shrine's turquoise focal point can be carefully removed and worn as a pin. "How courageous it is to love another," Nancy muses. Infused with this sense of wonder and discovery, the shrine stands as a tribute to the ability of the artist to make laser-sharp selections and always let emotion furnish the key ingredient.

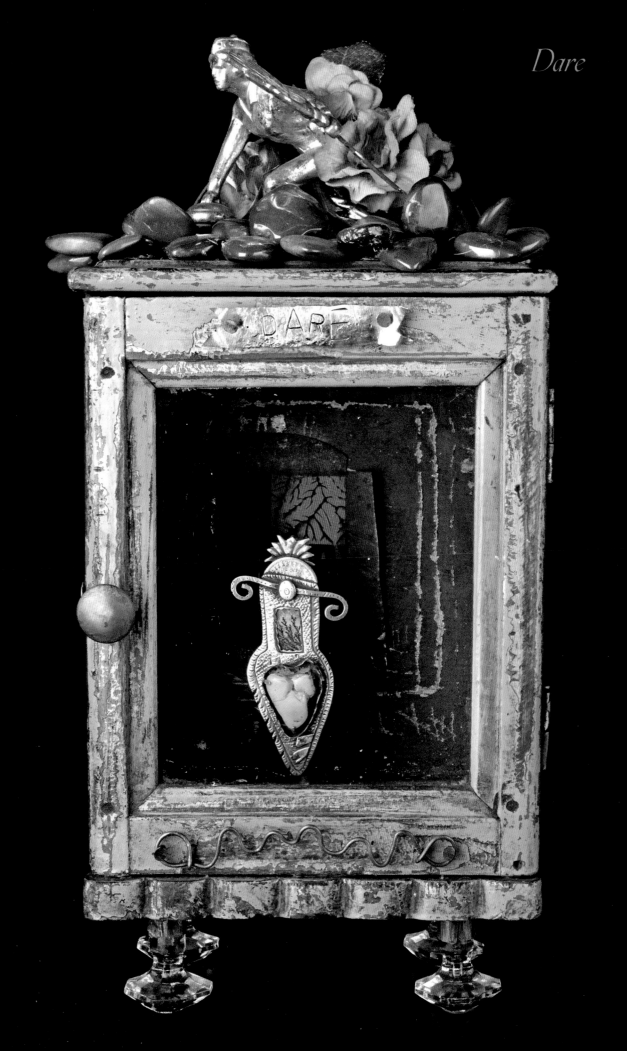

Dare

"The strangest thing that I ever brought home was a dead fish that I found while beachcombing. It was dried and withered but had the most marvelous iridescent scales. The smell was over-whelming. Not even my cat would come into the house."

—BERYL TAYLOR

"Duck decoys. A whole bunch of them—twenty, or so. I found them at a flea market and still haven't used one."

—MICHAEL DEMENG

"A fossilized mammoth tooth!"

—GAIL RIEKE

"A bass fiddle."

—CATHY ROSE

"It seemed like a good idea at the time"

Artist/collectors reveal the strangest things they ever brought home.

"I drove back to my hometown and filled the bed of my pickup truck with six inches of dead cicadas and shells. I still use them, to this day."

—DANIEL ESSIG

"I became interested in natural plant dyes and read that lichens could be boiled to make pretty colors. On a trip to Scotland, I scraped lichen off a rock along a shore-line. I packaged it up and mailed it to my home in Colorado. When it finally arrived, it was so moldy and stinky, I threw it out."

—MONICA RIFFE

"I brought home a three-foot-long, 1920s-era skee-ball machine, complete with a rubber band mechanism for keeping score. I got it dirt cheap, and it is just amazing. I have never seen anything like it before or since."

—TRACY V. MOORE

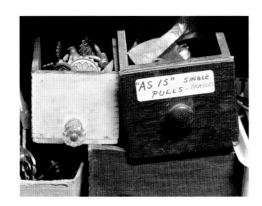

"The strangest thing? Probably old taxidermy. Two large matching automated monkeys playing drums. Yes, two."

—LYNN WHIPPLE

"A worn broom head. It's still waiting for me at a friend's studio in Ohio."

—NINA BAGLEY

"What comes to mind is a metal thing that used to function as a guard on a utility pole. It had an amazing patina and was attached by many very large, serious bolts. I looked at it, admired it, for years. One very late and snowy night, emboldened by another artist, we freed this wonderful sculpture from its mooring. Today, it is in my house—one of my favorite objects."

—GRACEANN WARN

"The strangest thing? A bone from a human arm. I'm quite sure of it."

—NANCY ANDERSON

"The strangest thing I ever brought home was an old metal box used for mailing eggs. Years later, it became an essential element in an art collaboration."

—LESLEY RILEY

"An old piano that I planned to repaint. I never did."

—CARLA SONHEIM

"Hubcaps and a car grill."

—OLIVIA THOMAS

"I brought home a stuffed jackass head that had been a prop in a movie. I eventually sold it to a bank. I still haven't figured out what to do with my Mexican confessional booth."

—STEVE TEETERS

"I brought home a third of a cow skeleton. Its ribs, vertebrae, pelvis, and leg bones made a very interesting frame for a mirror."

—NICK NICKERSON

"I came across a suitcase full of curly mohair at an estate sale. I bought it and, a few days later, discovered it was covered with insects. I was mortified!"

—LISA KAUS

Denise Andersen Photography
Website: www.daphotoart.com
509-346-9441

Nancy Anderson
Sweet Bird Studio
1301 Spruce Street
Boulder, CO 80302
303-301-2968
Email: info@sweetbirdstudio.com
Website: www.sweetbirdstudio.com

Anne Bagby
Email: annebagby@bellsouth.net

Nina Bagley
Website: www.ninabagley.com
Blog: ornamental.typepad.com

Sarah Blodgett
Website: www.sarahblodgett.com

Bottle Shop Antiques
Washington Hollow
2552 Route 44
Salt Point, NY 12578
845-677-3638

Bowen Barn
Route 82
Stanfordville, NY
845-868-7085

Ann Bromberg
621 Lafayette NE
Albuquerque, NM 87106
505-266-6488
Email: cityscape@swcp.com

Michael deMeng
Website: www.michaeldemeng.com

Daniel Essig
111 Grovewood Road
Asheville, NC 28804
Email: books@danielessig.com
Website: www.danielessig.com

Lisa Kaus
Lisa Kaus Art Studios
Website: www.lisakaus.com
877-727-4602

Ellen Kochansky
1237 Mile Creek Road
Pickens, SC 29671
864-868-4250
Website: www.ekochansky.com

Marianne Lettieri
360 Nova Lane
Menlo Park, CA 94025
Email: mariannelettieri@yahoo.com
Website: www.mariannelettieri.com

Susan Lenart-Kazmer
Email: susanlenartkazmer@adelphia.net
Website: www.susanlenartkazmer.net

Keith Lo Bue
Website: www.lobue-digital.com

Tracy V. Moore
Email: tracyvmoore@hotmail.com
Website: www.zettiology.com

Nick Nickerson
P.O. Box 618
Copake, NY 12516
518-329-1664
Website: www.nicknick.com

Julie Pearson
319 Franklin Street
Traverse City, MI 49686
231-933-6062

Lynne Perrella
Email: lkperrella@aol.com
Website: www.LKPerrella.com

Joanna Pierotti
P.O. Box 213
Volcano, CA 95689
Website: www.Mosshillstudio.com

Lisa Renner
Email: lisarenner@tx.rr.com
Website: www.lisarenner.com

Gail Rieke
Email: gail@riekestudios.com
Website: www.riekestudios.com

Judi Riesch
Email: jjriesch@aol.com
Website: www.itsmysite.com/judiriesch

Monica Riffe
1903 W. Mulberry Street
Fort Collins, CO 80521

Lesley Riley
Bethesda, MD
Website: www.LaLasLand.com
Blog: www.myartheart.blogspot.com

Rodger's Book Barn
Rodman Road
Hillsdale, NY 12529
518-325-3610

Cathy Rose
www.cathyrose.com

Laura Stanziola
1 Omistad Place
Santa Fe, NM 87508-8325
(By appointment) 505-466-2525

Carla Sonheim
Salida, CO
Website: www.carlasonheim.com

Melissa Sorman
2201 Route 82
Ancram, NY 12502
518-329-3136
Email: msorman@taconic.net

James Michael Starr
2546 W. Five Mile Parkway
Dallas, TX 75233
214-330-3151
Email: jamesmichaelstarr.com
Website: www.jamesmichaelstarr.com

Beryl Taylor
Email: berylptaylor@aol.com
Website: www.beryltaylor.com

Steve Teeters
719 Buddy Holly Avenue
Lubbock, TX 79401
806-741-1590

Olivia Thomas
15441 North First Street
Phoenix, AZ 85022
Email: pezman@concentric.net
Website: www.oliverose.com

Linda Warlyn
Email: Ldyintmoon@aol.com

Graceann Warn
Email: gwarnart@aol.com
Website: www.graceannwarn.com

Lynn Whipple
Website: www.whippleart.com

KC Willis
Email: info@lipstickranch.com
Website: www.lipstickranch.com

Jane Wynn
Wynn Studio
P.O. 43069
Nottingham, MD 21236
Email: jane@wynnstudio.com
Website: www.wynnstudio.com

Laurie Zuckerman
526 East Elizabeth Street
Fort Collins, CO 80524
Email: zucky@qwest.net
Website: www.lauriezuckerman.com

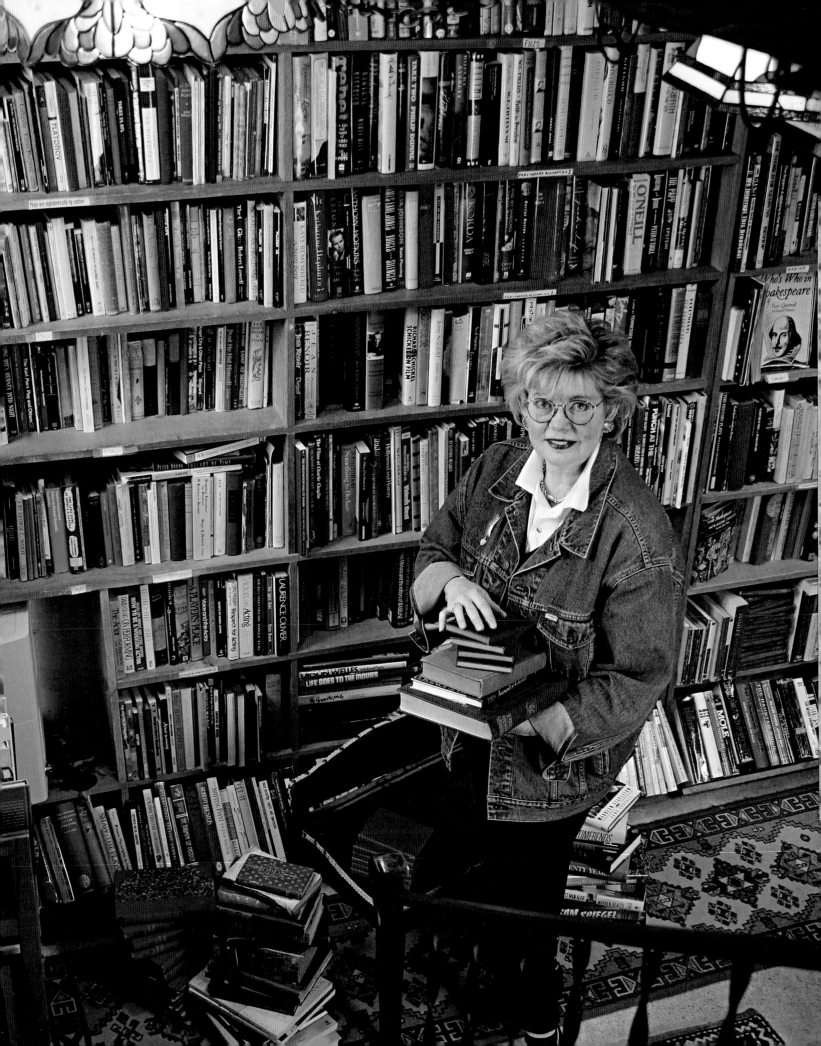

Lynne Kendall Perrella is a mixed-media artist, author, designer, workshop instructor, and incurable collector. Her interests include collage, assemblage, one-of-a-kind books, and art journals. She conducts creativity workshops in the United States and abroad and exhibits collage in galleries throughout the Berkshire Mountains. She is on the editorial advisory boards of *Somerset Studio* and *Memories* magazines and contributes frequent articles and artwork to various paper arts publications and books.

Lynne is the author of *Artists' Journals & Sketchbooks: Exploring and Creating Personal Pages* (Quarry Books, 2003); *Alphabetica: An A-Z Creativity Guide for Collage and Book Artists* (Quarry Books, 2006); and *Beyond Paper Dolls* (Stampington, 2006).

She lives in Columbia County, New York, with her husband, John.

For more information and inspiration, please visit www.LKPerrella.com

ACKNOWLEDGMENTS

In the process of working on this book, I became even more deeply convinced of the power of objects—not as possessions but as talismans and starting points to provoke storytelling, as well as works of art.

As a lifelong collector and artist, this book was my opportunity to join with my "tribe," a kindred group of colleagues and friends who speak the language of Collecting and never fail to see the true possibilities of every object. They fearlessly sent along their artwork and their beloved collections and generously shared their astute sentiments about this complicated mutual passion of Hunting, Gathering, and Making.

My thanks to my editor, Mary Ann Hall, for holding the vortex of the project and providing laser coaching on how to keep all the plates spinning. And a hearty high five to my friend and photographer Sarah Blodgett, who brings excellence and cheer to every endeavor.

This book is dedicated to the generous, encouraging spirit that thrives in this community of mixed-media artists. Thank you, one and all.

—LYNNE PERRELLA

"Joy is not in things; it is in us."

—RICHARD WAGNER